T5-CGB-943

Gold

Gold

by Johann Willsberger

Translated from German by Joachim Neugroschel

Doubleday & Company, Inc.
Garden City, New York
1976

Through over six millennia, and in nearly all cultures, gold has proven to be more than a combination of properties. It is a symbol. It is the archetypal epitome of godliness, ownership, and power and might. Anyone who sees gold, grabs it. And if gold grabs you, it never lets you go again.

Gold turned men into explorers. It lured the Egyptians on fragile boats and perilous expeditions around the African continent. It drove the Cretan and Phoenician captains to the very edges of the world of antiquity. And when Christopher Columbus landed in America during the fall of 1492, the very first thing he asked the natives was: "Where is the gold?"

Gold made men into inventors. While working gold, the Egyptians developed brilliant skills in metallurgy. While mining gold, the Romans created new mining techniques. And when alchemists tried to produce gold from test tubes, they came up with gunpowder and porcelain.

Gold turned men into slaveholders and murderers. In order to possess it, the Egyptians subjugated the Nubians, the Romans conquered Gaul and Spain, the Spanish conquistadors wiped out whole nations in Central and South America.

In the course of history, men have given gold any number of meanings: a symbol of divine omnipotence or earthly authority, a status sign for the rich, or merely a means of payment. But whatever the significance, a piece of gold was always unsymbolic and bitterly realistic in one way: as a shiny proof of human suffering.

Gold created empires. High cultures like Egypt flourished because of their opulent gold production. And even in the nineteenth century, the United States owed its rise to the economic potency of the gold found in California and Alaska.

Lack of gold has forced empires into wrack and ruin. Rome's dominion collapsed when its gold was lavishly wasted in all directions. Spain lost its importance when the source of gold dried up in the New World.

And gold has inspired artists to create works that have survived the millennia and still allow the "soul of gold" to shimmer forth.

When gold was still divine

Gold entered the theater of history with the first high culture known to us. In the fifth millennium before Christ, the Sumerians, a nation of unknown origin, wandered into the area between the Euphrates and the Tigris. They founded the city of Ur, south of what later became Babylon, developed cuneiform writing, and constructed the first potter's wheel.

And they worked gold. Yet this metal had no monetary value for the Sumerians. Ur, like all Asiatic countries, had silver or copper currency, since they had rich silver deposits. Yet gold was at the very top of the priority list for Sumerians.

Gold was divine. The sacred instruments of the temple were made of gold. And so were the insignia of earthly deities—the kings and priestesses.

It wasn't easy for the Sumerians to quench the gold thirst of their rulers. Mesopotamia had no gold sources of its own. So the Sumerians took up trading with other countries that did have gold, probably Afghanistan and India, and perhaps even Egypt. Caravans, threatened by lack of water and gold robbers, transported the yellow metal from those places to Ur and Uruk. We don't know how the gold merchants were paid, in goods or metals. If the Sumerians paid their bills in silver, the merchant caravans would have marched back with even heavier loads than they had brought. For a pound of gold cost at least eight pounds of silver around 3000 B.C.

Nothing was too dear, however, for the shiny image of the divine kings. Nor was the matter settled with the purchase of gold itself. Artists, certainly not cheap ones, had to forge it properly for its use in temples and representation.

In 1934, the British archaeologist Leonard Woolley discovered the royal tombs of Ur. There he brought to light examples of the high artistic standards of the Sumerian goldsmiths. In the first tomb, the mausoleum of King Meskalamdug, Woolley found gold beads, gold bowls, a shell-shaped lamp of gold, axes of gold containing a great deal of silver (electron), golden head ornaments, spiral rings of gold wire. For all their scientific sobriety, Woolley's detailed list, his meticulous descriptions reveal how deeply impressed he was by these gold orgies amid putrefied skeletons.

The most valuable piece in the tomb was the royal helmet of the king himself, which later scholars regard as meant to be a magic protection against enemies. Here, as in a wig, every lock of hair is carefully hammered out. The individual hairs are indicated by delicately engraved fine lines.

The mortuary of Queen Shubad also shimmered with gold. The queen's headgear outshone everything: "Its base was a broad golden band, wound in ribbons around the hair. Over it lay three wreaths. The lowest, hanging down over the forehead, consisted of three gold rings; the second, of gold beech-leaves; the third, of bundles of three long willow-leaves each, with golden flowers. . . . In back, on the hair there was a golden comb with five teeth, which ran out in gold blossoms. . . . Heavy spiral rings of golden thread were wound into the curls at her temples. . . ." (Woolley)

The excavations of the tombs of Ur also confirmed that the Sumerians considered their "sun metal" sacrosanct. For the remains of guards, servants, coachmen, ladies in waiting, entertainers who were buried in the chambers with the rulers wore only copper and silver adornments—a clear sign of their lower rank.

The goldsmiths of Ur were already masterful craftsmen, who exploited all the properties of their art material to produce the greatest aesthetic effects. For instance, they knew how to

hammer it into utterly thin leaves or bend it into narrow rings.

The kingdom of ancient Sumeria survived until about 2350 B.C. Then its power and treasury were assaulted by a neighboring king from the north: Sargon of Akkad. King Sargon conquered Ur and Uruk. But he was greedy for gold and even tin, which was not as valuable, but nevertheless equally desired. So he began a war of conquest that brought him to Asia Minor, Cyprus, Crete, and finally Spain. Sargon thereby earned himself a lead role in the heroic legends of coming generations. He was supposedly the original of Herakles. However, his wars brought such chaos into the well-functioning economic (and gold) system of the Mediterranean that it didn't recover for several centuries.

The first empire was built on gold

Around that same time, when the Sumerians were in Mesopotamia, Egypt, the gold-richest land in early antiquity, was experiencing its first economic and cultural boom.

In Egypt, the gold poured out of the earth and the rivers. There was gold on the shores and in the bed of the Nile. There was gold throughout eight thousand square miles in the eastern plateau desert.

Of course, gold would not have sufficed to make Egypt the foremost power in the world. After all, the black Nubians to the south also had lots of gold. But they didn't even know how to get it out

of the ground properly—until the Egyptians came and taught them with the whip.

Along with their natural resources, the Egyptians also possessed the necessary intelligence for making the gift of nature an instrument of power. Gold hunger sent their creativity to dizzying heights. Heinrich Quiring, a German specialist in gold mining, writes: "If we were to draw a list of the most important inventions in the area of metallurgy and ores, mining, firing, and fusing during the Age of Copper (3900–2100 B.C.), we would have to attribute eighteen of the twenty-two inventions to the Egyptians, who, in that era, were at the top both in finance and in skill."

Actually, the invention of the alphabet would have been enough to assure Egypt's cultural importance for posterity.

Egypt's experts in precious metal did not merely collect gold, which rivers and fields willingly yielded. They correctly surmised that this visible *alluvial gold** must come from hidden sources. They discovered *native gold** and found out that it always appeared in connection with veins of quartz.

As late as our century, geologists noticed how well the Egyptians possessed the technique of

* Gold occurs as native gold and as alluvial gold. Native gold is to be found in rock within arteries of ore or quartz. It has to be obtained by mining. Alluvial gold is revealed by weathering and erosion. It is scattered around the deposit area as gold dust, gold foil, gold particles, gold nuggets. Some alluvial gold, washed away by water, is found in the gravel and sand of brooks and rivers.

prospecting. While seeking new deposits, these modern geologists did not come upon a single source that their pre-Christian colleagues had not already discovered. And wherever there were not typical traces of quartz (even right next to gold-occurrence areas), the ancient Egyptian prospectors hadn't even taken the trouble to dig for the metal.

In order to get at the gold in rocks, they had to drive galleries into the earth. The Egyptians invented mining. First with stone tools, later with copper and iron tools, they dug tunnels as wide as 13 feet and as long as 300 feet. And in some places they reached a depth of 300 feet.

Almost peripherally, since the miners on the desert plateau needed water, the Egyptians created a network of deep wells, by which in turn the road builders could find their bearings. Egypt never again had such fine traffic connections as in the days of the Pharaohs—at least until present-day programs of aid to developing nations.

The most important step in processing crude gold had already been completed by the Egyptians.

They had invented the art of smelting, which in turn went back to another Egyptian invention, the blowpipe. First the quartz fragments from the mines were smashed in mills, and then cleansed of the worst dirt in sieve-like vessels. After this washing, the gold was put in an oven, and the charcoal fire heating it was kindled with blowpipes. The gold melted and flowed out through holes. The base admixtures, slag, and metal ox-ides remained behind. However, the silver, always present in gold, likewise dripped out through the hole filter since it has a lower melting point.

Around 2000 B.C., the Egyptians solved this problem too and devised gold refining, the separation of silver and gold. They had realized that during the smelting of crude gold, more silver than gold evaporated. So they extended the process over a period of five days, until the silver component had shrunk to a tiny percentage.

The Egyptian gold experts, however, weren't just knowledgeable about metal technology. They simultaneously developed excellent goldsmith artists, and their only serious competition was to be found to the north, on the island of Crete. The Egyptians, in the course of centuries, perfected such methods as hammering and engraving, chiseling and embossing. They pasted gold platings on stone and wood, and they gilded copper in fire. A papyrus from the third century B.C. reads: "They rub gold and lead into dust, two parts lead and one part gold. This mixture is blended with gum water, and the copper ring is dipped into the mixture and then fired red-hot. The process is repeated several times until the object has taken on the golden color. The heat consumes the lead, but not the gold."

Granulation, the "soldering" of tiny gold balls on other metals, likewise belonged to the repertoire of Egyptian goldsmiths. Presumably, they learned this complicated technique from the masters in Crete.

Gold is habit-forming. The Pharaohs weren't satisfied with the gold from Egyptian soil, which during the 1,800 years of the Age of Copper (3900–2100 B.C.) actually constituted nearly 80 per cent of the world yield. So the rulers sent their gold-minded geologists to Arabia, Cyprus, and the Far West: Historians are fairly certain that Egyptian gold hunters dug on the Iberian peninsula.

However, the divine kings had their most significant gold suppliers right at their front door: the land that began at the southern border of Egypt and was soon named after the Egyptian word for gold, *nub:* Nubia. This land was populated. But even though the Nubians were known as doughty soldiers, they were helpless against the modernly equipped army from the kingdom of the Pharaohs. Nubia became an Egyptian colony, and the Nubians became miners, gold washers, and Egyptian mercenaries.

The systematic exploiting of Nubian gold started with the establishment of the Middle Kingdom around 2100 B.C. The methods could have come straight from a manual for the master race. Hatharsa, a treasury official sent to Nubia, reported: "In my youth, I began a mine. I forced the chiefs to wash gold; I took away the yield. I pierced into the black land of Nubia, the blacks fell to their knees out of fear of the lord of both lands. . . ."

The territory controlled by the Egyptian occupiers was off limits for black housing. Blacks could cross the border only for trading purposes. At first, the Egyptians brought home just the alluvial gold washed out of the river gravel. As of 1300 B.C., they built mines as well. It was worth the effort. The gold expert Heinrich Quiring estimates that ancient Nubia supplied over four million pounds of crude gold to the Pharaoh's treasury.

Far to the south of Nubia lay the legendary land of gold and incense, a land called Punt, from which Egyptian boats returned with cargoes of gold. Punt was probably on the southeastern coast of Africa, near the mouth of the Sambesi. Here the Egyptians did not use force of arms to get gold. They resorted to trickery. They gave the natives knives and glass beads, frippery and axes in exchange for solid gold, wood (important for the motherland which was poor in wood), myrrh, incense, and ivory, with which they stuffed the bellies of their ships.

During one of these voyages to Punt, they probably circumnavigated Africa for the first time —with hundred-foot-long vessels having thirty sets of oars. These ships were an imposing sight on the Nile. But taking them out to sea required a good bit of courage.

The wealthier Egypt grew, the bigger and better its armies became, the more new gold they brought from their campaigns in the north, the south, and the east. The conquered countries were obliged to pay tributes—naturally in gold.

A tightly organized administration controlled and regulated the stream of gold. The highest bookkeeper was the Pharaoh himself. He owned

all the gold in the realm—he and the gods. They got their share in the form of the royal subsidies of the temple—a system that occasionally triggered conflict between Pharaohs and priests. For a few rulers, such as Ramses III, were chintzy with the divine gold and preferred using it for political aims. The yellow metal could buy a lot of allies. For all the states in the Mediterranean area, especially the kingdoms succeeding the ancient Sumerians in Mesopotamia, suffered from a lack of gold. After all, the Egyptians had collected it all themselves.

The eastern neighbors stormed the Pharaohs with begging letters and pleading messengers: Send us gold! You've got gold like dust (today we'd probably say "Gold like water"). The gold was not gratis. The Near Eastern kings paid with pledges of allegiance, spices, or their daughters, whom the Egyptian nobility highly desired as wives.

The gold that the Pharaohs sent by caravan was not always perfect. We have extant letters of complaint, protesting against the poor quality of a gold shipment—a sign of the arrogance of the Egyptians, who were so convinced of their technological advancement that they didn't even credit others with being able to distinguish between gold with a copper admixture and copper with a gold admixture. The transports were usually escorted by soldiers because the trading routes were plagued by gangs of gold robbers.

Along with its religious symbolism, the Egyptians gave gold a new and profane function: they gradually transformed gold into money. Originally, during the first few dynasties, gold was only part of the sacred sphere, as it was for the Sumerians in Ur. Gold was the solar metal, Pharaoh was the sun-god Horus incarnate. Gold was the god's body turned into metal.

Toward the end of the Old Kingdom (the second half of the third millennium B.C.), Horus, the sungod with the falcon's head, was replaced by Ra, the sun-god in human form.

Historians surmise that it was around this time that the royal exchequer began circulating the first gold rings. They were standardized, 7.5 or 15 grams, and they were no longer a symbol or an ornament. They were money. They had a market value. They were a measure for commercial affairs. For a specific number of gold rings you got a specific number of cows, wagons, slaves.

The gold standard changed the economic order of antiquity—and is still with us today.

However, the Egyptian gold rings were far from being popular money. Slaves and poor people, i.e., most Egyptians, never got their hands on it. Gold rings were the money of the elite, the kings, priests, and later the great merchants.

The new role of gold did not sully its divinity. It still symbolized celestial power and manly virtue. Pharaoh would pin medals of pure gold, in the shape of flies or lions, on the chests of courageous officers. These gifts of honor are regarded as the predecessors of modern military medals and insignia.

The gold history of Egypt did not run as smoothly as a brief survey might make us think. It lasted for over 4,000 years, almost to the beginning of the Christian era, and it went through good and bad periods.

The Egyptians first became a world power during the Old Kingdom. The testimony to the boom, which was due to gold, were the pyramids.

The Old Kingdom collapsed under the assaults of Near Eastern nations. Gold mining was stopped. The Pharaohs didn't even have enough gold for their diadems. They could only afford silver.

The second flowering of Egypt came with the Middle Kingdom, around 1800 B.C. The best-known monuments of this epoch are the Holy Barque (the vessel of the sun-god) and the statues of gods in the temple of Abydos—all of gold.

The Middle Kingdom, too, was destroyed by aggressors. The mines went to wrack and ruin. The Egyptians vegetated under the occupation.

The New Kingdom, as of 1580 B.C., created an economic miracle in just a few years. This age brought forth the temples of Memphis and Luxor.

The Eldorado of the Gold Brigands

The wealth of the Egyptians is best documented by the tombs of its kings, or rather, the few tombs that the gold robbers spared. For ever since the bodies of Pharaohs, together with the insignia of divinity and power (gold in all forms) were immured in a tomb under a temple of the dead —ever since the early days of the Egyptian dynasties, the land on the Nile has been plagued with gold gangsters.

They plundered every mausoleum they could get at. Not even the worst punishments could intimidate them. They forced the Egyptian tomb architects to keep devising better and better tricks for hiding the valuable corpses: labyrinthine corridors, false tombs, secret doors, walls several feet thick for leading gold robbers astray and keeping them off.

Nothing helped. The gangsters bribed the priests and the architects, who revealed the construction plans to them. And then they went to work. A police report offers the statements of a few thieves who were caught: "We opened the coffins and the wrappings they were covered with. We found the sublime mummy of the king. There was a huge series of amulets and gold ornaments on his throat, his head was covered with a golden mask. The sublime mummy of the king was covered over with gold. . . . We tore off the gold that we found on the sublime mummy of this god. . . ."

Pharaoh Thutmose I, around 1500 B.C., learned a lesson from all these desecrations. He committed an enormous sacrilege, which went against all tradition. He separated his death chamber from his death temple. Now supposedly only the unity of the temple (i.e., regular sacrifices) and the tomb guaranteed life after death. But Thutmose

felt that a well-preserved mummy, albeit far from the temple, had better chances of survival than a plundered corpse, even though it lay right next to the altar. Thutmose declared the location of the tomb and its construction to be state secrets. Historians surmise that when the work was done, he executed all the slaves that had built his tomb, so that they wouldn't be able to betray anything. But the robbers finally found him too. Even when the Pharaohs built their graves close to one another in the Valley of the Kings to make guarding them easier and more effective, the plunderings kept on—until today.

That was the constant and frustrating experience of modern treasure hunters, the archaeologists, who were after knowledge, not gold. Just about every tomb they managed to dig out with arduous work had at some time been afflicted by gold robbers. And if they did happen to find an untouched grave, then they could be sure that the next morning a few of the workers would vanish —along with precious objects from the chamber.

When British archaeologist Howard Carter, aided by his friend Lord Carnarvon, found the tomb of Tutankamen in 1922, he checked the antechamber very briefly and then covered it again, locking it up with an iron grating.

Carter's careful methods saved one of the most important finds in the history of archaeology —the most brilliant demonstration of the wealth of gold and power enjoyed by the New Kingdom of Egypt around 1300 B.C.

The antechamber was filled with treasures. A wall of massive gold stood in front of the coffin chamber. Pharaoh's sarcophagus was surrounded by four golden chests. Upon opening it, they found a golden portrait of the Pharaoh —and a second coffin. Then a bas-relief statue of Tutankamen. The third coffin was made of solid gold. It contained the Pharaoh's mummy and the precious gold mask that covered his head and shoulders. And all this splendor for a ruler who, according to our information, was fairly insignificant and died at eighteen!

C. W. Ceram, in *Gods, Graves, and Scholars,* asks: "If this eighteen-year-old Pharaoh was buried with such luxury, way beyond all Western concepts, then what were the grave furnishings that accompanied Ramses the Great and Sethos I to their tombs?" And: "What inconceivable treasures fell into the hands of robbers from the royal tombs in the 'Valley' through the millennia?"

The luxury island in the Mediterranean

Under the dynasty of the Minoan kings around 1500 B.C., the Cretans, with their modern navy, dominated trade in the Mediterranean area, especially gold and silver. They obtained both from Spain, selling it to Near Eastern countries that lacked it.

The Cretan gold hunters were no less daring than their Egyptian colleagues. Outside of Spain, they prospected in the Balkans, the Carpathians, the Sudetens, and even the Erz Mountains. They looked for gold and silver, tin and copper.

The Cretans, as prospectors and merchants, got their hands on huge amounts of wealth—which they knew how to enjoy. They didn't invest their gold in military campaigns. Instead, they preferred building palaces on their island, adding all the modern comforts, such as running water. The palace of Knossos, discovered by Arthur Evans, reveals something of the Cretan life-style and *joie de vivre*. The palace is located at the very spot with the best view of the surrounding hills. And it was never fortified for defense purposes. The Cretans didn't like war. They set great store by taste, they valued sensuousness in fashions and art: the Cretan goldsmiths set the trends of their epoch. Cretan vases and jewelry were exported throughout the world, especially, of course, to the countries that paid well. These exports influenced the styles and technology of Egyptian goldsmiths—whose works were in turn refined by the Cretans.

It is not surprising that such a rarefied culture failed to endure the tempestuous second millennium. The Achaeans from the north could barely count to three. But they knew how to drive their swords, and they destroyed Knossos without much effort.

Yet they couldn't withstand the lure of Cretan culture. They brought Cretan art, Cretan myths, elements of Cretan religion back to the mainland, to Mycenae. The things their goldsmiths learned from the Cretans were unearthed by Heinrich Schliemann, the discoverer of Troy, when he dug up the tombs of Mycenaean kings in 1876. (The history of gold is also a history of graves.) Schliemann noted in his punctilious records: diadems, laurel leaves, crosses of gold, thin gold leaves (701 in a single tomb) with floral and animal ornaments, ornaments in the shape of stags, doves, lions, griffins, a crown with 36 gold leaves, gold needles and curlers, hundreds of gold buttons, gold boxes, beakers, gilded weapons—and finally golden masks on the putrefied heads of the corpses. Schliemann regarded them as the masks of Agamemnon and his retinue—the ruler who led the Greek army to Troy and who upon his return to Mycenae was murdered by his wife Klytemnestra.

However, the corpses, packed in gold, laden with gold, were a few centuries older than the dynasty of the Atridae. They were kings of Mycenae, which, after the conquests of Crete and Cyprus, enjoyed a brief naval dominion in the Aegean area. Soon after the Trojan War, around 1200 B.C., they were subjugated by military nations from the north. The former barbarians had to yield to new barbarians. Hellenic civilization came to an abortive end. For three hundred years, the Greeks lived through more dark ages, without art or literature. Or gold.

A Goldsmith Drops from the Sky

After a dry spell of three hundred years, Homer and Hesiod recounted Greek mythology, the tales of gods and heroes. And gold plays a crucial role in these stories.

In contrast to Sumeria and ancient Egypt, however, gold was no longer the symbol of divine sublimity. Now it was an indispensable attribute

of the high society of the gods, a status symbol. The Olympians owed it to their image to sit on gold (Hera), gird themselves with gold (Aphrodite), and shoot golden arrows (Eros). In the very human society of Greek gods, gold had a clearly materialistic flavor. It had lost its magical value. It had, so to speak, become democratic. It no longer belonged to just one god. All the gods had it. The sun-god, who in Egypt was the only one with a claim to gold, could luxuriously adorn himself with gold in Greece: Helios drove a golden sun chariot, and at night he slept on a golden ferry. But the gold didn't make him powerful. He was a sub-god, not even a member of the Olympian country club.

A divine goldsmith appears for the first time in Greek mythology: Hephaistos. He was the son of Hera, the mother of the gods. She didn't like him (he was too delicate), so she threw him down on the earth right after he was born. Fortunately, he fell into the ocean and was saved and hidden by other goddesses. Out of gratitude, he set up a smithy and presented his benefactresses with artistic gold jewelry.

At a gathering of the gods, Hera admired a brooch on the breast of a goddess. She asked who the artist was, and upon learning it was her own son Hephaistos, the gold-obsessed mother brought him back to Olympus.

Hephaistos gladly forged a golden throne for her. But he hadn't forgotten his plunge to earth. When Hera sat down on her throne, fetters closed around her wrists and ankles. She couldn't stand up. Hephaistos blackmailed her: either he got Aphrodite as his wife or Hera could spend her eternal life sitting. He got Aphrodite. The Olympic gods, ever receptive to gross jokes, especially when played on women, rewarded Hephaistos with goldsmith commissions.

Yet he was a poor businessman (and a kind-hearted god). Once when Zeus punished Hera for disrespect by hanging her from the sky by her wrists, Hephaistos critized him—risking both his life and his career.

Zeus threw him down from Olympus (Hephaistos knew the way). But this time he landed on the earth, breaking both legs. From then on, he could only walk about on golden crutches that he forged himself. Since he could no longer work as hard, he created mechanical women of pure gold, who helped him in the smithy.

The story of Hephaistos' broken legs probably has a real background: good goldsmiths were so sought-after in antiquity that kings and princes did everything to keep them at their courts. Sometimes they would cripple them to prevent them from hitting the road. This motif recurs in the Germanic saga of Wieland.

A God Heals Gold Fever

Astoundingly many Greek stories about gold connect it with negative things: murder, trickery, unhappiness.

There was, for instance, the Macedonian king Midas. Once he found the drunken satyr Silenus,

the teacher of Dionysos the wine god. Silenus was lying in the road, and Midas brought him to his palace so that he could sleep off his hangover. Dionysos rewarded him by granting him one wish. Midas wished that everything he touched would turn into gold. At first he was enraptured with his new faculty. Soil, stones, leaves—everything turned to gold, and Midas was intoxicated with gold. Until he noticed that the wine he wanted to drink, the meat he wanted to eat hardened into gold under his fingers. Finally, about to die of thirst and hunger, he begged Dionysos to remove the gold curse from him. Dionysos told him to bathe in the Paktolos, a river in Asia Minor. Midas actually did lose his gold-making talent—and made the Paktolos a legendary golden river. Today, we still don't know which river this was.

A King's Son as a Gold Robber

Jason the Argonaut likewise had no happiness with gold. He yearned for the Golden Fleece, a golden sheepskin in the Temple of Colchis on the Black Sea. His desire was political: the regent of his home town promised Jason that if he got the Fleece, he would become king. Jason managed to get to Colchis. But it was impossible to steal the Fleece because it was guarded by a dragon.

Jason tried diplomatic insolence. He demanded the Golden Fleece as a token of hospitality from Aietes, the king of Colchis. Hospitality was highly valued in Greece. But Jason's request was offensive—as though a state visitor in England were to ask for the crown jewels as a present.

Aietes, polite man that he was, did not simply turn down the request. He promised to give Jason the Golden Fleece if he first performed a few superhuman tasks. He was to plow a field with two oxen that Hephaistos had forged, sow the teeth of a dragon, and then, with his sword, kill the warriors that sprang from these seeds. It was a hopeless task. But then Jason was helped by gold, in the form of the arrows of Eros, the god of love, who made Medea, the daughter of Aietes, fall in love with Jason.

She promptly told him what tricks to use for putting the oxen, the dragon's teeth, and finally the guardian dragon of the Golden Fleece out of action. In exchange, Medea wanted Jason's eternal troth, and naturally he promised it on the spot.

After getting the Fleece, he fled from his furious host Aietes with Medea and his followers. Jason knew that the tricked owner wasn't the only one after the Fleece ("It was as large as the hide of a bull or deer, and of pure gold"). He noticed the dangerous glitterings in the eyes of his friends, who all wanted to touch the Fleece. Jason wavered between vanity ("First he put the Fleece around his shoulders, it fell from his neck all the way down to his feet") and fear ("Then he rolled it up, fearful that a warrior or a god might tear it from him").

He could defend the Fleece against all dangers and finally dedicated it to Zeus. But the curse of

the gold stuck to him. He broke his promise of fidelity and left Medea for a more beautiful woman. Medea, an expert poisoner, killed their children. Jason became homeless and after years of vagabondage he died in the harbor of Corinth–killed by the falling bow of the *Argo,* the ship that had brought him to the Golden Fleece.

Now, the Midas legend tries to explain the gold wealth of several rivers in Asia Minor. And likewise, in the myth of the Argonauts, the Colchians, a Black Sea people, are not accidentally the owners of the Golden Fleece. Historians have ascertained that huge amounts of gold were obtained on the southern shore of the Black Sea during antiquity. The prospectors presumably used sheepskins to wash out the gold, and grains of the heavy metal got caught in the hairs of the fleece.

And just as the limping goldsmith recurs in Germanic legends, these Nordic mythologies likewise offer a replica of the gold-guarding dragon in the Jason story. This Germanic dragon occurs in the tale of the hoard of the Nibelungs — a treasure that, like the Golden Fleece, brings misery to its owners. First the giant who gets the treasure as ransom for three gods is murdered by his sons. Then one son, Fafnir, who turned himself into a dragon, is killed by Siegfried. The second son is killed when he tries to rob the gold from Siegfried. Finally Hagen wipes out Siegfried and sinks the treasure into the Rhine–without being able to wash away the curse. Hagen and with him all the Nibelungs are finally destroyed by the Huns.

A Sage Advises a King

The Greeks, as their golden legends tell us, had a rather materialistic and realistic attitude toward the godly metal. It goes without saying that the first coins were minted in Greece, probably in coastal cities of Asia Minor. The Egyptians (and probably the Babylonians in Mesopotamia) had taken the first steps toward changing gold into money by introducing their gold-ring currency. The Greek cities that minted coins regarded and treated gold even more consistently as a pure means of payment.

The economic marketplace value of gold changed, but its psychological effect remained the same. Whether as a divine image or as bars, whether as jewelry or coins–no matter what form people saw it as, the result was gold fever.

An especially grave case was that of Croesus, the king of Lydia in Asia Minor and the son of Alyattes. Around 600 B.C., Croesus created the most progressive coinage system of his time, a system that recognized silver as a second mint metal and precisely established the market ratio of silver to gold as 12:1. Croesus ruled a rich and mighty country. The Lydians had conquered the Medians and the Cimmerians. Croesus considered himself the happiest, most godlike man in the world.

And he wanted to have this feeling confirmed by one of the wisest men in the world, Solon, the legislator of Athens.

Solon wandered through the chambers of Croe-

16

sus' treasury. The king asked him—rhetorically—whether he couldn't call him one of the most fortunate men on earth.

But instead of agreeing with him, Solon named a rather average citizen of Athens: Tellos, saying that he was the happiest man he had ever known. Tellos had always earned a good living, had had fine sons, lived a long time—and finally died a heroic death in war.

Solon wouldn't even allow Croesus a second place in the list of the fortunate. He granted this honor to two young men of Argos, who had, like oxen, drawn their mother's chariot in order to get her to the festival of Hera in time. After this sublime achievement, they had gently passed away.

Solon's moral was: Gold doesn't make men happy, and no man can be called happy until he dies. Croesus shook his head. Gold was most certainly a guarantee of happiness. For with gold you could even buy gods. Croesus sent a load of gold to the Delphic oracle to determine his chances of success in the war against the Persians. The oracle gave the king the expected —apparently positive—answer: "If you cross the border river Halys you will destroy a great kingdom." Croesus did cross it—and was demolished. The Persians occupied Lydia. A great kingdom was destroyed: Croesus' kingdom.

The Persians had seized most of the noble metal between the Black Sea and Egypt during their military campaigns. By defeating these Persians, the Greek city-state of Athens completed its rise to a great power, which it had previously achieved with its own strength and without riches.

The gold taken from the Persians or paid by them as tribute produced Athens' eighty years of economic and cultural flowering—and probably helped to bring about its end, just as in Rome centuries later, the prosperity mentality (utility thinking, egotism, hunger for private property) strangled those ideals of freedom and reflection that Pericles had called the basis of Athenian culture. Decadent Athens, the city with the financially most powerful upper class of that time, was destroyed by Sparta, a military dictatorship that prohibited its citizens from owning gold.

The Golden Dream of an Empire

When Alexander the Great in 334 B.C. set out against the Persians, who had once again become a world power, he did not have gold on his mind, like most generals before and after him. Alexander wanted to erect a world empire, a state of many nations, based on the knowledge and laws of the Greek philosophers such as Aristotle, who had been his tutor.

Alexander needed no other inspiration than the dream, the idea, the utopia of an ideal state. He was rich, but he set little store by riches. Before the campaign commenced, he gave away all he owned.

However, he needed soldiers for his war of conquest, and soldiers want money. For a few

months, Alexander managed to keep his men together with the strength of his personality and the hope for enormous war booty. By the time they started grumbling, he luckily met the army of Darius III and defeated it.

Darius' camp was stuffed with gold. The prospect of more gold made Alexander's soldiers invincible. His war was a war on two levels. There was his own struggle, with its idealistic goals for world politics. And there was the war of his soldiers, who suffered any and all tribulations because all they wanted was the divine metal. Alexander, who soon became ruler of Persia, Asia Minor, Arabia, and Egypt, showered his men with gold.

The best-known description of his generosity comes from Plutarch. In 324 B.C., when Alexander married the daughter of the Persian king in Susa (a shrewd political maneuver), he declared his willingness to pay all his soldiers' debts. To keep them from concealing the size of their debts out of embarrassment, he had piles of gold heaped up, and every soldier, with no further verification, could take whatever he needed to cover his debts. According to Plutarch, Alexander's treat cost him five hundred tons of gold in one day.

Alexander knew that the money wasn't lost. He understood its economic significance. His spend-happy soldiers would help the economy of the occupied countries.

Nor did Alexander hoard his golden war booty in his treasury. He invested it, and the gold created new jobs. He built roads, canals, and temples and restored destroyed cities. He employed a brain trust of scientists and scholars–physicians, geographers, historians, philosophers–who thought for gold.

During his lifetime Alexander was already a myth, a kind of pre-Hellenistic John F. Kennedy. He proved that gold is not an end in itself, that it can improve the lives of people. Gold could be a way of making ideals come true.

Alexander died at thirty-two. His followers had no more ideals. All they had was gold–and lust for more. Within a few short years, Alexander's empire was destroyed.

In Quest of Lost Technology

The Italian art dealer Augusto Jandolo, in his memoirs, describes the opening of a sarcophagus that had rested in Italian soil for over two thousand years.

"It was not easy to move the cover. But finally we managed to lift it and get it upright, and then it fell down heavily on the other side. What happened next was something I could never forget: . . . I saw the body of a young warrior in full regalia–helmet, spear, shield, and greaves. Note that I didn't see a skeleton, I saw his body, a fine physique, stretched out stiffly, as though he had only just been laid to rest in his grave. . . . Then everything seemed to dissolve in the glow of the torches. The helmet rolled to the right, the round shield fell into the sunken breastplate, the greaves

18

lay flat on the ground. . . . Upon contact with the air, the corpse, untouched for millennia, had now crumbled into dust. . . . Yet a golden dust seemed to be hovering in the air, around the flames of the torches. . . ."

The man in the coffin was an Etruscan. The thing that had outlived his body, the thing that hadn't crumbled, the golden armor, was not delighting people, these archaeologists, for the first time. It had once been one of the most desired artifacts of antiquity.

Living in northwestern Italy, the Etruscans, as of 800 B.C., were an important maritime and commercial power in the Mediterranean, and they remained one for six hundred years.

The Etruscans were the first to colonize Iberia, desired for its mineral resources. The colonizers built the trading base of Tarsis on the Atlantic coast of Spain, and from there the metals that made the Etruscans rich were shipped out: tin, copper—and gold. The Etruscans exported all over the world, to England, Ireland, Sweden, Greece, Egypt. Not raw materials, however, but finished products. The Etruscans, in the opinion of their contemporaries and today's experts, were the best goldsmiths in the world.

Etruscan jugs and vases, tripods and bowls, flambeaus and goblets, of pure gold or of gilded tin or copper, show that their makers had an unerring flair for the effectiveness of the sun metal, for its shimmer and its many colors—and that they possessed all the techniques of heightening this effect.

They covered a smooth surface with ornaments of hair-thin gold wires: filigree.

They multiplied the golden glow by distributing hundreds of tiny golden marbles on a beaker or a shield, and these minuscule spheres reflected light and cast shadows.

This method, known as granulation, was always copied by later goldsmiths, but none of them ever achieved the quality of the Etruscans. It remained an enigma: how did the Etruscans manufacture those tiny marbles with diameters of a fraction of a millimeter, and how did they fasten them to the metallic foundation?

The search for the lost technology persisted into the twentieth century—and its rediscovery is a curious chapter in gold history. It all happened (as art historian Helga Pohl writes) because of a slap.

A German goldsmith apprentice named Johann Wilm once accidentally put two weights into the pot while smelting silver. The casting was ruined, the master slapped Johann, the pot fell to the floor, the molten silver scattered in the coal dust in front of the oven.

Years later, the apprentice, who had long since become a master, was studying the goldsmithery of the Etruscans. He recalled the slap and its consequences: when the cooled silver had been gathered up from the coaldust, some of it had rigidified into tiny spheres.

Wilm immediately tried to do the same with gold.

He mixed gold with coal dust and melted the mixture. The results were golden grains of a microscopic, i.e., Etruscan size. A short while later, Wilm also discovered the complicated method that his fellow goldsmiths had used in pre-Roman Italy to attach the grains to the metal surface.

The Etruscans have remained a mysterious nation. We know very little about them. The frescoes and ornaments in their tombs lead us to conclude that they were a sensuous, joyful people, obsessed with beauty. The loved gold because it is the most sensuous, most joyful, most beautiful metal. Johann Wilm, who studied Etruscan art intensively, put it this way: "The Etruscans knew that gold has a soul, and they made that soul shine forth."

Too Much Wealth Makes You Go Bankrupt

The Romans had no inkling of goldsmithery when they threw off the Etruscan yoke in the fifth century B.C. They weren't particularly civilized (they caught up only a few centuries later with the help of Greek teachers), they had no time for culture. They had to fight–against Etrurian neighbors and soon against Celtic aggressors as well.

Early Rome was poor. When the Gauls conquered the city in 387 B.C., they demanded a thousand pounds of gold, a very modest price, for leaving. Still, the Romans had great difficulty paying. A few dozen wars later, they could merely laugh at such sums. In 214 B.C., they annexed Iberia–the gold chamber of Europe.

Their craving for the precious metal drove the Romans, who weren't exactly creative, to a technological stroke of genius. Now at first they employed conventional methods: panning (in river gravel) and shaft mining. Mines were an arduous problem, demanding a lot of work for little gold. The Roman engineers had a brilliant idea: they combined both methods. They would find a mountain in whose rock they hoped for gold and they would hollow it out with tunnels. These tunnels were supported by posts. When the tunnels were deep enough into the mountain, the miners would knock down the posts, starting with the last. An observer would signal at the first sign of collapse. If the mountain crashed down prematurely, i.e., when only a few posts were removed, then the miners had little chance. If it burst when they were near the exits after knocking down the final posts, then most workers could save themselves.

The mountain was now a heap of ruins, from which the Romans panned gold. They diverted a river, allowing it to run over the rock fragments. For this task, they constructed viaducts, which transported the water dozens of miles. The new technological feat, demanding a staff of at least 3,000 people, multiplied the yield of gold lightning-fast.

Every year, some 13,000 pounds of gold flowed into the Roman treasury from Iberia.

Nor was Iberia the only supplier. The Romans got gold from the soil of Gaul, Dacia (Carpathians), Illyria, Thrace, and Macedonia. And the generals were even more successful than

the miners. They marched back from Asia Minor, Greece, Carthage, the valley of the Nile, laden with gold.

After beating Perseus, the king of Macedonia, in 168 B. C., the army of Aemilius Paullus had so much gold in its luggage that all Rome didn't have to pay taxes for a couple of months. Plutarch describes the triumphal entry of Aemilius, which lasted for three days:

"The first day, on which they passed with 125 wagons full of the statues and pictures they had seized, barely sufficed for this spectacle. On the second day, the loveliest and costliest weapons of the Macedonians were presented on wagons. . . . On the third day, we saw boys with gold and silver vessels. They were followed by men with minted gold, which they carried in 77 jugs, each weighing three talents (180 pounds), so that four men had to bear one single jug. Next came the holy bowl, which Aemilius had ordered to be made of ten talents of gold and incrusted with jewels, and then there were a mass of bowls and the table service of Perseus. Next came Perseus' wagon and armor, on which the royal diadem lay.... This was followed by 400 golden crowns, which the cities in Asia and Greece hat sent to Aemilius as trophies, by way of emissaries. And behind these crowns came Aemilius himself on a splendidly adorned chariot. He wore a gold-brocade garment and held a laurel branch in his hand. . . . Behind the victor, a slave stood in his chariot, holding the heavy golden wreath of the Capitol's statue of Jupiter above the victor's head. The slave's task was to keep reminding the victor, who was caught in his divine resemblance: "Do not forget, you're only a human being, a mortal man. . . ."

Triumphal processions of this kind and this extravagance were par for the course in the great days of Rome. Plutarch's description shows that the Romans didn't have the slightest bent for giving gold a metaphysical significance. They were only interested in its financial value. Gold was the universally acknowledged token of wealth and success.

Anyone who wanted to become something (and remain something) in Rome had to spend money with a free hand. A politician needed gold for circus games (to make himself popular with the populace); for luxurious feasts (to remain popular with his friends); and for graft (to win over his enemies).

No wonder that most of the top politicians in Rome kept getting into debt periodically. But they had no grounds for despair. The man who couldn't stand the dunning of his creditors went on a military campaign or became governor of a province. In either case, he returned with his finances back in order.

Caesar, for instance, became a propraetor in Spain, the favorite foreign post of Roman politicians. Returning home after a few months, he brought back so much gold that he could easily wipe out a few million in debts and pay for circus games and luxurious feasts.

And for his most glorious war, he found just the right opponent: Gaul had quite a mass of gold.

The consequences of the Roman gold boom were described by the historian Pliny:

"Money was the primary source of the greed, the cunning usury, and the striving to get rich through laziness. But soon the situation degenerated even further, and there was a true fury and craving for gold. Thus Septimuleius cut off the head of his friend Gaius Gracchus, because he had been promised its weight in gold. But before delivering the head, he poured lead into the mouth, thereby not just killing his friend but also deceiving the state. And it is to the shame of not just the citizens of Rome, but to everything Roman that King Mithridates (who ruled the Crimean territory and Asia Minor) performed the inhuman mockery of pouring molten gold into the mouth of the Consul Malius Aquilius in order to quench his thirst for gold.

From conquered Asia, luxury wandered to Rome. This Asia, that fell to our lot, made morals sink even deeper.... And the victory in the Punic War had an enormous influence on moral corruption. Carthage was destroyed, but at the same time voluptuousness was introduced, so that, while we were rid of one evil, we were already embracing the other."

Drastic words, bitter truth. Romans, dragging gold from all the treasure houses of antiquity to the Temple of Juno Moneta (i. e., admonishing Juno), the Roman mint, did not know how to deal with gold. The military was not able to switch to peace and use gold for assuring peace, developing a solid economy, and putting state finances on a sound basis. The Roman elite did not care for general prosperity. The wanted luxury for a few. They lavished gold, they suffered from a permanent mania for consuming. Foreign merchants sold silk, pearls, and spices for Roman gold money, which they transferred to their homelands.

The amount of gold in circulation shrank. Money became dearer and loan rates higher, import commodities receded, and food prices shot up. Whatever gold was left came into the hands of usurers, speculators, businessmen, and the authorities. In addition, every rich Roman was a chronic tax dodger, and the state coffers, which politicians and emperors regarded as private bank accounts and unscrupulously plundered, became emptier and emptier.

There was no way to beef up the economy. Military campaigns brought nothing more. Mining in the provinces had come to a standstill, not because the ground was exhausted, but because the Romans had grown lazy. If any gold was drawn from the earth, it never got further than the governor's pockets, and the governor preferred spending it for his own good life rather than financing the gluttony in faraway Rome.

Nor did the astronomical taxes extorted from small and medium earners help any more. The middle stratum of farmers and artisans was soon as poor as the Roman proletariat. By the second century A.D., there was hardly any gold left in Rome. The coins were minted from poor alloys. By 300 A.D., Rome was bankrupt. Emperor Constantine administered the bankruptcy of the once richest empire on earth.

Out of the Crisis with Gold

Did Christianity owe its victory to gold? A question which every serious historian can answer with a clear *no*. And yet there are signs that make it interesting to speculate about this question.

In 324 Emperor Constantine declared Christianity the state religion of Rome. All the touching tales about his conversion to the cross are probably made up. Constantine had attentively followed the growth of the Christian community and had come to the conclusion that only this religion contained the substance and discipline he needed for saving and reviving the Roman Empire.

Furthermore, Constantine's recognition of Christianity helped to keep government finances from total collapse. For during that time of crisis, Rome had gold that was standing around shiftlessly: the statues of gods in the temples. The enthronement of the one Christian God disempowered the Roman deities, including the self-nominated ones such as Augustus or Nero. Constantine melted them down—and minted coins from them. Some historians wonder whether these domestic and economic reasons weren't the real causes for his declaring Christianity the official religion. It is at least doubtful whether he himself was a convinced Christian. He did declare himself bishop of all Christians. But on his coins he appeared as pontifex maximus, and he didn't mind getting occasional advice from his "innards prophets"—those pagan dissectors who could read the future in a fresh chicken liver.

Gold for the Greater Glory of God

Constantine's followers, the Byzantine emperors, were more steadfast in their faith. And for this faith, they took in gold.

The story of gold in the Eastern and especially in the Western Roman Empire is, until the late Middle Ages, the history of basilicas, churches, and cathedrals. The commercial role, the monetary value of gold, became secondary. Gold, as once in Ur, again became a divine metal, the insignia of God's imperial vicar on earth, the sign of first celestial and only then earthly power. Gold was the expression of light.

The pre-Christian nations had quite sensuously and naturalistically understood it and depicted it as the image of the visible shine of the sun, the emanation of the sun-god.

The Christians transmuted gold into the symbol of supernatural, metaphysical light, the glowing of the Holy Ghost. In addition, gold, the indestructible metal, represented the eternity of God.

The pomp of Byzantine masses in the gold-bursting Hagia Sophia had only an external resemblance to the ostentatious triumphal processions of the Roman emperors. For the golden bowls and monstrances, crosses, and chalices were not meant to prove any human wealth. They belonged to God.

No one would have dared to reckon up the material worth of the sacred objects. The preciousness

was of a totally different sort and not measurable. Gold per se meant nothing to faithful Christians, as can be seen most conspicuously in the cult of relics. Relics were the physical remains of saints —a bone, a patch of skin, a tuft of hair. All sorts of powers were ascribed to them. They guaranteed God's blessing, they strengthened faith, they promised healing of diseases, they protected cities, monasteries, and churches as well as house and home.

Relics were priceless. No owner of a relic would let go of it. Anyone who wished to purchase a relic could find no seller—unless he used trickery, as in Venice during the ninth century. Venice was an up-and-coming city, but its populace had an inferiority complex because they lacked a town saint. What could they do? They had to buy one. But where? Not even all the gold in Venice could have moved a single proud relic owner, whether a city, a cloister, or a church, to part with even a splinter of a bone. However, the Venetians did find someone who might be talked into selling: the prior of the monastery of St. Mark in Alexandria, Egypt. He was in an unhappy situation. Alexandria was occupied by the Arabs and those Muslims could easily be expected to rob the bones of St. Mark from the monastery—out of pure cussedness, thus stripping the monks of their most precious possession.

The envoys from Venice painted the danger in dark colors—and indicated a way out for the prior. Venice, they assured him, was a safe place. Not an Arab in sight. They were quite willing to take upon themselves the trouble of transporting the remains of the saint over the Mediterranean.

Why, they would even pay the monastery a high sum. The prior refused.

The Venetians, who, for all their warnings to the prior, had good relations with the Arabs (their most important trading partners), roped the anti-Christs into doing some Christian work for them.

They asked the commander of Alexandria to send a couple of soldiers to the monastery. They were to act as if the Arabs were really and truly interested in the relics.

The prior got scared—and the Venetians got their St. Mark. It goes without saying that they first beat down the price.

The Romanic churches kept their relics—bones of no material value—in golden coffins and shrines that cost a fortune. Cologne built the Shrine of the Magi, and master goldsmiths labored for fifteen years on Charlemagne's reliquare in Aachen. However, carats and art alone counted for little. For it was only the spiritual force of their sacred contents that made the shrines genuine, i. e., Christian gold, the most precious metal of faith.

When Otto I, king of the Germans, was crowned emperor in Rome in 962, he didn't think about how many millions the Pope was placing on his head. The emperor wasn't mighty because he could afford a gold crown set with jewels. The crown was merely a symbol of the power that God was temporarily lending to him, Otto. When he died, he would not take along the crown as prop-

erty into the grave. His successor on the imperial throne would wear it.

Not only the subjects, but the German emperors themselves were in awe of the symbol of the empire. Before putting on a crown, an emperor would fast for three days. Whenever the emperor wasn't wearing it, the crown would be kept on the precious head relic of a saint.

The Epoch Without Gold

In Merovingian and Carolingian France, gold vanished almost totally from economic life. Byzantium, as a commercial power, could not do without gold as legal tender, despite all religious appreciation of the noble metal. However, the empires of Charlemagne and Otto I did very well without gold, for there was practically no commerce. Germany and France were purely agrarian countries dominated by big landowners. Being self-sufficient they didn't have to buy anything. Their serfs produced whatever the lords needed, and anything left over could be traded for silk, spices, or gold brought infrequently by Syrian or Jewish salesmen.

Yet trading spread, the cities grew and required gold coins for their transactions, more and better coins than the emperors stamped. Meanwhile the Arabs, having occupied Spain, were assiduously hauling gold from her earth. In the tenth century, the emperor of the Holy Roman Empire imitated them and started working the Roman mines again in Bohemia, Hungary, Transylvania, and Silesia.

The Cross in Their Hands and Gold on Their Minds

The (at first) pious Middle Ages was not reluctant about using the second and faster method of getting gold: war.

It was a good thing that the Arab conquerors of Jerusalem were both rich and Muslim.

The latter fact inspired a Christian slogan: "Get the heathens out of the Holy City." The former fact convinced warriors who were less steadfast in their faith that a crusade was a necessity. They had heard more than enough tales about the fabulous treasures and feasts of the caliphs, perhaps even eye witness reports:

The caliph sat in his pavilion. He had had his servants buy up all the roses in Bagdad and its environs. When the guests and the singers arrived, the banquet commenced. Meanwhile, servants brought the rose petals to the roof of the pavilion, whence, mixed with gold and silver coins, they were strewn down upon the guests in a continuous rain. This downpour of roses, gold, and silver lasted from afternoon to the evening prayers, so that the guests were completely covered.

Another time, the floor of the room was laid with two long rows of carpets made of golden threads and embroidered with precious stones. Then the guests sat down facing one another. A huge plate of massive gold, encrusted with jewels, was placed before each guest. Now, servants came with huge baskets, from which they poured

pieces of gold and silver between the two rows of guests, so that the pieces formed into heaps, covering the gold plates. The guests were allowed to take three handfuls of gold and silver for every goblet they drained. Whenever a noticeable ebb occurred at any point, the servants would pour on new sacks of gold. At last, a servant proclaimed: The Lord of the Faithful announces that everyone can take as much as he likes. Some of the guests left the hall, gave the gold to their servants, returned, and filled their pockets up anew. . . .

This, and not just the liberation of the Holy Sepulcher, was what the knights had in mind when they gathered at the end of the eleventh century for the first crusade to Jerusalem.

In 1119 the victorious knights founded the Order of the Temple in Jerusalem. This order had some 20,000 members by the thirteenth century, and it is no coincidence that it soon developed into one of the most financially powerful organizations in the world. The order operated in many countries, acquired property throughout Europe, set up currency exchanges for pilgrims in Jerusalem, and lent money to merchants—and even kings.

The Order of the Temple lent Philippe le Bel of France 500,000 francs so that he could give his sister a proper dowry and throw a marriage feast for her in keeping with their station.

The Templars didn't work for themselves (though they didn't exactly starve), but regarded themselves as employees of a firm, in which God was the top boss. It was His money they were doing business with; it was His profits they were raking in.

The success of His managers destroyed the order. King Philip of France felt he could make better use of the cash than God. So he launched a trial against the Templars (after borrowing 150,000 gold florins from them) and had their leaders executed. Then he confiscated the entire property of the order. His money troubles were over.

The knights of the first few crusades had been sincere about liberating the Sacred Places, and they regarded Arabian money as the just reward of victory. But the sincerity level of the subsequent crusades kept getting lower each time, and soon there was scarcely a noble knight to be found among the crusaders. These armies were made up of thieves, mercenaries, failures who had nothing left to lose and everything to gain. Especially gold. They didn't care whom they took it from, pagans or Christians, as shown in Byzantium.

A group of crusaders wanted to go to Egypt to take booty from the Arabs. The doge of Venice didn't care for this at all. Venice had nothing against the Arabs. On the contrary: they were reliable trading partners. But it didn't much care for Byzantium, the flowering merchant city on the Golden Horn. Byzantine merchants were grabbing good business deals away from the Venetians. Byzantium was preventing Venice from expanding to the export markets of Europe and Asia.

The doge of Venice, using gold, convinced the crusaders that Byzantium was a more rewarding target than Egypt. A year later, 1204, Byzantium was demolished, its churches plundered, its art treasures melted down. The Christian arsonists got the equivalent of 200,000 dollars in silver.

Venice and the North Italian cities became the trading center of Europe. They invented the stock exchange and founded modern monetary economy. The divine age of gold was over for all time.

Gold from the Test Tube

Even in the best times of extraction and extortion, the amounts of gold circulating as coins in Europe, standing as statues in churches, and being worked into jewelry were relatively small. Experts estimate that fifteenth-century Europe had at most one billion dollars' worth of gold. Reinforcements kept shrinking because the mines had been exploited to the final accessible depths. New gold countries had not yet been discovered. What to do? The alchemists had the answer: make gold.

The dream was an ancient one. The Egyptian priests of the post-Alexandrian era almost made it come true—at least in terms of financial success. They colored cheap metals like copper with quicksilver and arsenic, exchanged it for the golden statues of gods in the temples (if no one scratched, then no one noticed), and melted down the gold. The metallurgical knowledge of the Egyptians (which had once been taught at the intellectual center of the Hellenistic world in Alexandria) had been taken over by the Arabs and deepened. Christian Europe, however, was dozing in anti-scientific mysticism. The chemical textbooks of the Arab physician Jafar became one basis for making gold. The other basis was Aristotle's sentence: "One thing can be transformed into another." According to Aristotle, perfection was the law of nature. The lower has to develop into the higher. And, likewise, the higher had derived from the lower.

How, the alchemists wondered, can this process be executed artificially? How, for instance, can we turn the "baser" metal copper into the most sublime metal gold?

This problem occupied the minds of black magicians for centuries. In their secret laboratories, surrounded by seething gases, they indefatigably hunted the philosophers' stone, the *quinta essentia* (the spirit animating matter), the red tincture, the elixir of life.

At regular intervals, rumors began that one of the gold makers had succeeded. For instance, Albertus Magnus, the church philosopher. Or Raymond Lully, who supposedly said: "And even if the entire ocean were quicksilver, I could turn it into gold." Or Paracelsus, the brilliant physician and scientist who employed a drinkable solution of gold as a remedy and realized that sulphur can contain tiny amounts of gold. That was why Paracelsus (who hated the alchemists because their interest in chemistry was merely lust for gold) acquired a reputation as a gold maker—and it was partly his own fault.

Because in his description of the sulphur experiments, which produced barely visible traces of gold, he concluded with misconstruable sentences: "It would be contrary to God for everyone to be rich—for God knows why he didn't give a goat a tail—some people would be helped with good words. But because riches lead the poor astray, depriving them of humility and virtue, and bringing them pride and haughtiness, and turning them into keen razors, it is better to keep silent and let them remain poor." On his gravestone, Paracelsus' alchemical talents were celebrated. He would have sharply objected.

The yearning for artificial gold speeded up the progress of science. In their quest for gold, the alchemists discovered spirits of wine (Arnaldo of Villanova) and black powder (Roger Bacon). And they relearned what the Egyptians had already mastered: how to separate silver from gold with aqua regia, a mixture of saltpeter and hydrochloric acid. But no one succeeded in spiriting gold out of the test tube. This didn't interfere at all with the business of the alchemists. Armies of them marched through Europe, mostly charlatans, and not to be compared to serious scientists like Paracelsus or Roger Bacon. These pseudo-researchers always found a sucker to finance their pseudo-experiments. The most gullible were the kings and princes, for they were always short of gold.

Maximilan I invested in the alchemical industry. Margrave Johann of Brandenburg even worked in the laboratory himself, just like Emperor Rudolf II, who supposedly spent more time there than at his imperial desk. Rudolf brought the English alchemist Kelley to his court and made him a baron by way of an advance payment for an achievement that never came. Others were likewise raised to the nobility by Rudolf and showered with presents, for instance a certain Herr Schwertzer and a Herr Mueller—signs that the alchemists could make money if not gold.

In 1666, the personal physician to the Prince of Orange, a truly enlightened man and an enemy of the alchemists, had a peculiar experience. He received a visit from a man who wouldn't give his name but dryly claimed to be in possession of the philosophers' stone. He allegedly even had three of them. He brought them out, three fragments as large as nuts, and he claimed he could use them to turn any metal into gold. That was how he had made the five pieces of gold hanging around his neck. The doctor was dubious. He wanted to watch the process himself. The visitor refused and murmured something about bad consequences. He left, but came back the next day. The doctor, having forgotten his distaste for alchemy, begged the stranger to show him how to make gold. "I implored him with more ardor than any lover might display in caressing his Amasia…" Finally, the owner of the stone yielded and pulled out a tiny bit, enough, he said, to transform one half ounce of lead into gold. He promised to help the physician with the experiment, but vanished and was never heard of again. The doctor tried to do it alone. He melted lead and threw the stone splinter into the pot. And in fifteen minutes, "all the lead had turned into finest gold."

The physician was converted to alchemy. Adepts

from all over the world admired his labors. But the man with the philosophers' stone in his pocket was nowhere to be found.

The Invention of White Gold

There is likewise something mystical about the beginning of the story of Böttger, an apothecary's apprentice in Berlin. Yet the entire case is historically documented.

A stranger appeared to him too and gave him something from the philosophers' stone, this time in liquid form. And Böttger too made gold out of lead with it. At least, that was the rumor. It was enough to arouse the interest of King Frederick I of Prussia in the sixteen-year-old. But the boy got scared—probably because he had never made gold and feared being thrown into prison for fraud. He fled, and the king offered a reward of 1,000 thalers for his capture. Böttger hightailed it to Saxony. Prussia demanded his extradition. Augustus the Strong, ruler of Saxony and also king of Poland, wouldn't dream of it. He informed Frederick that Böttger belonged to him.

For a while it looked as if Prussia and Saxony were about to go to war over a child.

Böttger was locked up in Dresden—in comfortable surroundings and with a complete chemical laboratory. He had to experiment day and night, and Augustus got blow-by-blow accounts of his progress. There was no progress. Under Böttger's guidance, the king tried his own hand at turning lead into gold. But it was no use. Still, Augustus did not lose faith or his liking for Böttger. Even though the apothecary escaped twice during his fifteen years of captivity and, contrary to custom, behaved outrageously toward the king, Augustus kept corresponding assiduously with him and even gave him money. However, after investing 40,000 thalers in Böttger's alchemical efforts, the king gradually lost patience. Böttger was in bad straits. So he invented porcelain, the white gold. Augustus was satisfied and he made Böttger director of the porcelain manufacture in Meissen on condition that he would not betray the formula for porcelain and never leave Saxony. The 40,000 thalers were amortized in a few short years.

The Great Show of St. Germain

The Böttger case was not the last big alchemy affair in the otherwise enlightened eighteenth century.

At the French royal court, Count St. Germain was making his career. Madame Pompadour hired him as the sole entertainer for the lethargic Louis XV. The count could do a huge number of alchemical magic tricks and he was even better at selling himself. He knew the value of an image. Giacomo Casanova reported on a visit to this professional charlatan:

"At eight o'clock, I was at the count's door. He appeared in Armenian costume with a pointed cap. His long, thick beard flowed down to his belt, and he held a long ivory wand in his hand.

29

All around him, I saw many bottles, carefully arranged and filled with all kinds of fluids. "Have you become an apothecary?" (A mordant question that shows what Casanova thought of the count.) "I give consultations for all manner of illnesses, and I can heal any disease." I expressed my doubts. "You are the first person ever to doubt me. I could make you regret that, but I am humane. Like the Eternal Father, I am all-powerful and all-forgiving. It is too bad that you have so little trust in me. Your fortune was assured. Do you have any money in your pocket?" I emptied my pocket into his hand. He took only a twelve-sou piece, which he placed upon a glowing ember and covered with a black bean. While stoking the fire by blowing through a glass pipe, I saw the piece reddening, igniting. When it had turned cold again, he said laughingly: "Here is your coin. Take it. Do you recognize it?" "What," I exclaimed, "Is that gold?" "The purest gold!"

Casanova, a man of the world, who couldn't easily be duped, concludes his report: "My reason wouldn't permit me to believe the alleged miracle, and I thus regarded this transmutation as simply the product of a magician's skill. But I was shrewd enough to hold my tongue. The man was actually happy about his folly!"

Count St. Germain was no fool. Today we know what his contemporaries overlooked, diverted as they were by the count's hocus-pocus. In her book on gold, Helga Pohl writes: "The alchemist St. Germain was already... producing synthetic materials. That is to say, he was no longer an adept, he merely played the part for the sake of publicity. In reality, he was the first industrial chemist, and he had also clearly recognized the political effectiveness and power of industry."

St. Germain lured people with the fairy tale about gold in order to get them interested in his other, more important investigations. For his contemporaries, however, the only one of his abilities that counted was the one he didn't have: making gold.

To America for the Sake of Gold

Ever since the first discovery of gold, men have dreamed about the gold paradise, the never-never land for gold fanatics, the country made totally of the longed-for metal.

The ancient Egyptians named it Punt and located it somewhere in Africa. The Bible called it Ophir without giving a precise location. The Greeks called it Golden Chersonese and placed it in the neighborhood of Malacca.

In medieval days, the promised land of gold was India. The legends about the fantastic wealth of this land on the edge of the world (the world was a disc) had nothing to do with the real India. People knew it existed. They got spices from there, spices that had been transported by land for thousands of miles. But most medieval notions about India were based on sensationalist accounts by ancient authors who had never been there, for instance, this factual report by the Greek historian Herodotus, the "Father of Historiography":

"The Indians obtain the precious gold dust in the following way. The eastern part of India is a desert. Great ants live there, smaller than dogs, but larger than foxes. While building their subterranean dwellings, these ants cast up sand. And this cast-up sand contains gold. The Indians go to extract this sand, equipped with three camels (two males and one female) and a spare horse. As soon as the Indians arrive in these places, they very rapidly fill their sacks with as much sand as they can get hold of, and then leave. The ants, as the Persians claim, can smell them, and they instantly go after them.

They are supposedly faster than any other animal. During the flight, the male camels are released and fall victim to the ants because they cannot run as fast as the female. However, the female, thinking about her colt, runs tirelessly. That is how most of the gold is obtained."

The Europeans wanted to take part in this race for gold, and all the seafaring nations tried to find the route to India. In the thirteenth century, the adventurous passions of kings and captains were spurred on by a globe-trotter who reported about many new things in the Orient: Marco Polo. This Venetian had wandered through Asia for twenty-four years. His travelogues sparkled with precious stones and were heavy with gold —which brought him the nickname of "Millions Marco". Marco Polo described the treasures of Kublai Khan in Peking, he raved about Java the spice island, which also exported gold, and the island of Zipangu (Japan), whose king prohibited the export of gold so that he might use it himself.

Marco Polo's books became compulsory reading for anyone who dreamt about new lands and gigantic wealth.

Marco Polo's readers included Christopher Columbus. Columbus was obsessed with gold, and since King Ferdinand and Queen Isabella needed gold for Spain's coffers, they financed his expedition to find a maritime route to India's riches.

Columbus feverishly reeled toward the Indian gold. But, when he landed at the Bahaman island of Guanahani on October 12, 1492, he was deeply disappointed, for the natives wore little gold jewelry. But "with the aid of sign language I determined that we had to travel southward in order to reach a king possessing huge golden vessels and many pieces of gold." The new course was clear. "Thus I resolved to forge ahead toward the southwest to search for gold."

Columbus' log during the next few months records a temperature curve of gold fever. It wavered between ludicrousness ("My men saw an Indian with a piece of gold the size of a Castilian ducat, and I reproached them for not buying it") and fear: "May the Almighty in his mercy help me to find the mines from which I can extract gold." Columbus had debts with the king, and he feared the consequences of returning from "India" without gold—and on the nature of these consequences he had no doubts.

Finally, in January 1493, he stumbled upon a river that contained gold. The Indians were permitted to help him with the panning. Thus began

not only the greatest gold rush in history, but also the enslavement and extermination of the tribes and peoples of South and Central America.

The amount of the "blessed metal" that the brand-new Vice-Admiral brought back to Spain was not overwhelming. But it sufficed to lure whole masses of dubious characters to the Golden West. The conquistadors were on the march.

The White Gods in the Gold Rush

Hernando Cortez had a better nose for gold than his model Columbus. He conquered Mexico.

Cortez had already come to South America at nineteen and participated in the occupation of Cuba at twenty-four. By the age of thirty-five he had gotten so rich from his shares in the Cuba gold mines that he could equip a small expeditionary force. Against the will of his superior, Governor Diego Velásquez, Cortez started out for Mexico in 1519 with 110 mariners, 553 soldiers (including 32 crossbowmen and 13 arquebusiers), 10 heavy and 4 light cannon, and 16 horses.

Cortez landed near Vera Cruz. Upon sighting the first fortified cities and mighty temples, he knew that there were no savages living here. This was a highly civilized people (the Aztecs).

His realization did not prevent Cortez from killing the lawful owners of Mexico wherever he met them. At first, the Aztecs didn't dare resist the aggressors. The intruders were white and had beards. In Aztec mythology, there was a good god who wore white, had a beard, and came from the land of the sunrise. He had passed laws and then been unfairly driven away. The Aztecs were puzzled: were these white men the descendants and emissaries of that god?

But soon they doubted it. They were used to truculent deities, to whom they sacrificed human beings. But Cortez and his soldiers murdered and plundered so brutally that they could only be men. The Aztecs attacked. Cortez beat them. Five hundred men fought against 20,000. But the 500 were better armed and knew something about war. Besides, Cortez was a skillful politician. He won over some of the nations subjugated by the Aztecs as allies to his cause, and he thereby occasionally strengthened his army by a few thousand men.

His "furious conquest" (C.W. Ceram) was abetted by the incapabilities of his antagonist, the Aztec king Montezuma II. The king could find no way of exploiting the numerical superiority of his army. He resigned early and committed the terrible blunder of sending Cortez presents to gain his good will. Knowing what the strangers grabbed hold of like madmen during their lootings, he sent him gold. The first shipment was a gold disc the size of a wagon wheel; it had a picture of the sun upon it. In addition, Montezuma sent a helmet filled with gold grains, 20 golden ducks, and two godly costumes adorned with gold and turquoise.

An Aztec eye witness reports how the Spaniards reacted at the sight of the gifts: "They laughed

32

their heads off. Like monkeys, they grabbed for the gold, laughing at the sight of the godly filth. For they thirst after gold, hunger for it, root for it like hogs. . . ."

Gold as godly filth: the Aztecs regarded the yellow metal as the rigid sweat of the sun-god. Its main significance for them was religious and cultic. It was the symbolic jewelry of the emperor and the nobility. It did function as currency, but only as one of many, such as woolen blankets.

The gold hunger of the Spaniards was unintelligible to Montezuma. Otherwise he would never have tried to sate it. He did the very opposite. Every new gift of gold that he laid imploringly at the feet of Cortez' advancing troops made them greedier, crueler, more impatient. The fall of Montezuma and his people was sealed. The Spaniards wanted the gold in the imperial palace and the temples of the capital.

Three months after landing in Vera Cruz, Cortez had reached his goal. He occupied Tenochtitlán.

Montezuma remained. He only had to say the word, and thousands of his soldiers would crush the handful of Spaniards, whose horses and artillery were useless in the city. But Montezuma held his peace and collaborated. He even sent the invaders manual laborers to help them build their chapel. He tolerated the conversion sermons of the Spanish *padres*. He worshipfully listened to Cortez' chitchat about honor and friendship. Then the Spaniards discovered a fresh mortar wall in the palace. They destroyed it and opened the door behind it.

Before them lay the treasury of Montezuma. Gold and silver towered up in a gigantic hall: jewelry, religious objects, bars. Bernal Díaz, the chronicler of the Mexican campaign: "I was a young man, and I felt as if all the riches in the world were in that hall." He obviously was more than just overwhelmed.

Cortez knew he couldn't get the gold out of the capital; the Aztecs wouldn't allow it. And besides, they seemed resolved to drive out the invaders. Only Montezuma prevented them. Cortez realized the godlike position of the emperor and took him prisoner. Now the Aztecs were helpless. If they attacked the Spaniards, the invaders would kill holy Montezuma. Cortez' men grew nervous and demanded that the treasures be divided. Cortez gave in and had the value of the gold computed. They reached a sum of 162,000 gold pesos–about 13,000,000 gold dollars. That would come to about 30,000 dollars per soldier.

But Cortez had other plans. First of all, they had to subtract the king's share–one fifth. Then Governor Velásquez' share–another fifth. Then Cortez, who had, after all, financed the enterprise, would have to get his share–another fifth. And fourth, the share for the people who had remained in Vera Cruz to guard the coast–still another fifth. All that remained for Cortez' soldiers was one fifth–too little, they felt, which was understandable considering the treasure that lay before them in full splendor. The soldiers mutinied. Cortez managed to calm them. He promised even more brilliant conquests, even greater riches.

But then, danger loomed from outside: Governor Velásquez had sent a punitive expedition after Cortez, 900 men strong. Together with a third of his troops (the other two thirds remained to guard Montezuma), Cortez marched against his pursuers. And his barely seventy men carried the day. Velásquez' soldiers joined forces with Cortez's mercenaries. Together they marched back to the capital.

The city was in a state of war. The Aztecs had begun their struggle for their liberation after the Spaniards had butchered 600 unarmed nobles in the temple. The leader of the uprising against Cortez was a brother of Montezuma's.

Cortez' men fought their way through to the encircled comrades. The situation got worse from day to day. Montezuma, the cowardly emperor, gave a speech to his people, ordering them to stop fighting. The Aztecs stoned him in the very presence of the Spaniards.

Cortez decided to break through the siege. He had his men load up one fifth of the treasure, allowing every soldier to take along as much as he could carry. But he warned them that every piece of gold would slow down their moving and fighting. Most of the soldiers paid no heed to his warning. The *noche triste,* the dismal night, began for the Spaniards.

The Aztecs didn't notice the flight of the Spaniards until they had reached the first of the two canals surrounding the city. The Spaniards used a transportable bridge to cross the water. But the heavily packed men and horses were so weighty that the bridge sank too deep into the mud to be conveyed to the second canal. The Spaniards were trapped. The Aztecs wreaked their revenge. Two thirds of Cortez' men were killed. One third escaped by swimming across the canal, most of them wounded and without gold. Cortez was one of them. With luck and recklessness, they reached the coast. Part of Montezuma's treasure lay in the canals of the capital. But most of the gold was still in the palace. Although they had just barely escaped the Aztecs, the Spaniards recovered only until troop reinforcements arrived. Then, at Cortez' command, they marched back to Tenochtitlán. This time there was no blitzkrieg. The Aztecs fought more skillfully. Their new emperor had learned from Cortez. The Spaniards were decimated—which didn't upset the survivors at all, for every dead man meant a greater individual share of the Aztecs gold. They seem to have been very much down-to-earth.

In August 1521, a year after his defeat, Cortez reconquered the capital, after a siege of seventy-five days. War chronicler Bernal Diaz writes: "The dead lay so dense that we could not take a step without treading on an Indian corpse."

This had no effect on Cortez. He was much more troubled by the fact that Montezuma's gold had vanished. The Aztecs had hidden it. The Spaniards tortured them, including their emperor. But no one revealed the whereabouts of the treasure.

Cortez and his soldiers had to make do with the gold that the Aztecs voluntarily supplied—and with whatever they found when looting the royal

tombs. Altogether, they had roughly one fifth of the gold that they had hunted out a year earlier behind the walled-up door. Cortez doled out a tiny percentage to his men and pocketed something for himself. Wanting to buy honor with gold, he sent the lion's share to Emperor Charles V in Spain.

The gold never arrived. Approaching the Azores, the Spanish treasure ship was grabbed by the French. Francis I of France gratefully received the gold.

In Mexico, the lust for gold destroyed a civilized nation. This case has no parallel in the history of gold—until the destruction of the Incas. Of course, earlier wealthy cultures had been devastated by gold-starved warriors: Babylon by the Assyrians, Nineveh by the Medians, Crete by the Achaians, Egypt by Rome. But all these cultures had one thing in common at the time of their downfall: they were ramshackle and decadent when the conquerors arrived.

Aztec culture, however, was at its peak when Cortez invaded Mexico. The Aztecs were excellent architects and pyramid builders. They had an extremely precise calendar, more exact than contemporary European systems. They were first-rate artists, particularly goldsmiths. And Cortez, as historians describe it, "decapitated this flourishing Aztec empire as a passerby tears the head off a sunflower."

In the name of Christ and gold, Cortez and his successors wiped the Aztecs from the face of the earth. In primitive fury, the Spanish priests burnt all the documents of the Aztec religion. In blind greed, the Spanish soldiers threw nearly all the Aztec art works into the oven to melt out the gold.

The people themselves were enslaved and forced to sluice gold out of the rivers. Eye witnesses report that the Aztecs died like flies—of sickness, hunger, exhaustion. Soon there weren't enough workers left to keep up the washing. Mexico, a fertile, well-populated country at the discovery of America, was depopulated and finally dried out because the Spaniards destroyed the Aztec irrigation system.

The Golden Room

Twelve years after Cortez' Mexican campaign, Francisco Pizarro butchered his way to the greatest treasure of the conquistadors. In 1531, with 180 soldiers, he set out to conquer Peru, the land of the Incas. As a precautionary measure, the king of Spain had already made him governor of Peru.

The Incas had no complex about white gods, and they could have gotten rid of Pizarro and his gang without lifting a finger. But they didn't trouble themselves about the Spaniards. There were too few of them, they weren't worth the bother. If they were to get irritating, one could always take care of them.

Atahualpa, the king of the Incas, had other worries. His brother had rebelled against him, the Incas were divided, civil war was looming. Even

35

when Pizarro's troops reached the capital city of Cajamarca, Atahualpa didn't bat an eyelash. He treated the intruders like state visitors, putting them up in splendid mansions. And just like Cortez upon meeting the Aztecs, Pizarro was astonished at the high level of Inca civilization. The king of the Incas promised to visit the Spaniards as soon as his fasting period was over.

Atahualpa's cordial reception was not due to any fear of the white men, as had been the case with Montezuma. The Inca king was simply polite. It never even crossed his mind that this tiny troop of whites could possibly spell danger to him, the divine king and commander in chief of a giant army.

Apparently he had never heard the story of Montezuma's end. Otherwise he wouldn't have fallen into Pizarro's trap.

The Spaniard copied Cortez' kidnapping strategy. Atahualpa appeared with a retinue of several thousand men, servants who swept the street before him, nobles who carried his litter, solar priests who advised him. All were unarmed.

Historian William Prescott quotes a contemporary description of the scene: "He came high over his vassals, borne on a sedan or an open chair, on which there was a kind of throne of solid gold, its value inestimable. The chair was adorned with the gaudy plumes of tropical birds and glowed with shiny plates of gold and silver. The ruler wore a necklace of emeralds of extraordinary size and beauty. His short hair was decked out with embellishments, and the royal borla wound around his temples. The Inca's bearing was sedate and dignified, and from his high seat he gazed at the crowd below with the calm look of a man accustomed to giving orders."

Pizarro sent out his father-confessor. With the aid of an interpreter, he made two modest requests: First of all, Atahualpa was to convert immediately to the Christian faith. And secondly, he was instantly to hand over his country to Charles I, king of Spain.

Atahualpa asked the priest what right he had to make such demands. The monk handed him the Bible. Atahualpa threw it on the ground. The priest became hysterical, screamed at the "savages", dashed over to Pizarro, and shouted: "Attack!" And he added in the same breath: "I grant you absolution in advance." The Spaniards didn't wait to be asked twice. They struck, sliced, and pierced into the bodies of the Incas, who, unarmed, could not defend themselves and formed a wall around Atahualpa to protect him.

After half an hour the king of the Incas was in Pizarro's power. Two thousand of his subjects had been murdered. The Spaniards had no losses, only one injury: Pizarro had accidentally been nicked by the sword of one of his men.

The Incas, whose main army was stationed in front of the city, were bewildered by the capture of the untouchable son of the sun, just as Atahualpa himself was. He, who had dubbed himself the mightest prince in the world, could

not grasp that he had been kidnapped by foreigners, who didn't give a damn about the taboo surrounding the king.

But Atahualpa was shrewd. He knew what the Spanish wanted, and so he offered them a ransom for his liberty: a gold ransom. He established the amount in a spectacular fashion. Taking Pizarro into a room that was 20 feet long, 16 feet wide, and 8 feet high, he promised to stuff the room with gold up to the ceiling.

What happened then was unique in the history of humanity. An entire nation became gold porters. The Incas dragged gold from all parts of Peru to Cajamarca for the life of their king. Some of the transports spent months going through the mountains. Atahualpa's subjects sacrificed their personal jewelry, and they even brought other things to the gangsters in the Inca palace: holy liturgical vessels and sculptures from the temples, religious bowls and solar discs.

After nine months, the room was almost full. Pizarro was scared. He feared, with good reason, that Atahualpa woud get back the gold after his release and kill the Spaniards. During his imprisonment, the king had given him an example of his unbroken power. Atahualpa's rebellious brother had held up the gold shipments because he didn't care to see his rival at liberty again. Pizarro wanted to rope him into his own machinations. But before the first conversation could even take place, the brother was assassinated—at Atahualpa's orders.

Pizarro weighed the gold: six tons. They decided not to wait for the final shipments. They put Atahualpa on trial (no one could possibly accuse them of murder afterward; they were not very humane, but certainly quite lawabiding).

Atahualpa was indicted for polygamy (the Incas were polygynous), idolatry, and any number of other things. The judgment of the high court was: burn him at the stake! But Pizarro's father-confessor demurred. He wanted to give him one more chance and told him that if he accepted baptism, he would merely be hanged. And so the god-king of the Incas was strung up as a Christian.

The gold of Cajamarca never reached the Spaniards, especially since the individual shares were reduced after the arrival of a second gang under the leadership of Diego de Almagro.

With 500 men, Pizarro marched south to the royal city of Cuzco, whose temples and tombs were said to be bursting with gold. The rumor was true. The Incas, after Atahualpa's death, couldn't organize themselves into a collective resistance. And so Pizarro, murdering, torturing, looting, reached Cuzco, and his men gathered over a ton of gold and over fifteen tons of silver: chairs and wall plates, jewelry and sacrificial vessels, weapons and solar discs.

The robbers profited from an Inca custom that forbade a new ruler from taking over his predecessor's wealth. The earlier ruler's palace with all its treasures was locked up and remained as a monument. The new ruler had to accumulate his own riches. Furthermore, the Inca upper class

was much richer in gold, and enjoyed it more, than the Aztecs. Thus, before the time of Atahualpa, the Inca king Huayna Capac had a 350-foot-long gold chain so that at festivals, his subjects, holding the chain, could dance around the grand square of Cuzco.

And in Cuzco, the Spaniards also saw the legendary artificial gardens of noble metals, which a descendant of the Incas describes as follows:

"Near all the royal buildings, there were gardens and orchards so that the Inca could have places to rest. Here there were the loveliest trees and the most splendid flowers and fragrant herbs of the kingdom, while countless others were replicas of gold and silver. They showed all stages of growth, from the shoot that barely rises above the earth's surface, to the full-blown plant. They made exact copies of cornfields with their leaves, cobs, stalks, roots, and blossoms. The beard of the cob was gold, and everything else was silver, with the parts melted together, They did the same with other plants: the blossoms or any other part that was yellow, they made in gold, and everything else, silver. In addition to all these things, there were all kinds of creatures of gold and silver in these gardens, such as rabbits, mice, lizards, serpents, butterflies, foxes, and wildcats. Plus birds in the trees that looked as if they were about to warble, and others bending over blossoms as if they were ready to suck out the nectar. There were all the animals of creation, each precisely in the place it ought to be."

What did the Spaniards do with all these masterpieces? They melted them down. Not a thing has come down to us of the gold booty of Cajamarca and Cuzco.

Pizarro and his henchmen grew rich. Some of them returned to Europe, married impoverished daughters of the nobility, and bought up estates. But most of them remained in South America. Here they spent their gold, which sent the prices in Spanish forts to astronomical heights: a horse cost 30 pounds of gold. Or else they gambled their booty away, like the cavalryman who in one night diced away the golden solar image of Coricancha, the imperial temple of the Incas.

The Hunt for the Golden Man

After these recesses, the conquistadors started out again for new supplies.

They were looking for the *hombre dorado,* the golden man who, according to legend, swam in a gold-filled lake some where in South America. Jiménez de Quesada found him in Colombia among the Chibcha Indians. The Chibchas wore gold jewelry and made gold bells for their doors, incredibly thin plates that jingled at the slightest motion. And they worshipped the sun-god, whose earthly deputy was their king. The *dorado* legend had arisen from the coronation of the king. The young ruler was rubbed with resin, powdered with gold dust, and then rowed across the sacred mountain lake. He bathed in the holy water and offered up golden objects to the sun-god. Quesada decimated the Colombian Indians, brought back rich spoils, and reported on the *dorado* cult.

But the conquistadors did not accept this sober explanation. They still dreamt about the land of solid gold. The golden man turned into Eldorado, the myth of the golden paradise, which persisted for centuries.

Pizarro was murdered in 1541–for gold. Three hundred years later, the Peruvians avenged themselves for the atrocities of Pizarro and his henchmen. In the Battle of Junín, 800 Peruvians (the size of Pizarro's troops) wiped out an entire Spanish army.

The conquistadors not only wrote one of the bloodiest chapters in gold history–they also added a curious footnote.

Of all people, the Spaniards (and Portuguese), the inhabitants of Iberia, the richest gold land of antiquity, the descendants of those people who had learned mining under the Etruscans and Romans–those people didn't have the foggiest notion of how to extract gold. They only saw the treasures of the natives and, at most, grains of gold in rivers. But they overlooked gold-bearing veins of quartz in the mountains of Mexico, Chile, Brazil, Peru, and gold-rich Colombia. And it never occurred to them to obtain the gold from the luxuriant silver deposits in these colonies by using a simple procedure. It would seem as if the dream of Eldorado interfered not only with humane feelings, but with the common sense of the conquerors. They didn't want to drudge for the gold as in Europe. They wanted it served on a silver platter.

And so gold extraction remained low in South America for two hundred years. Mexico, for instance, dripped a mere 750 pounds annually into the coffers of the Spanish state, Peru 850. Compare the Californian gold rush, at which time 110 tons were extracted per year.

With the conquistadors, a multi-millennia era of gold history came to an end. Gold was as fascinating as ever, it still aroused desires, it still produced murderers and men of power. But after the conquistadors, the world would never again witness the combination that had determined the history of gold since the Sumerians: the combination of gold and an urge for knowledge, gold and adventurousness, gold and creativity.

Gold now lost its mystique. Individuals, sometimes thousands, were caught up in some gold rush, as in California and Alaska. But gold no longer made world history–like the gold mania of the Romans or Columbus. The significance of gold was reduced to concrete terms. States realized that there are other standards for prosperity–such as labor, productiveness, etc.

The history of gold now unrolled in banks and stock exchanges. In the temples and palaces of antiquity and the Middle Ages, it was important to see gold. Today, the bulk of gold has gone underground. It only becomes visible as numbers in budgets and balances. The treasury guards in Fort Knox, America's gold safe, have taken the ultimate step. In their steel vaults, there isn't a shimmer of gold. The divine metal, the body of the sun-god, the light of the Holy Ghost is dead. The ingots are covered with black paint.

Sumerians

Which land was the original model for the biblical Garden of Eden? Nobody knows for sure. But it is not unlikely that the authors of the Scriptures located Adam and Eve in southern Mesopotamia, the alluvial land of the Euphrates and the Tigris, south of Bagdad. Here, in 3000 B.C., the Sumerians created the first high culture in world history. They transformed the mostly parched country into a blossoming garden by means of an ably arranged irrigation system.

They organized their state into temple districts, and priests collected taxes from the populace. And they recorded important events in cuneiform script on clay tablets.

Sumerian culture, the only one ever to arise without foreign influence, became so strong that it survived the decline of the Sumerian people around 2000 B.C. The Babylonians, who succeeded the Sumerians, took over their administration, religion, and architecture practically unchanged and they translated Sumerian history and stories into their own language. A Babylonian priest wrote: "All the things serving to improve life were given to humanity by the Sumerians."

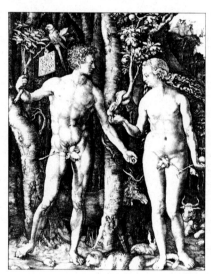

Adam and Eve in Paradise
Albrecht Dürer

Gold helmet from Mesopotamia, c. 2700 B.C. Iraq Museum, Bagdad, Iraq.
This helmet of Prince Meskalamdug dates from the first dynasty of Ur. This most conspicuous example of early Sumerian goldsmithery was found in the royal tombs of Ur of the Chaldees. The helmet of beaten gold is in the form of a wig. The hair and the braided headband are worked out in meticulous detail.

Following double page:
Bull's head from Mesopotamia. 2685–2645 B.C. Iraq Museum, Bagdad, Iraq.

Vessel from Mesopotamia, c. 2700 B.C., c. 13 cm. high. British Museum, London, England.
The bull's head and the golden vessel likewise come from the royal graves of Ur, which were discovered and excavated in 1934 by English archaeologist Leonard Woolley.

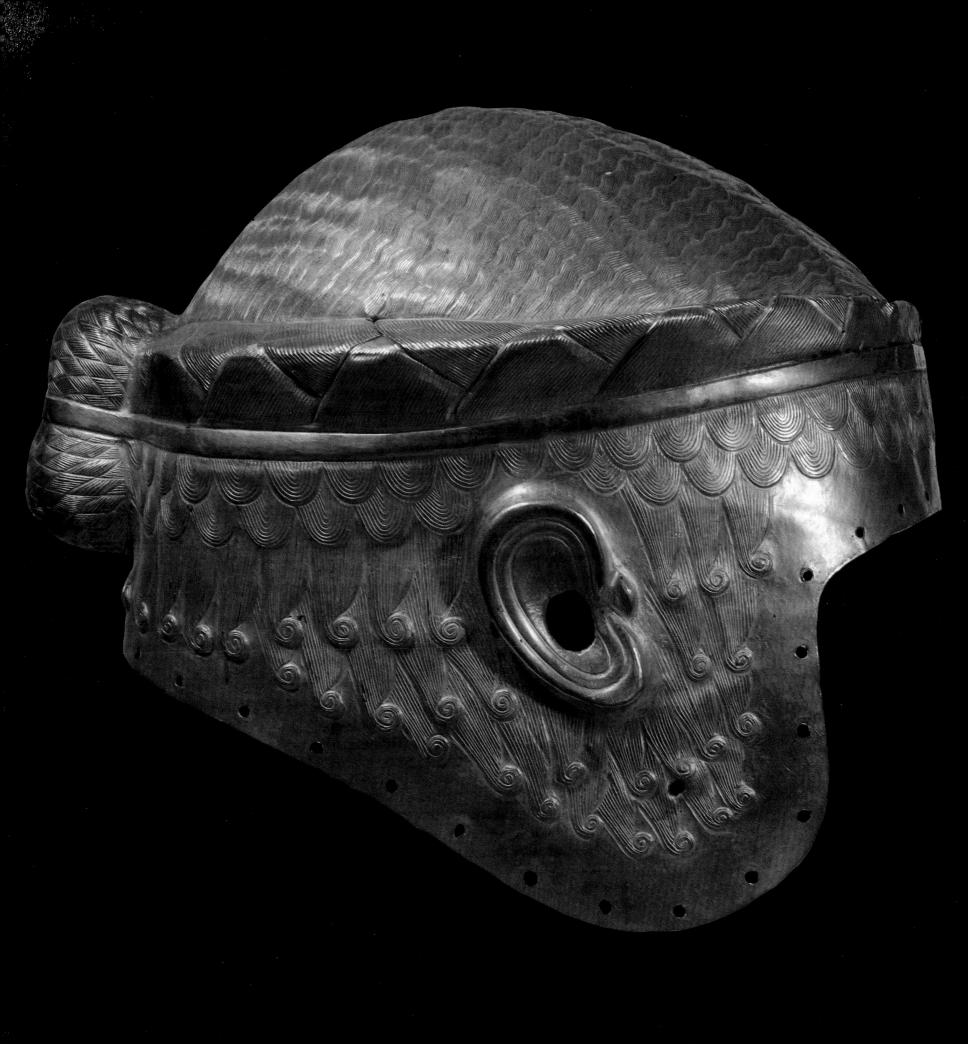

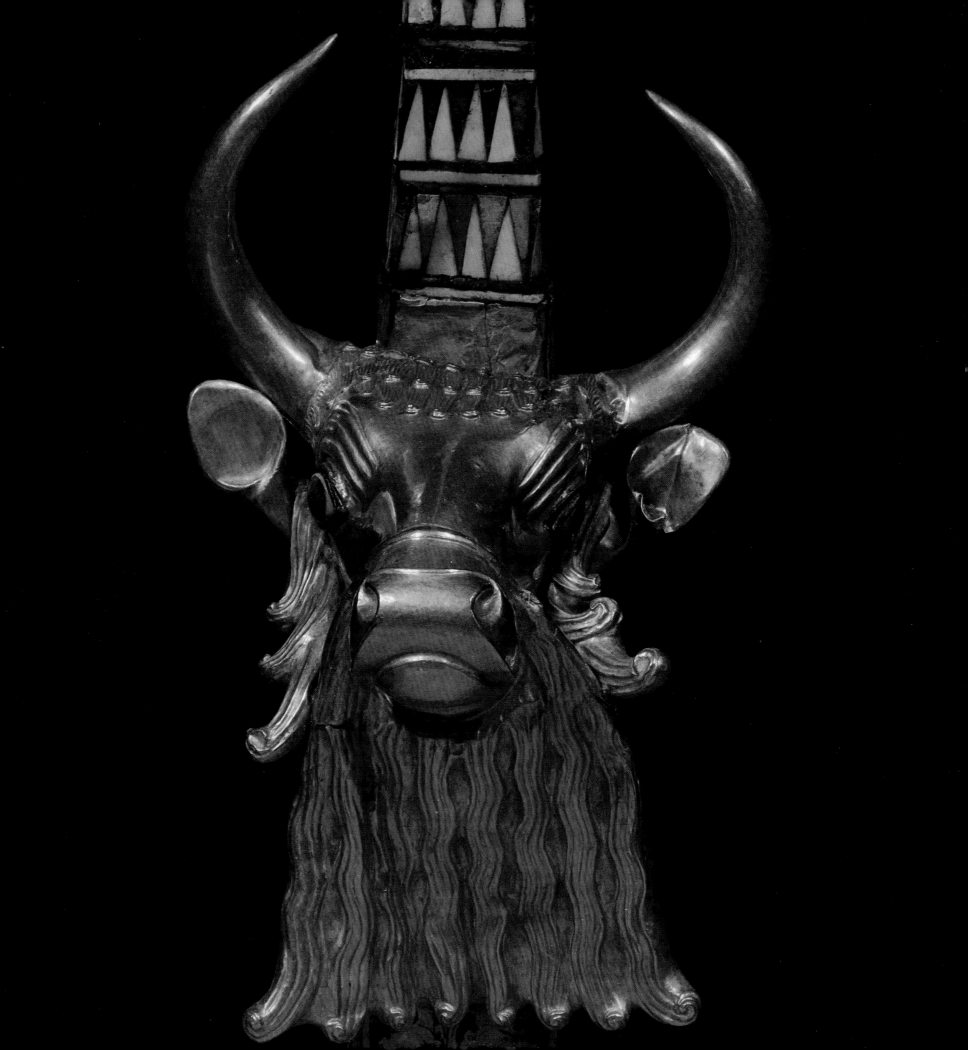

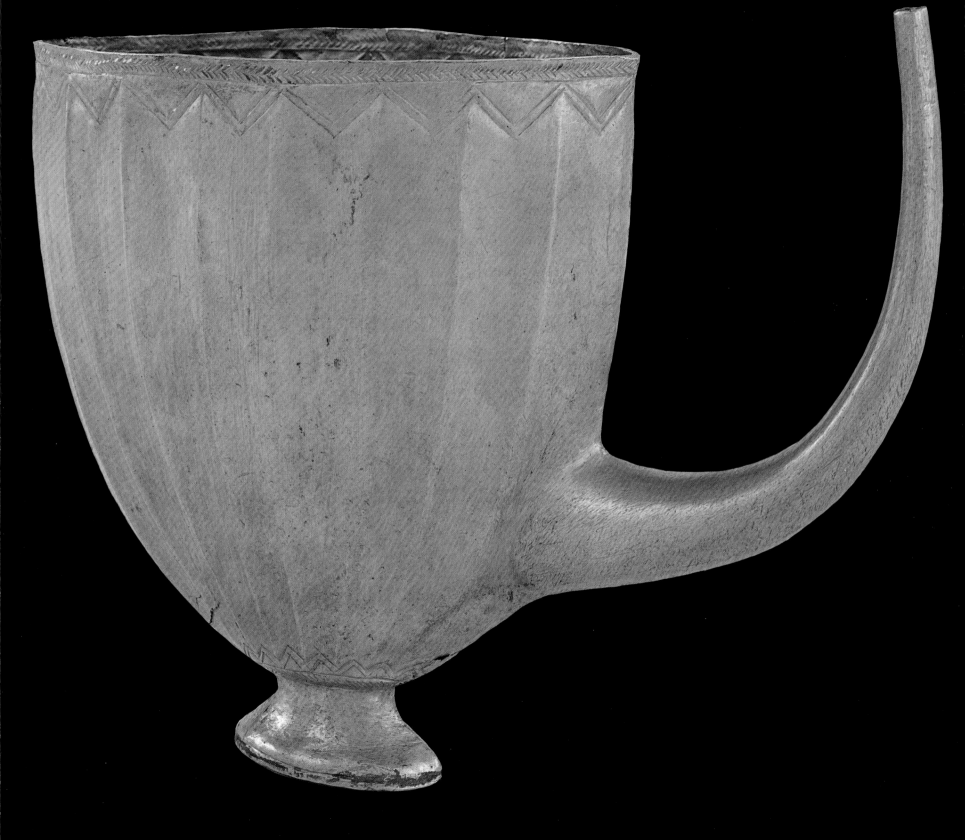

Pre-Hittites

The Hittites, like the Etruscans, were rediscovered only by the archaeologists of the twentieth century. They were mentioned in the Bible, but only today do we know that the Hittites were an Indo-European nation, who, around 1750 B.C., migrated from an unknown region to Anatolia. Here they created a civilization and a huge empire, which survived until about 1000 B.C. And we also know that when the Hittites reached Anatolia, they did not (like the Etruscans in Italy) find primitive peasant tribes. No, they came upon a cultured society, which had a written legislation. It also

Royal tombs in Alaca Höyük.

plied a zealous trade with Assyria, six hundred miles away: grain for gold, silver, precious stones, and copper. Alaca Höyük, excavated by Turkish scientists between 1935 and 1938, was one of these pre-Hittite principalities, between 3000 and 1200 B.C.

The gold and silver finds in the thirteen kingly tombs even outdid the treasure of Priam, which Schliemann had discovered in Troy in late May 1873.

The artistic artifacts and figures from the graves of Alaca Höyük are not all religious objects such as bulls' heads or solar discs. A portion is nothing but profane jewelry.

The Hittites who came here were very shrewd. They did not subjugate. They learned from the original dwellers. And they became a major power.

Beaked can from Anatolia c. 2300 B.C., 15.3 cm. high. Archaeological Museum, Ankara, Turkey.
Along with this can, many other tomb furnishings of gold, silver, electron (argentiferous gold)
bronze, and ceramic were found in the royal graves of the
pre-Hittites at Alaca Höyük, Turkey, about 60 miles south west of Ankara.

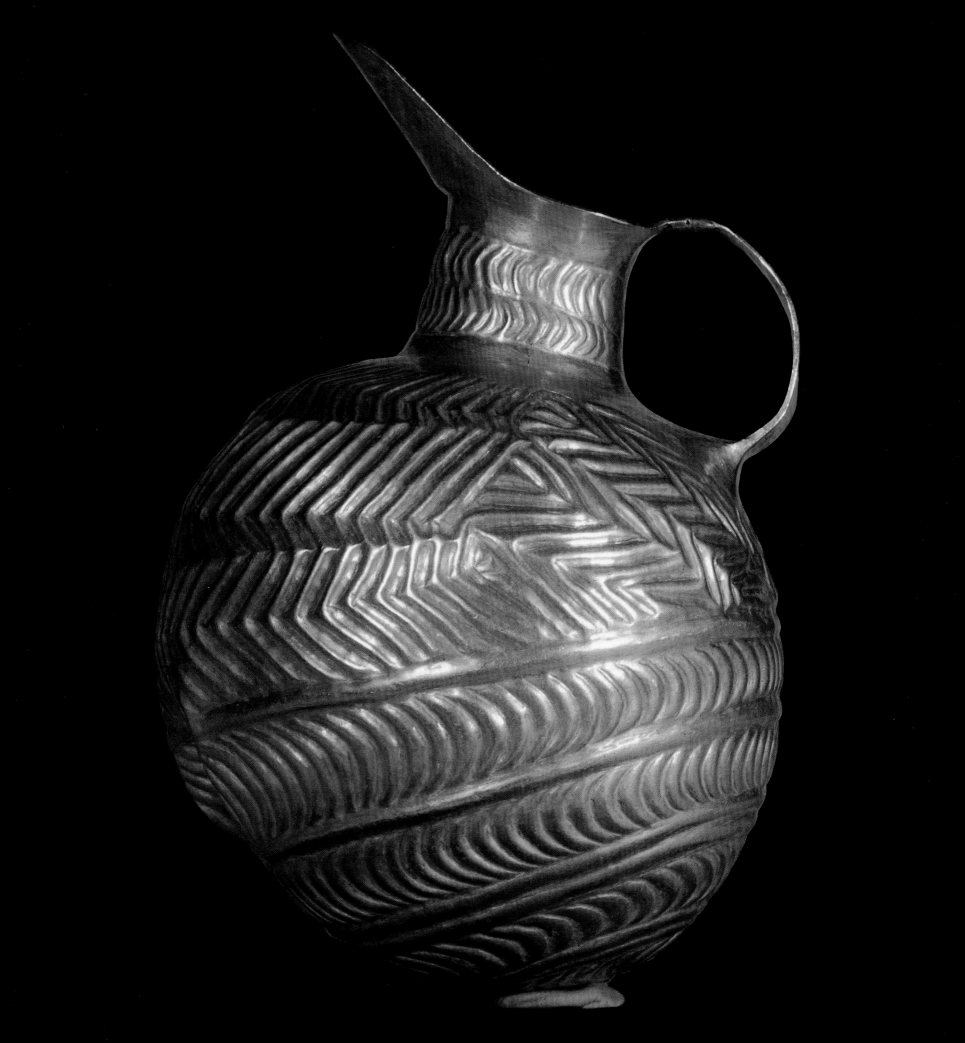

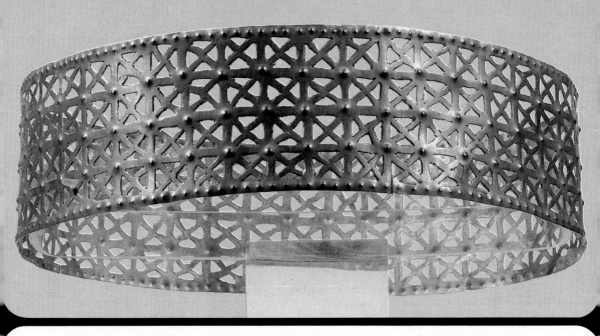

Diadem from Anatolia, c. 2300 B.C., 19.4 cm. diameter. Archaeological Museum, Ankara.
*This diadem with its grillwork pattern comes from the royal tombs of Alaca Höyük. The fine work
is highly unusual for the early Bronze Age. Next to the finds at Ur of the
Chaldees, the pieces from central Anatolia are among the earliest examples of goldsmithery.*

Statuette from Anatolia, c. 2300 B.C., 24.4 cm. high. Archaeological Museum, Ankara.
*This female figure of gold and silver was found in Hasanoglan, near Ankara. Like other female
figures, it is connected to the fertility cult.*

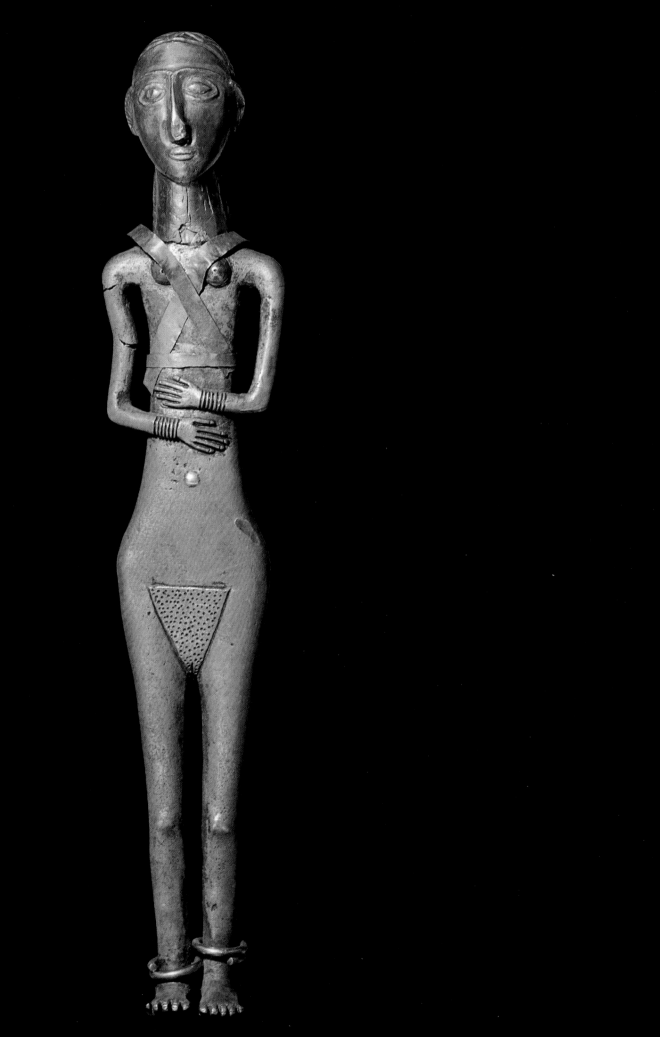

In 1922 the British archaeologist Howard Carter and his assistants uncovered the tomb of Tutankamen. In the antechamber, the scientists found a small clay tablet with the inscription: "Death will slay with his wings whoever disturbs Pharaoh's rest." By 1929, this curse (or so maintains writer Phillip Vandenberg) had struck thirteen of the twenty people directly involved in opening the tomb. Until today, people with a bent for the supernatural have forwarded theories on how the mummy of Tutankamen wreaked vengeance on the "grave desecraters":

Howard Carter in Tutankhamen's tomb.

- The archaeologists were killed by magical, bioenergetic forces.
- The Egyptian priests put venomous mushrooms into Pharaoh's tomb.
- The mummy's bandages were soaked in cyanide.
- Radioactive rays in the grave and in the mummy poisoned the scientists.

There is no proof of any of these theories. Yet the curse-believers reject the most obvious explanation for the many deaths. First of all, the archaeologists were working under exhausting and unsanitary conditions. And secondly, many of them had decades of strenuous drudgery behind them. They were simply old.

Death mask from Egypt, 1333 B.C., 54 cm. high. Egyptian Museum, Cairo, Egypt.
Tutankhamen's mask is the most beautiful ever found. It is made of solid gold, life-sized, with inlays of precious stones and colored glass. The forehead shows the two symbolic animals of the tutelary goddesses; the chin has the beard of the gods. Tutankhamen was king of the Egyptians until 1333 B. C. He died at eighteen. In 1922, his tomb was discovered, unviolated, in the Valley of the Kings.

Following double page:
Coffin of Tutankhamen, 204 cm. long, 79.5 cm. high.
The second coffin is made of gold-covered wood, adorned with precious stones and polychrome glass. It is a picture of the goddess Osiris with the royal insignia in her hands. This second coffin contained the third (of massive gold), which held the mummy with the mask, as well as all the ornaments and amulets.

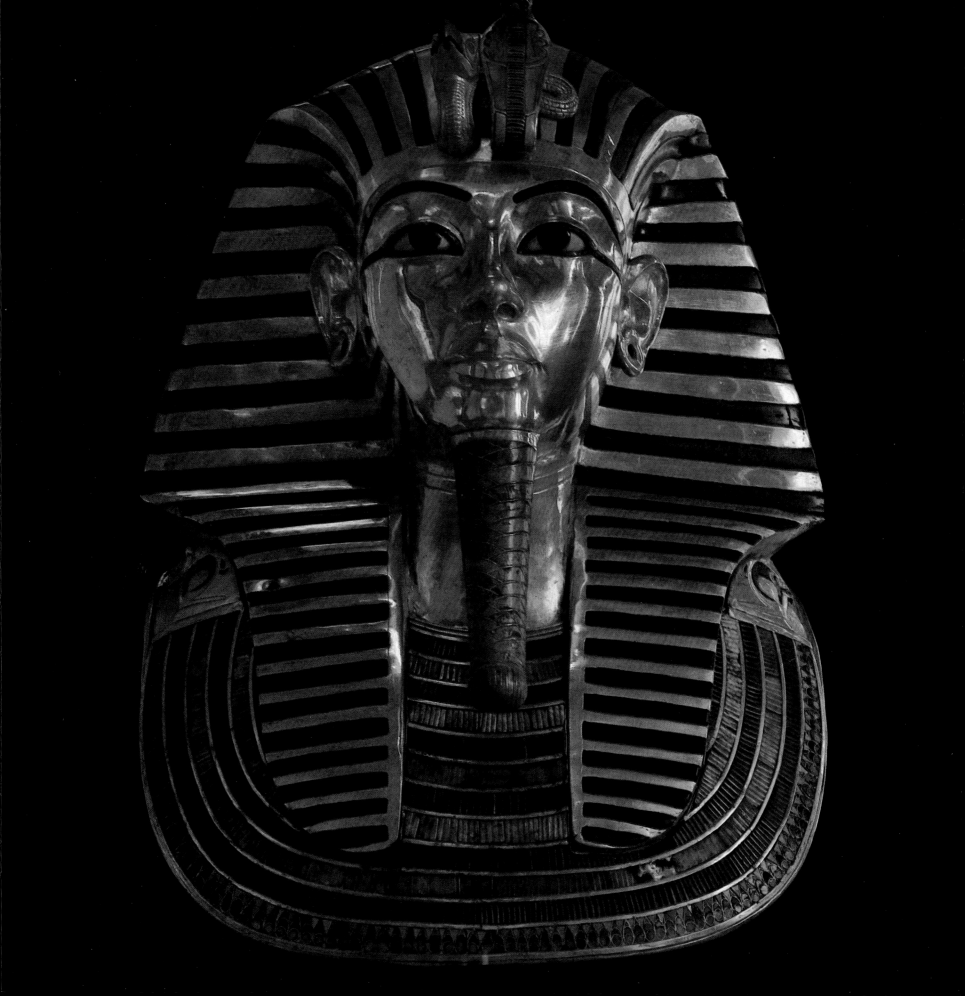

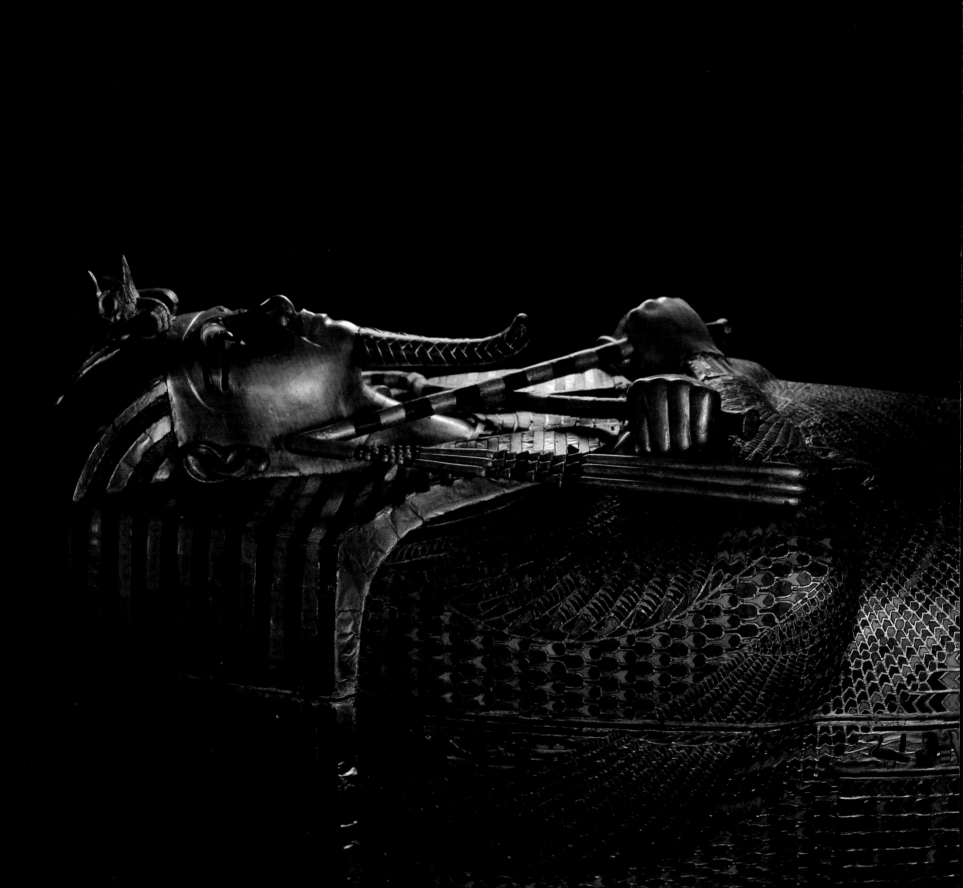

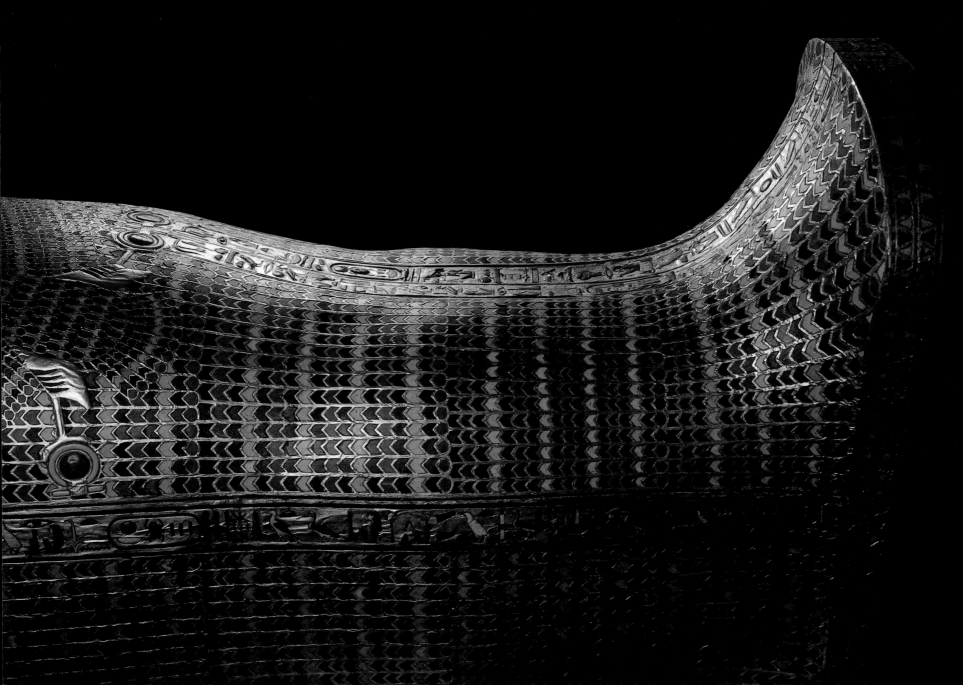

Grave furnishings from the third sarcophagus of Tutankhamen:
bangle and rings;
necklace with picture of the vulture-goddess of the south (height of vulture, 6.5 cm.);
king's dagger (over-all length 32 cm);
bangle with pendant.
The serpent-goddesses of the north and south, on either side, protect the holy eye, the symbol
of the perfection of the body. It was meant to help the dead be born again.

Following double page:
Every finger of Tutankhamen's had a golden fingerstall on which the nail was clearly worked out.
Signet rings were placed on the ring and middle fingers. The priests also put golden sheaths
on the toes before placing the golden sandals on the feet of the embalmed and bandaged king.

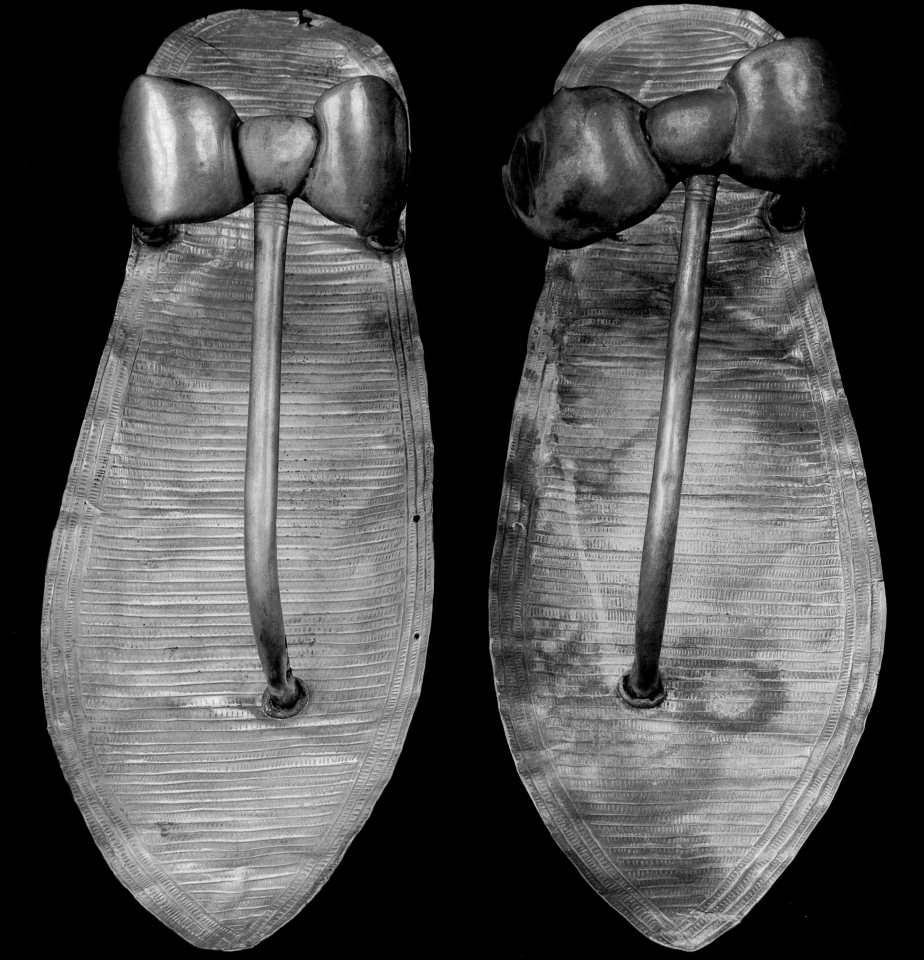

Statuettes of the king and of various deities, Egyptian, 13th cent. B.C., c. 75 cm. high.
Egyptian Museum, Cairo.
The statuettes of gilded wood were found in the so-called treasure chamber of Tutankhamen's tomb.
Such figures were used for the exorcism ceremonies during the burial rites.

Ancient Iran

Around 522 B.C., the Persian king Darius I began constructing the city of Persepolis. He called together the best architects and artisans in all Asia. However, Persepolis was not meant to be the metropolis and administrative center of the giant empire –it lay too far away from major arteries. The monumental buildings served almost exclusively as temples. Persepolis was one gigantic place of worship, which was probably used only once a year, to celebrate the festival of the New Year.
In 330 B.C., Alexander the Great destroyed the reli-

Persepolis, the temple city.

gious center and annihilated the Persian empire. It wasn't until a good 500 years later that the dynasty of the Sassanides (226–651

A.D.) turned the country into a great power again and defended it successfully against the Roman expeditions.
The Sassanide period produced the oldest extant pieces of the Persian crown treasure. Only a few have survived. For when the Arabs conquered Persia in the mid-seventh century, they scattered their booty to the four winds. In what was then the capital, Ctesiphon, the conquerors found a carpet two hundred feet long, encrusted with gold and jewels. They cut it up and doled it out piece by piece to their troops.

Rhyton from Iran, 5th cent. B.C., 17 cm. high. Metropolitan Museum of Art, New York City (Harris Brisbane Dick Fund, 1954).
The imagination of the Achaemenidian goldsmiths was deployed on these typical vessels:
the forms were richly inventive, the depictions of animals more and more realistic.
The piece probably comes from Hamadan. A beaker is fitted into the body of the winged lion.

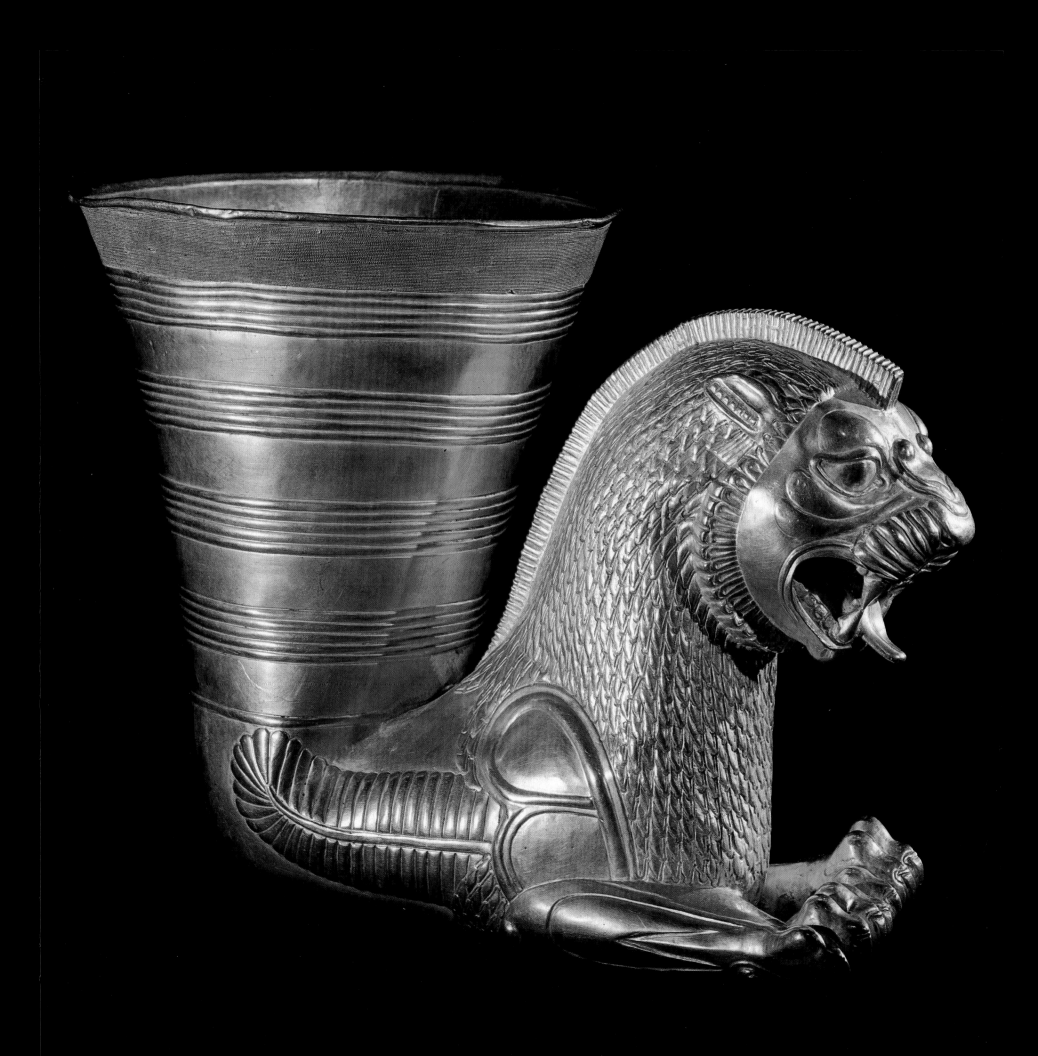

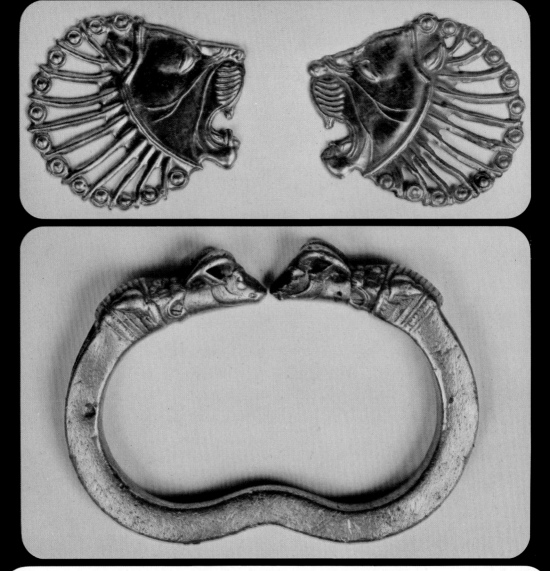

**Lion's head pins and bangle from Iran, 5th cent. B.C., 5 cm. high (lions), 10.6 cm. diameter (bangle).
Badisches Landesmuseum, Karlsruhe, Germany.**

**Pectorals from Iran, 8th–7th century B.C., 28 cm. wide. Metropolitan Museum of Art, New York
(Dick Fund, 1954; Rogers Fund, 1962).**
*In the village Ziwije in 1947, Persian farmers found this breastplate in the tomb of a Scythian prince.
(The area was occupied by the Scythians in the 7th cent. B.C.)
The plate was broken into pieces by the finders and could only be reassembled very recently.*

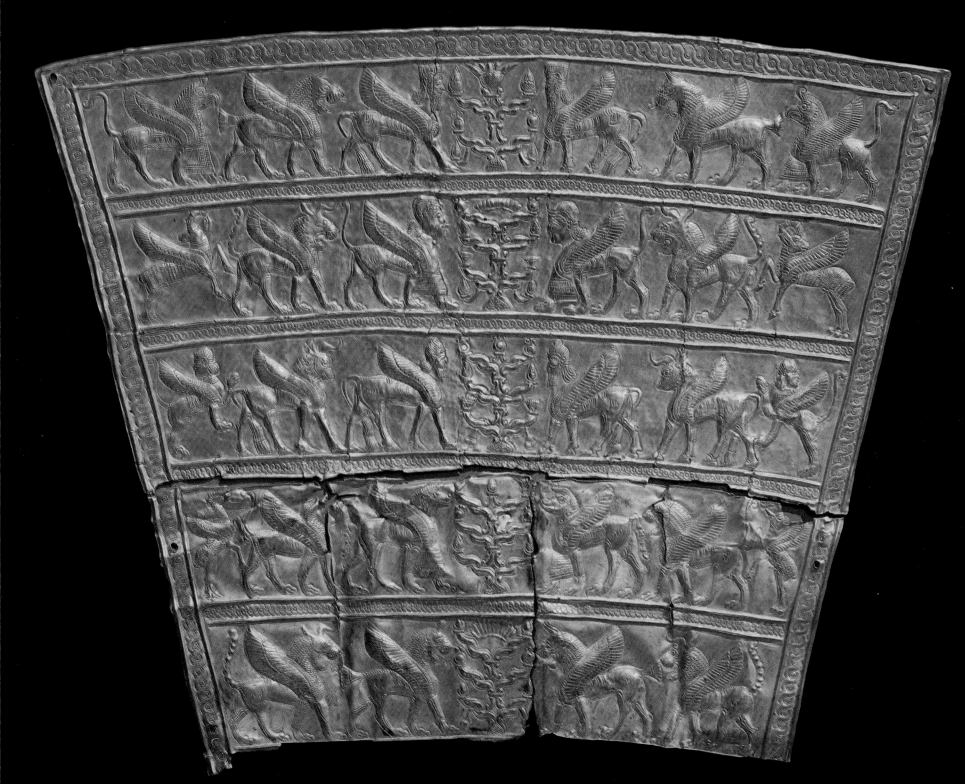

Scythians

The Greek physician and writer Hippocrates went on a journey along the Black Sea. En route, he met a nation that (he wrote) was so lazy, fat, and boisterous that it spent most of its time drinking, swearing brotherhood, and singing and dancing to the music of drums and flutes. Hippocrates meant the Scythians, one of the most feared military nations of antiquity. Still, his observations did not contradict their reputation. The Scythians, a nomadic people, whose tribes wandered through eastern Central Europe as of 1000 B.C., were both hardy warriors and epicures. Their rapid cavalry scared even the in-

Scythian tomb in Russia.

vincible Persians. They pushed as far as Egypt on their looting expeditions. But in their free time, they appreciated good conversation, beautiful clothing, splendid jewelry, and sumptuous food. Roasted game was so popular among the Scythians that shortly before a Scythian-Persian skirmish, the Persians dumbfoundedly watched as Scythian soldiers suddenly dashed after a rabbit that was hopping about between the battle lines. Around 600 B.C., the Scythians began bartering with the Greeks on the Black Sea. They exchanged grain and utensils for jewelry of bronze, silver, and gold. The Scythians learned from Greek and Asiatic goldsmiths. And they themselves manufactured some of the loveliest art works in the era between 600 and 300 B.C.

Figure from Russia, 6th–7th century, 8.6 cm. high. Historical Museum, Kiev, U.S.S.R.
*Human figures occur very rarely in the works of Russia's steppe peoples. This dancing nomad
of partly gilded silver was unearthed near the Dnieper River.*

Following double page:
**Pectoral from Russia, 4th cent. B.C., 30.6 cm. diameter, wt: 1,150 grams.
Historical Museum, Kiev, U.S.S.R.**
*This breastplate is one of the most unusual pieces of golden jewelry found in southern Russia.
A goldsmith, presumably from Greece, depicted the life of the Scythians at home and
in the wilds. Along with humans and animals (48 altogether), the artist also created rich floral
ornaments. The pectoral was found in the princely grave "Tolstaya mogila" near Ordzhonikidze.*
**Diadem from southern Russia (Kerch), c. 300 B.C., c. 23 cm. diameter.
Staatliche Antikensammlungen, Munich, Germany.**

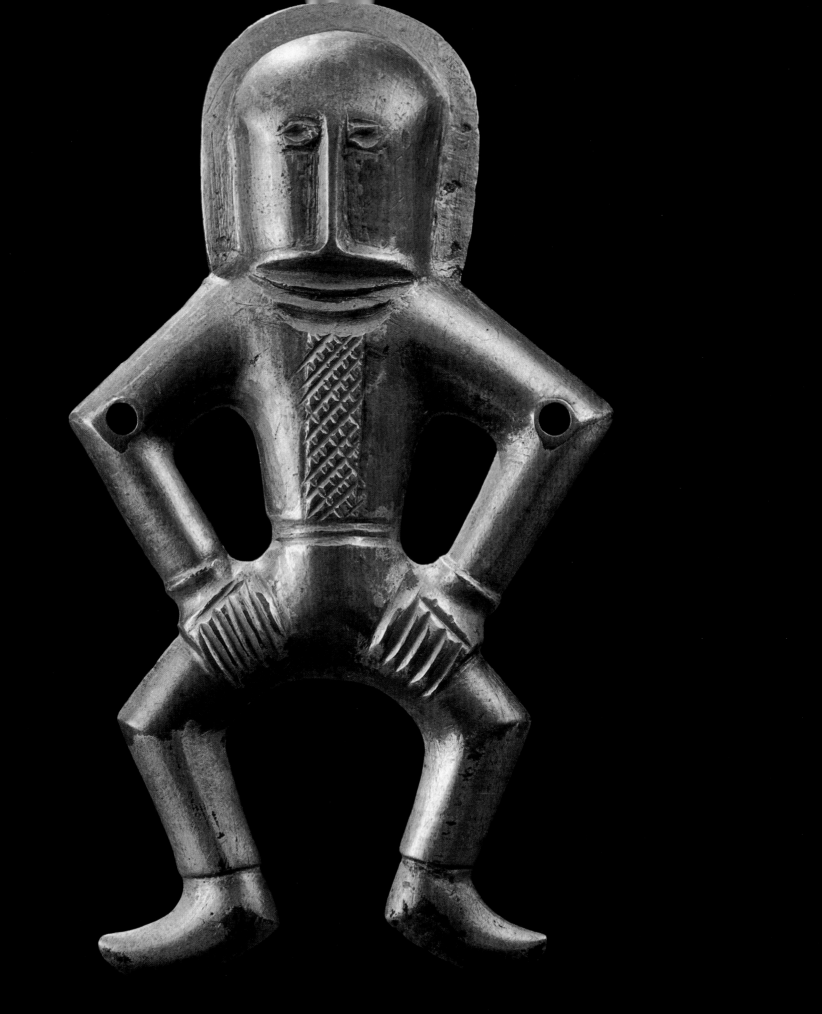

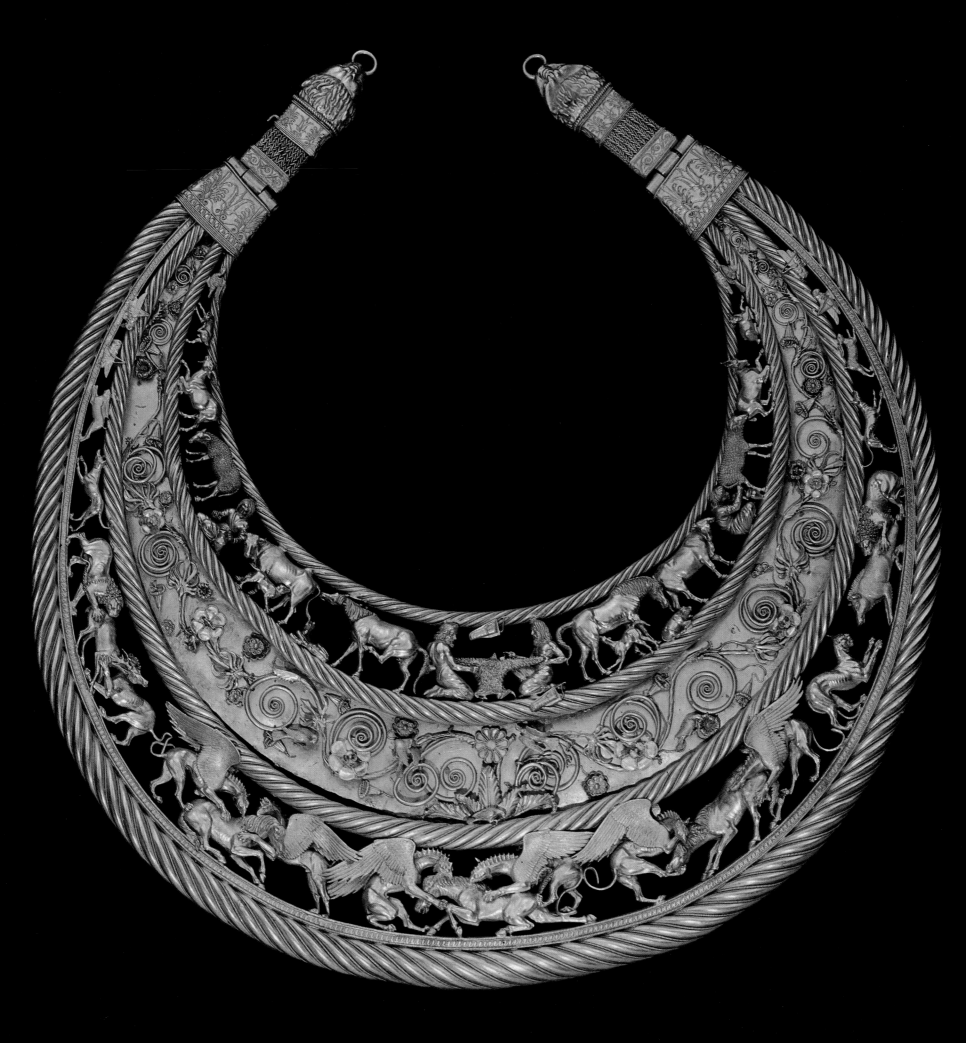

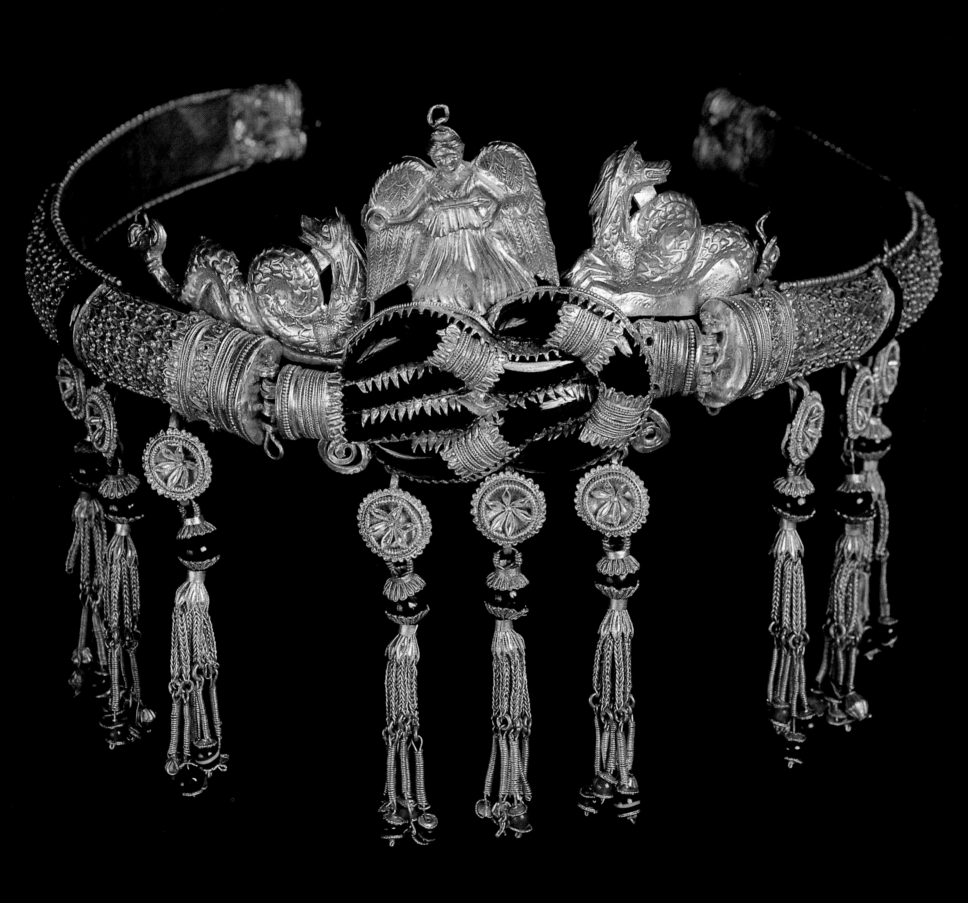

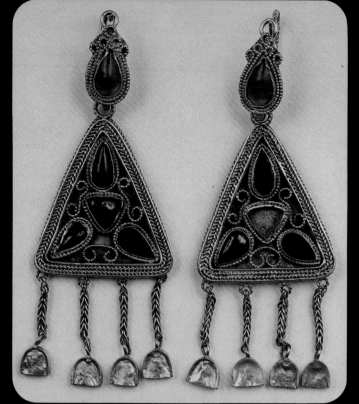

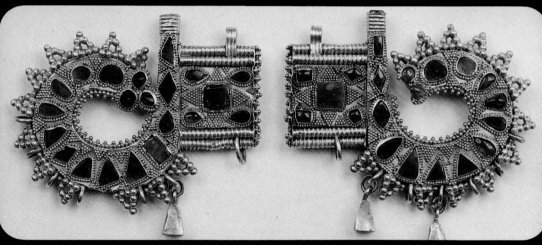

**Earrings from southern Russia (Kerch), early 5th cent., 8.1 cm. high;
Ornamental pieces from Varna, Bulgaria, 5th cent., 6.9 cm. long.
Roman-Germanic Museum, Cologne, Germany.**

*Although found in Bulgaria, the question-mark-shaped pieces, whose use is unknown, belong
stylistically to the formal sphere of southern Russia.
Originally, seven gold bells hung from each lower semicircle, but only three have survived.*

**Diadem with eagle attachment from southern Russia (Kerch), first half of 5th cent., 6.9 cm. high.
Roman-Germanic Museum, Cologne, Germany.**

*This headband was found in the grave of a rich Hunnish woman, along with other splendid jewelry.
The headband could hardly have been worn on ordinary days; it was probably reserved
for religious festivals since the eagle was the symbol of higher power and supernatural strength.*

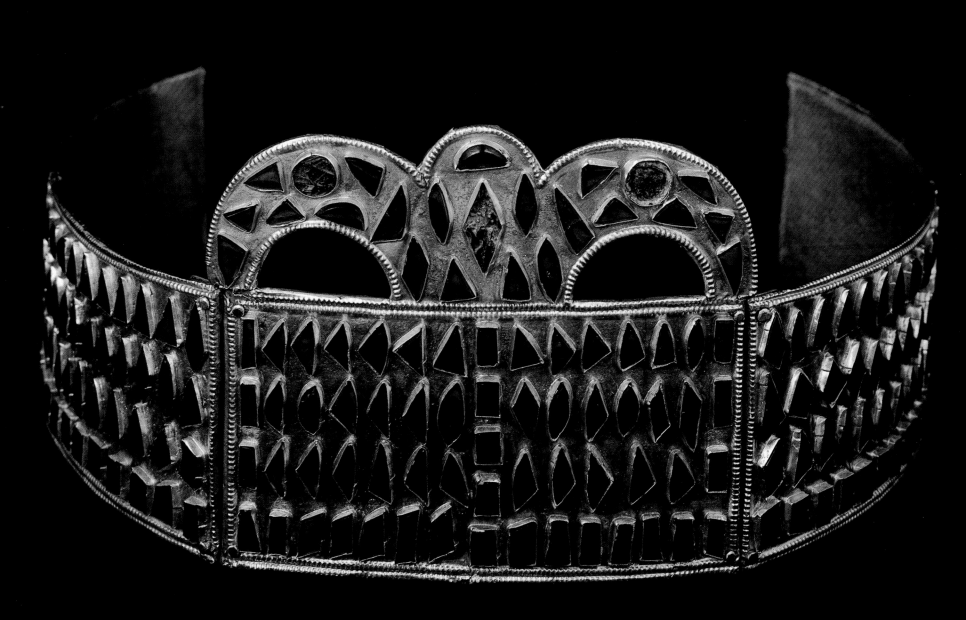

Greece

In 1873, Heinrich Schliemann stood in the place where Troy had once stood, excavating priceless gold treasures, which he kept secret. He didn't want the art works falling into the hands of the Turkish government, the lawful owner, because he didn't trust their scientific care. Schliemann smuggled the treasures out of the country. His Greek wife Sophia brought some of them across the border. She put on the millennia-old gold jewelry and passed unhampered through the Turkish customs. Schliemann, with the help of his wife's relatives, got the rest of the gold to Greece —a highly hazardous adventure.

When the Turkish government found out, it intervened in Athens and had Schliemann's house searched. But the gold was in safety long since. It was hidden in hayricks, kitchens, vegetable gardens, and stables. The Turkish gold hunters couldn't find a thing.

Heinrich Schliemann was the first gold smuggler to transport the divine metal illegally across state borders—out of pure motives, for art's sake.

Sophia Schliemann with the golden jewelry of Troy.

Death mask from Mycenae, Greece, 1600 B.C., height 19.5 cm. National Museum, Athens, Greece.
Heinrich Schliemann mistook this expressive mask for the mask of Agamemnon. He found it in 1876 while excavating the royal graves of Mycenae. In his diggings, Schliemann followed Homeric descriptions and was successful—both in Troy and in Mycenae.

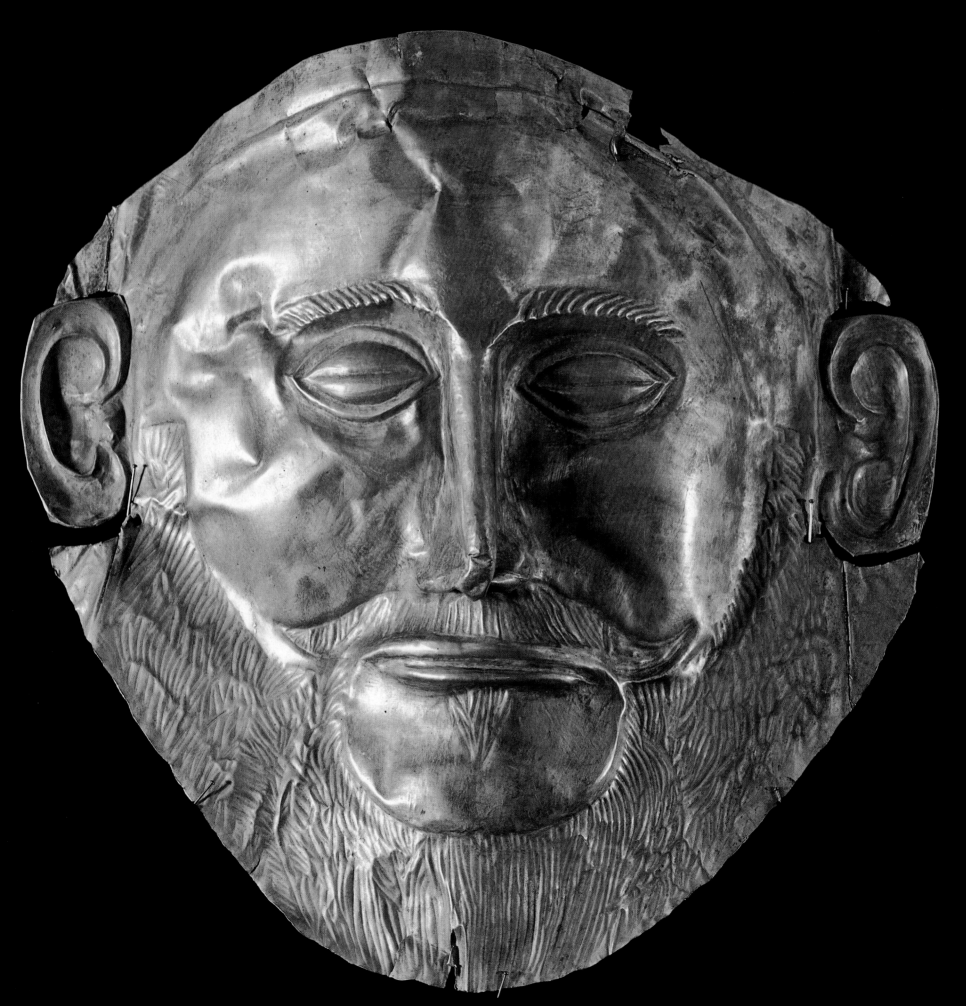

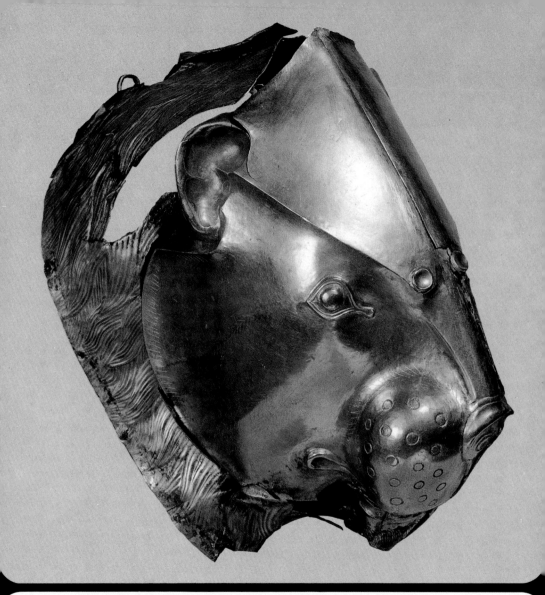

Lion's head from Mycenae, Greece, 1600 B.C., 20 cm. high. National Museum, Athens, Greece.
*This lion's head was found in Tomb IV of Mycenae. The libation vessel, of artistically embossed
gold foil, is stylistically quite different from the other pieces found here.*

Bull's head from Mycenae, Greece, 1600 B.C., without horns 15.5 cm. high.
National Museum, Athens, Greece.
*One of the most peculiar finds in Tomb IV: a bull's head of silver with gold horns and a rosette
on the forehead. It was lying near five corpses simply covered
with gold and precious stones. They were probably members of the royal family.*

Signet ring from Greece, 15th cent. B.C., 5.6 cm. long. National Museum, Athens, Greece.
*The lion-headed demons are bringing gifts of ewers to a goddess. The scene probably shows
a fertility rite.*

Goblet from Lukania, Greece, 15th cent. B.C., 8 cm. high. National Museum, Athens, Greece.
A masterpiece of Mycenaean goldsmithery: the bull was caught with a net hung between two trees.

Following double page:
**Wreath from Armento, Lukania, 2nd half of 5th cent. B.C., c. 32 cm. high.
Staatliche Antikensammlungen, Munich, Germany.**
*The oak-leaf wreath of gold foil and gold wire is interwound with ivy and adorned with blossoms,
bees, and winged figures of gods. The base of the larger figure
has an inscription: the name of Creithonius, who consecrated the wreath.*

**Dance of death from Asia Minor, 2nd half of the 4th cent. B.C., c. 40 cm. wide.
Schmuckmuseum, Pforzheim, Germany.**
*The large golden wreath of two olive branches is set with tiny golden blossoms. The wreath was
probably a decoration for an ancient sepulchral vase.*

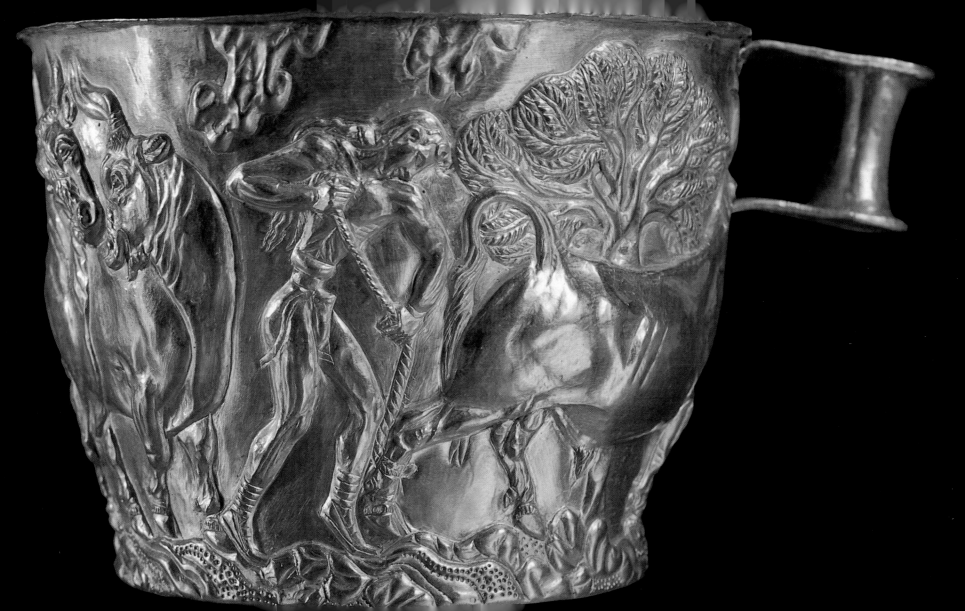

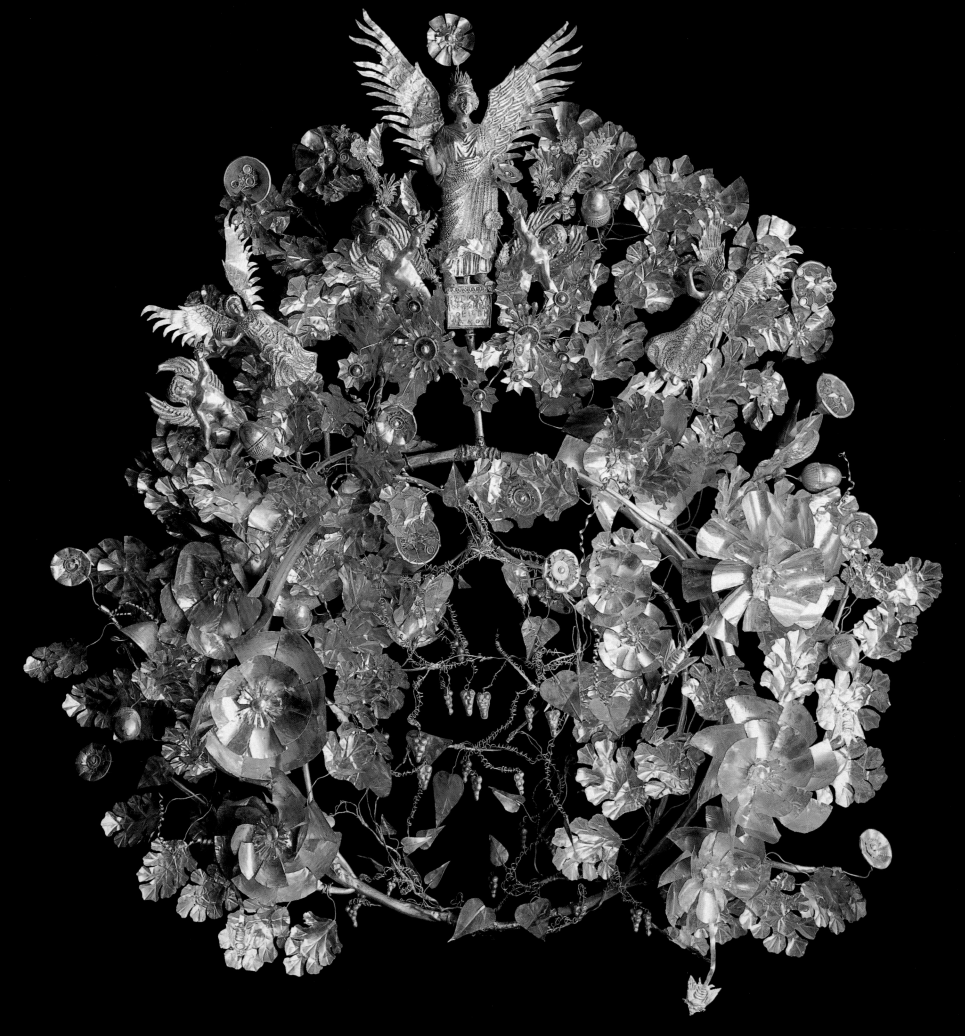

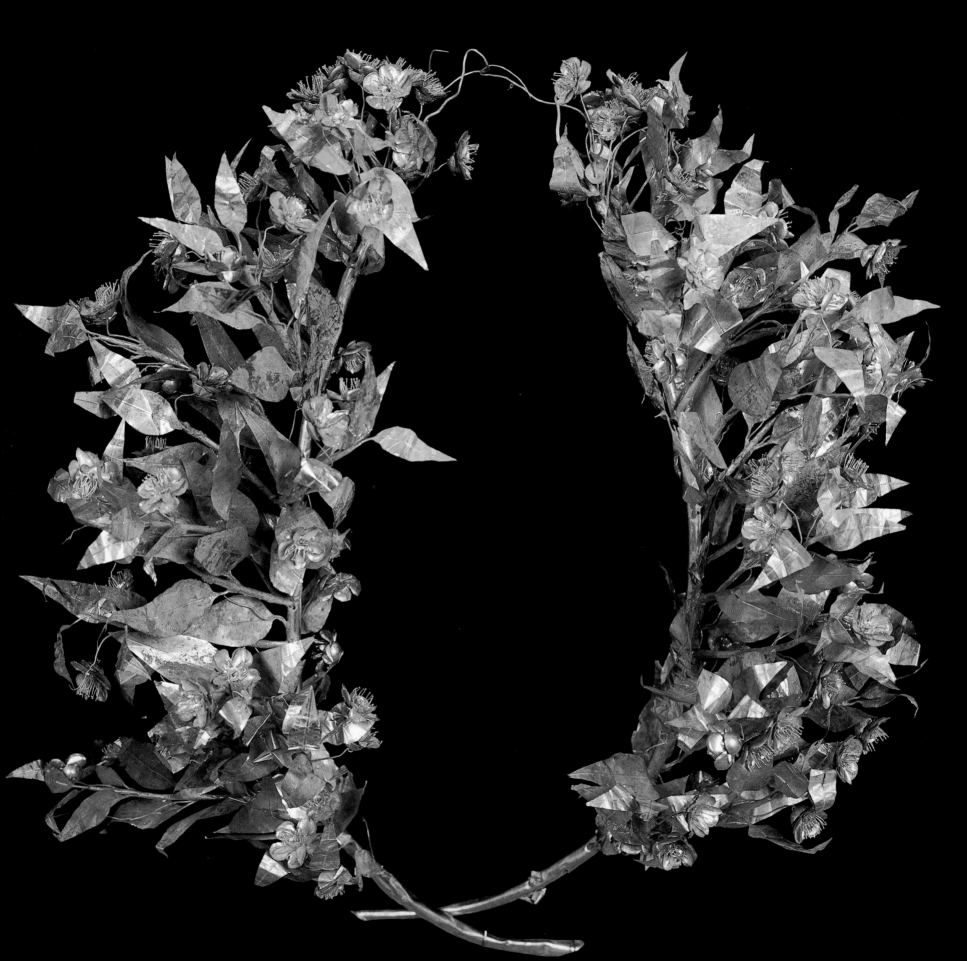

Necklace from Greece, c. 300 B.C., 41 cm. long. Staatliche Antikensammlungen, Munich, Germany.
This necklace probably comes from a northern Greek workshop. It is made of braided gold wire with a richly decorated knot; there is a lion's head at either end.

Brooches from lower Italy, 2nd half of 4th cent. B.C., 9 cm. long.
Staatliche Antikensammlungen, Munich, Germany.

Bangle for upper arm, from Eritrea, 300–200 B.C., 11.5 cm. high.
Schmuckmuseum, Pforzheim, Germany.
A large representative bangle made of two serpents uniting at the center in a so-called Heraclean knot. In antiquity, this knot was used as an amulet to ward off evil and heal wounds.

Following double page:
Earrings and necklace from Asia Minor, 2nd half of 4th cent. B.C., 5.3 cm. high; chains 20 and 34 cm. long. Schmuckmuseum, Pforzheim, Germany.
These jewels of a rich Greek woman were found in her tomb near Troy. The chains are braided of gold wire; one is decorated with delicate blossoms.

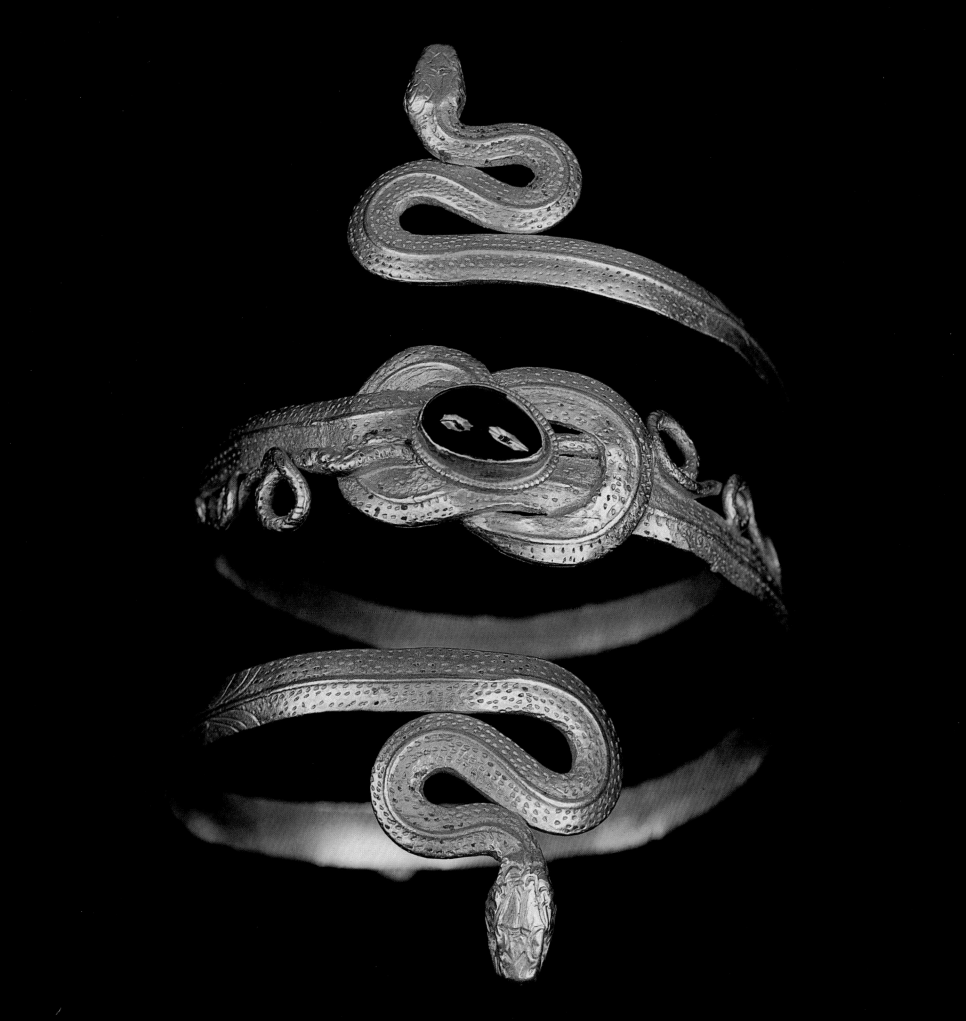

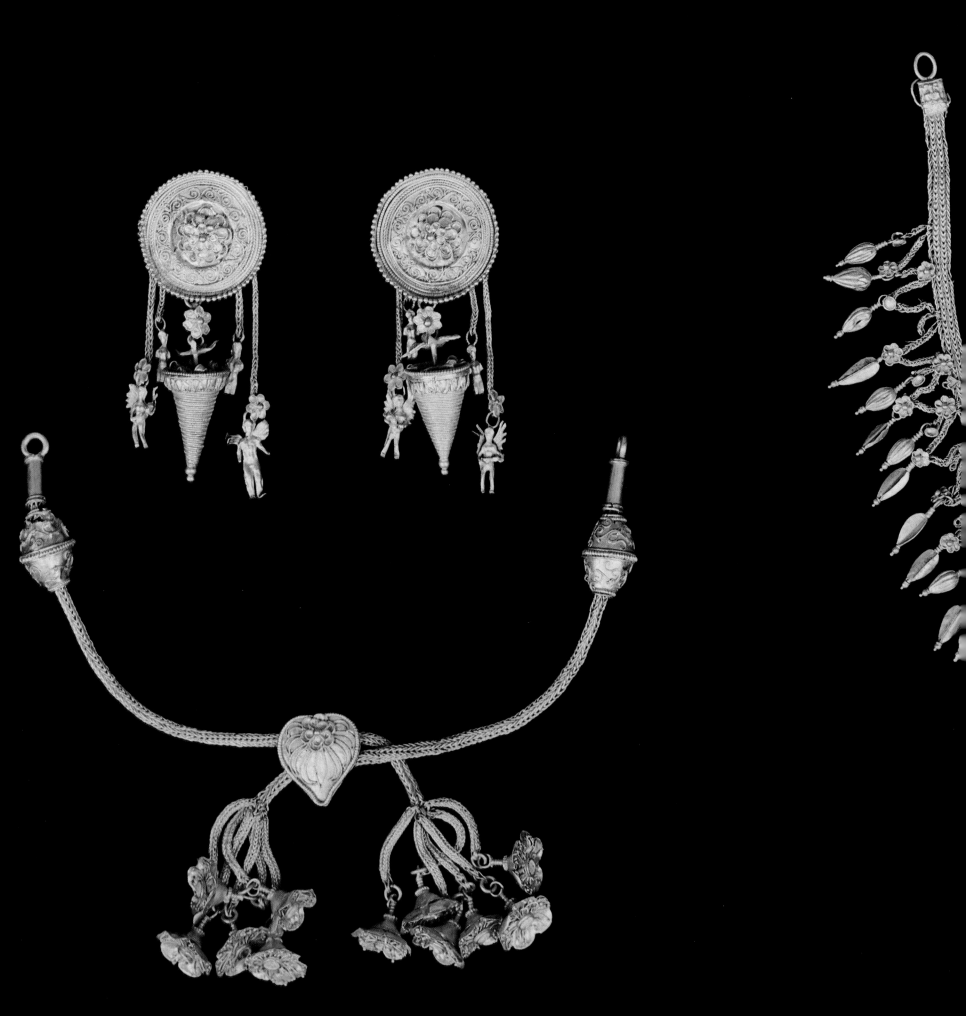

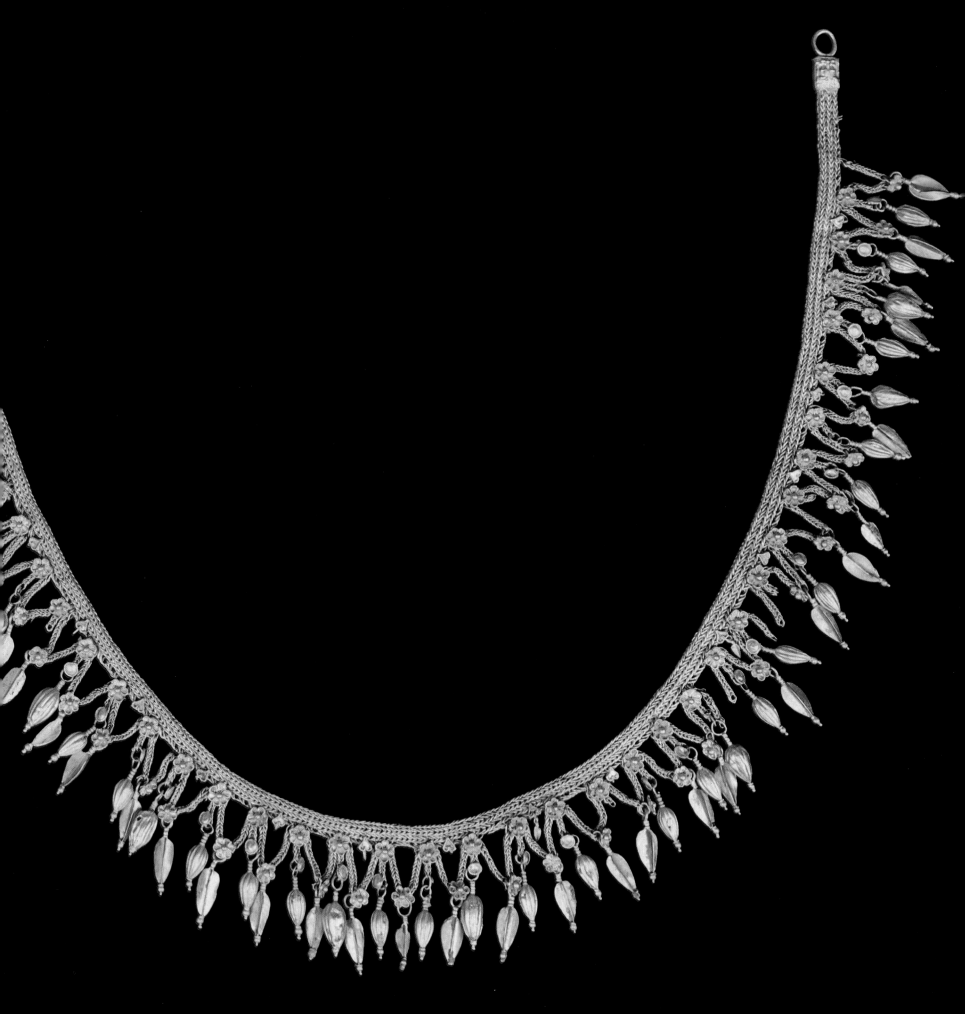

Etruscans

In the year 264 B.C., Consul Fulvius Flaccus marched in triumph through the streets of Rome. He had just destroyed the Etruscan city of Volsinii, and that was the ultimate victory of the Romans over a people to whom they owed their culture and their rise to a major power. The Etruscan role in Rome's history was later consistently devalued and even denied by Roman historians.

Yet Rome would probably have long remained an unknown, malaria-infested village on the Tiber if it hadn't been for Etruscan merchants who discovered a ford near Rome in the eighth century B.C., there-

Wolf with Romulus and Remus, the founders of Rome.

by facilitating the route to the south. The Etruscans named the spot Rumlua, from which the Romans derived the name of the legendary founder of Rome: Romulus. Rumlua became the most minor of colonies of a nation that had migrated from the east centuries earlier and now ruled most of the Italian peninsula. The Etruscans taught

Rumlua's peasants and shepherds the art of life and survival. They drained the swamps, thereby conquering the malaria epidemics. They built a fortification wall, thereby making Rumlua a city. They introduced coinage. They gave the later Romans their religion and their gods, their political and administrative techniques, their handicraft skills. The Romans were such good pupils that they finally wiped out the Etruscans, degrading them to historical nonentities. It was only the excavations of the twentieth century that restored the Etruscans to their rightful place in Roman history.

Bowl from Italy (Etruscan), 6th cent. B.C., c. 18 cm. diameter. Villa Giuglia, Rome, Italy.
Etruscan crafts include many works which reveal the influence and use of Greek forms. This bowl of gilded silver is an exception. Its execution recalls Egyptian pieces.

Following double page:
Ornamental tray from Italy (Etruscan), 7th cent. B.C., c. 14 cm. long. Villa Giuglia, Rome, Italy.
One of the most beautiful examples of granulation technique, this tray is adorned with lions and other animals.

Ear discs and parts of a necklace from Italy (Etruscan), 6th cent. B.C., 4.5 cm. diameter (discs), 17.5 cm. long (chain). Schmuckmuseum, Pforzheim, Germany.
A further example of the marvelous granulation technique of the Etruscans, this necklace is made of 15 large hollow balls. The separating rings are made of smaller hollow balls.

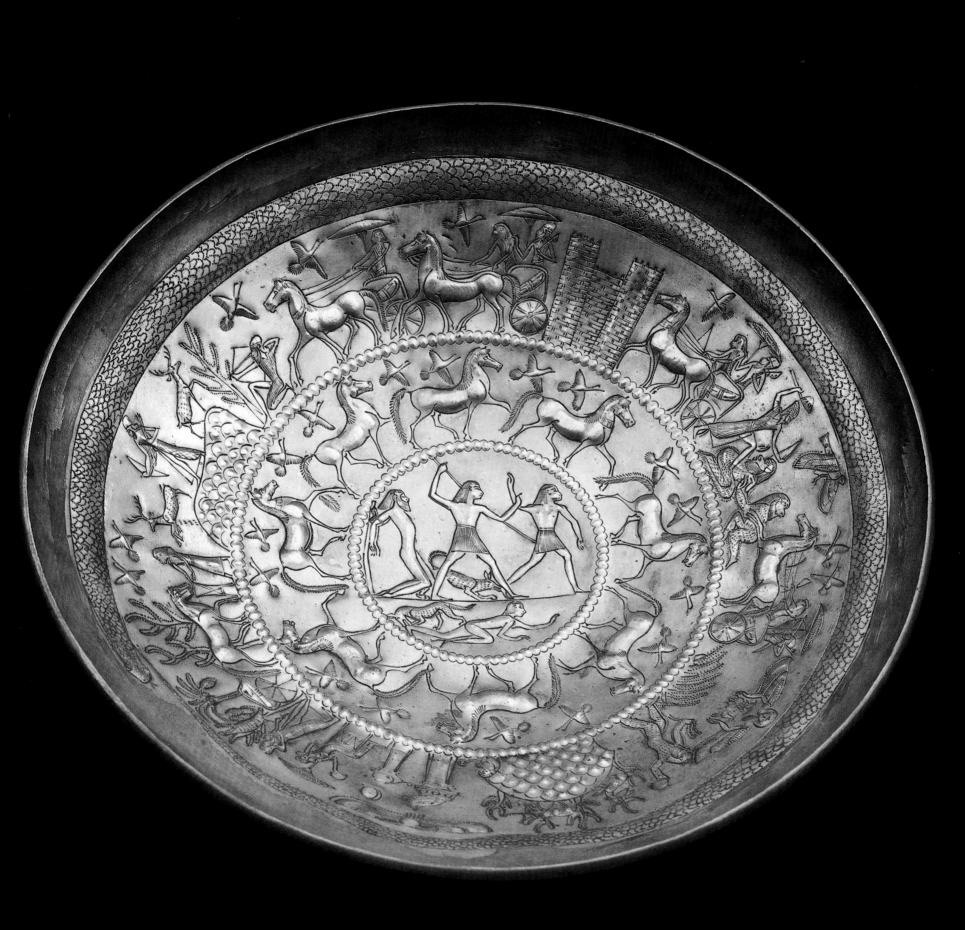

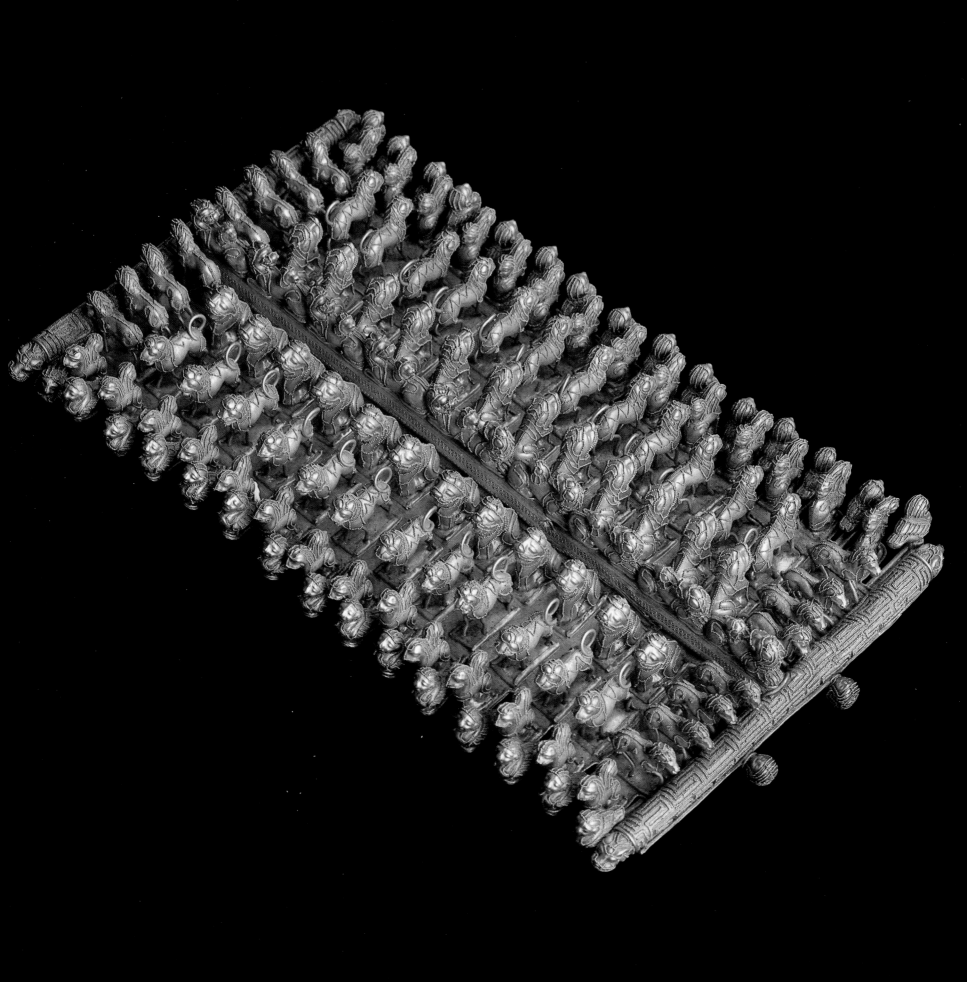

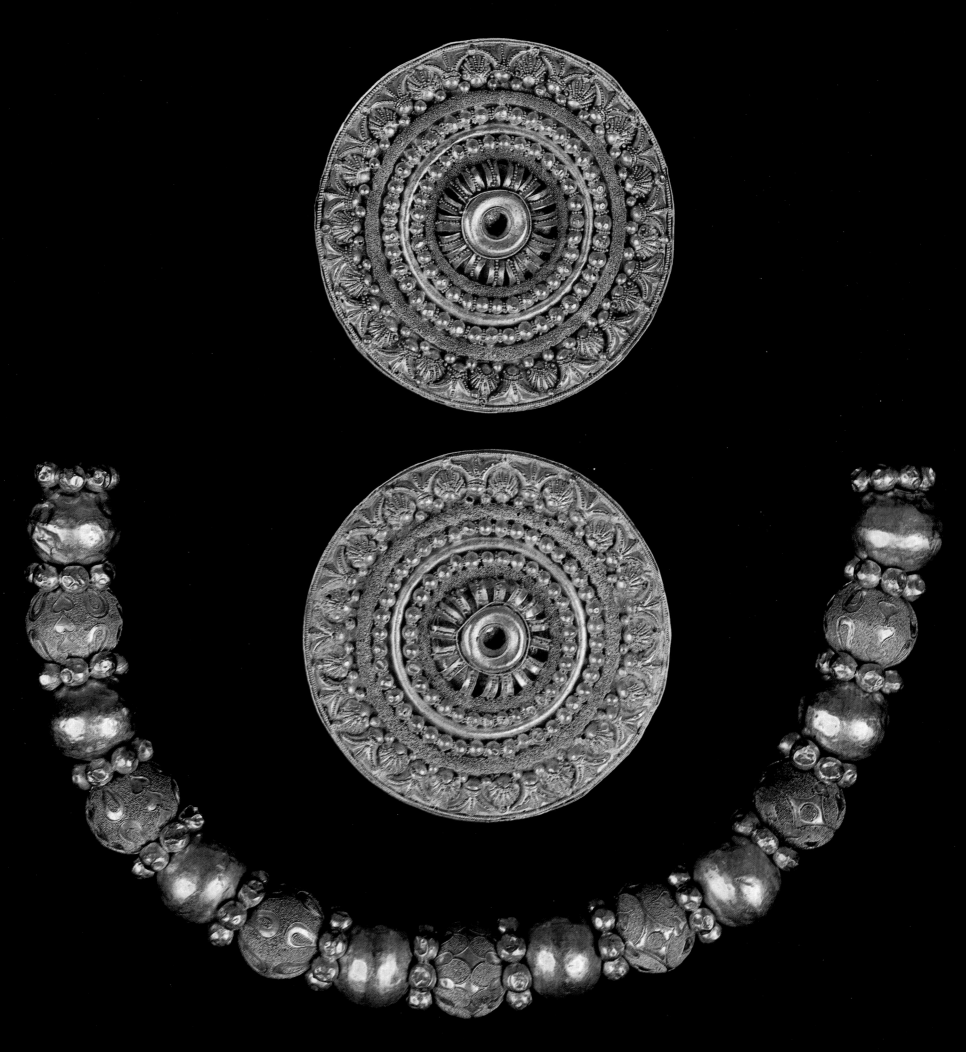

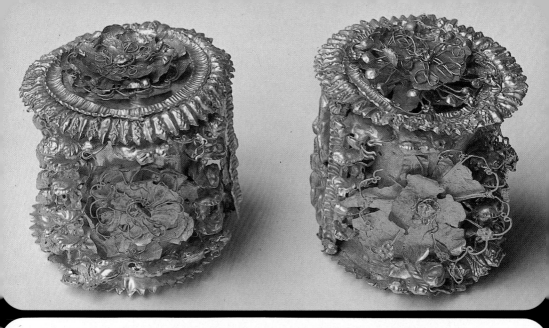

Earrings from Italy (Etruscan), 2nd half of the 6th cent. B.C., 2.5 cm. diameter (rosette disc). Staatliche Antikensammlungen, Munich, Germany.
These basket earrings with rosette leaves are made of thin gold foil.

Necklace from Italy (Etruscan), 6th cent. B.C. Villa Giuglia, Rome, Italy.

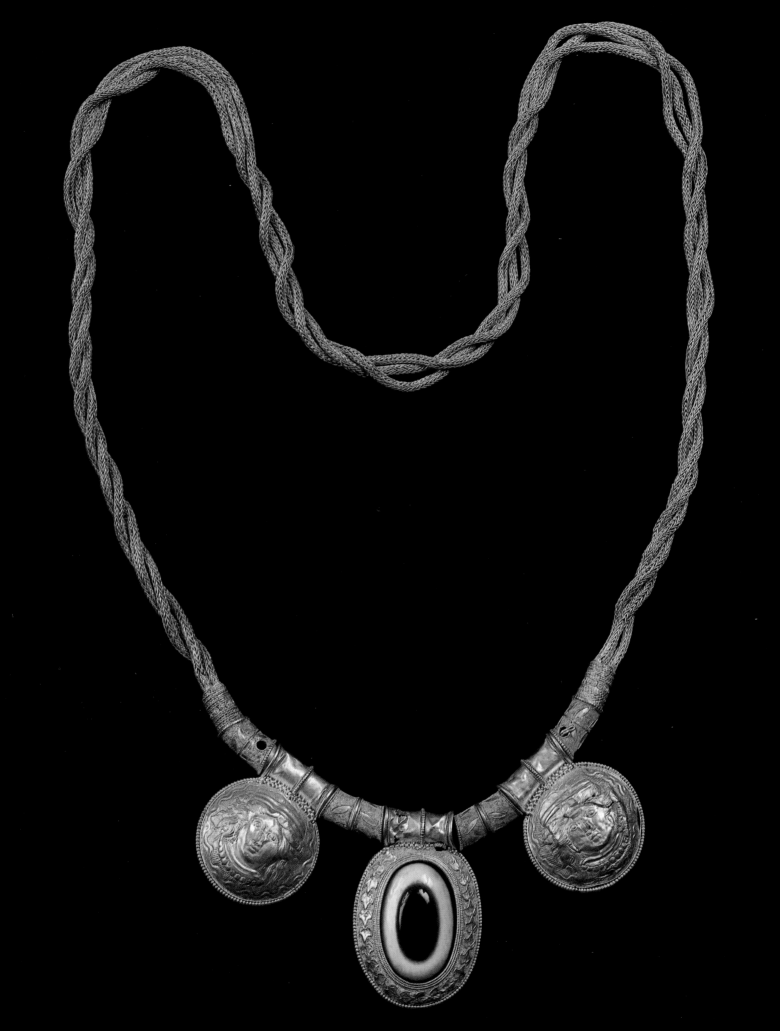

Africa

In no country in the world, except for India, has gold had such a huge significance for the people as in Ghana on the African west coast (once known as the Gold Coast). Or more exactly: the tribe of the Ashantis.

The Ashanti tribe has a gold culture going back for centuries. They attribute magical powers to the noble metal. A fetish (a piece of wood or a rare stone) can ward off evil spirits only if it is gilded or kept with gold.

When asked why a people that had converted to Christianity long ago still believed in the magic of gold, an Ashanti said: "Because it works."

African jewelry.

The present king of the Ashantis (who has maintained administrative autonomy in the Republic of Ghana) is a lawyer, who studied in England—an enlightened man. But he too has to yield to the cult of gold. He wears the golden insignia of the royal family—sandals with eye-shaped ornaments, symbolizing omniscience, and a ring with a hedgehog, symbolizing preparedness. On a court day, he sits on a golden throne, the national relic of the Ashantis. His master of ceremonies has a golden cap and a golden staff.

The works of Ashanti goldsmithery, all of them highly sought-after collector's items, partially go back to old Egyptian models.

Pendants from Africa (Ivory Coast/Ebrié). Brooklyn Museum, New York.

Following double page:
Bird with nest from Ghana, Africa, 19th cent., 57 mm. wide.
Museum für Völkerkunde, Hamburg, Germany.
This Ashanti piece was executed by the lost-wax process. The nest was braided with wax threads.

Crown from Abyssinia, 21 cm. high. Victoria & Albert Museum, London, England.

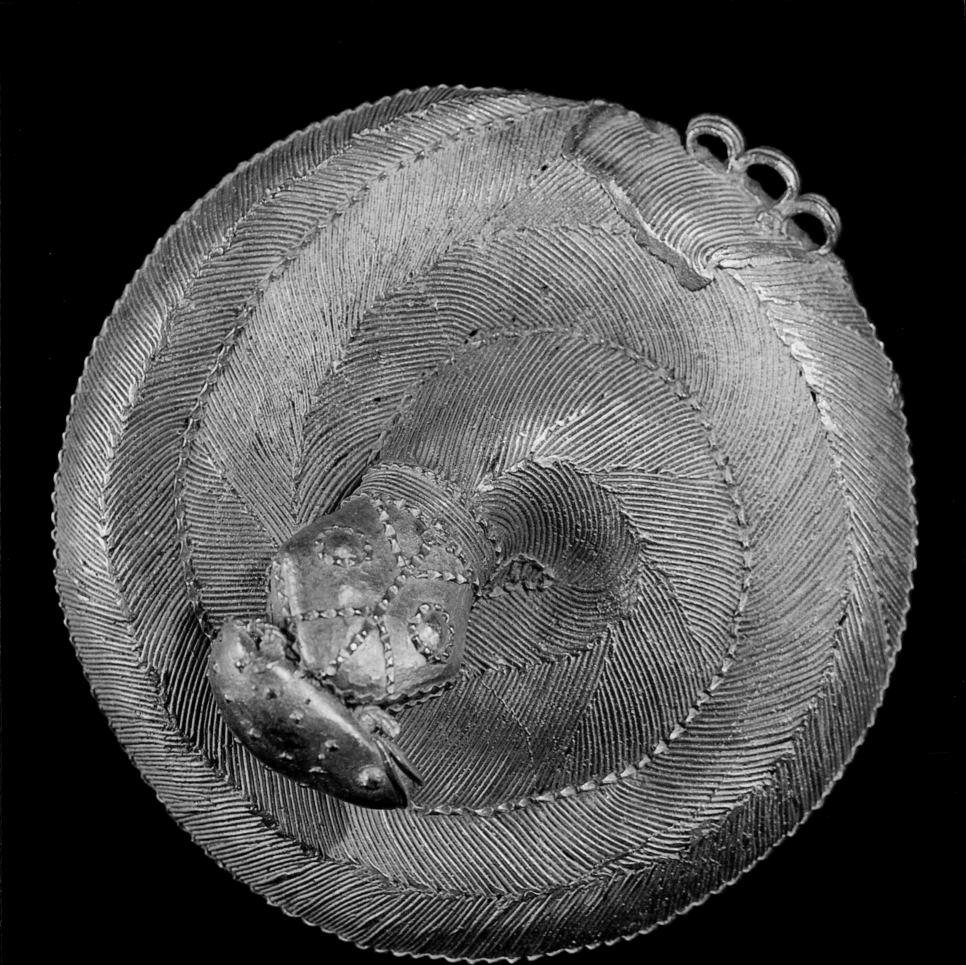

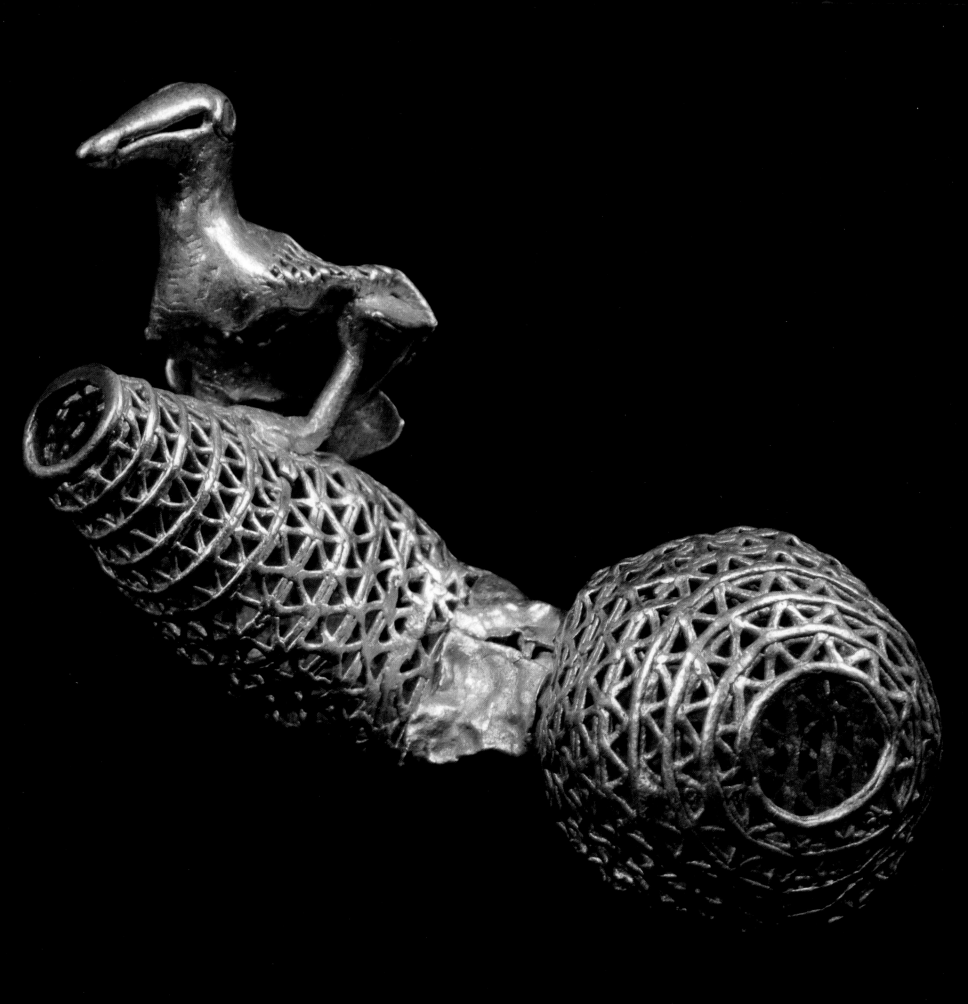

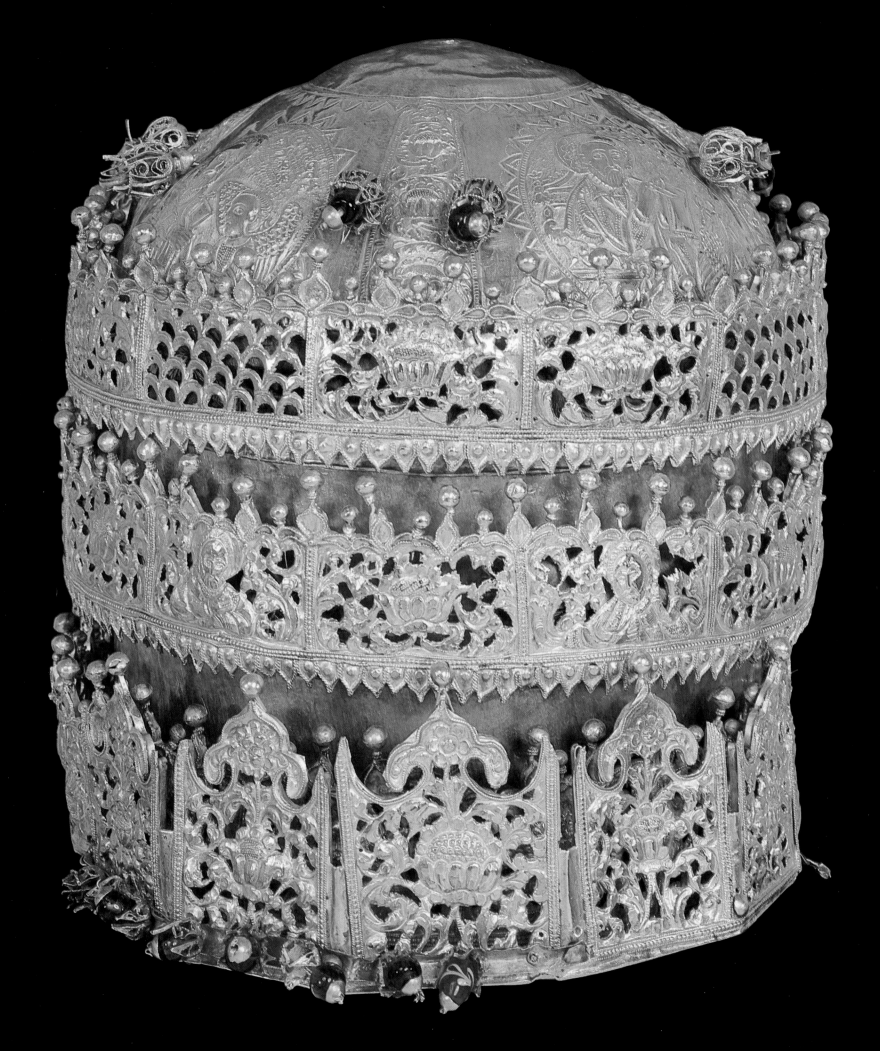

Japan/China/India/Burma

In the thirteenth century, Marco Polo spent seventeen years at the court of Kublai Khan in Peking. He watched the Khan gathering riches: "On New Year's Day, all the provinces, all the princes, all the nobles of the empire sent presents to the Khan.... He received on this day 100,000 horses, 5,000 elephants. They have gold-embroidered blankets and are brought to court in long processions. On their backs, the creatures carry chests filled with golden and silver vessels. They are followed by camels, and the long train of subjects,

Sword dance in Burma.

who wish their lord good fortune...."
Still, the Chinese, unlike the gold-obsessed, gold-hoarding Indian princes,

were never blinded by the dazzle of gold. On the contrary. They treated it together with silver as a pure means of payment, so that even before Marco Polo's arrival they had a paper currency. Marco Polo was astounded to note: "When the great mass of paper money is put into circulation throughout the empire, no one would dare refuse to accept it as payment.... Anyone wishing to have large amounts of gold or silver goes to the mint, where he can turn in his paper money and get the same value in gold...."

Standing figure from Japan, c. 1400, 65.5 cm. high. Museum of East Asiatic Art, Cologne, Germany.
The sculpture shows Bodhisattva Seishi, one of the two companions of Buddha Amida.
The depictions symbolize the arrival of the Buddhist deity to lead a dead believer to the
"Paradise of the West". The figure is made of wood with an enamel coat and gilt.
It comes from a temple near Nara.

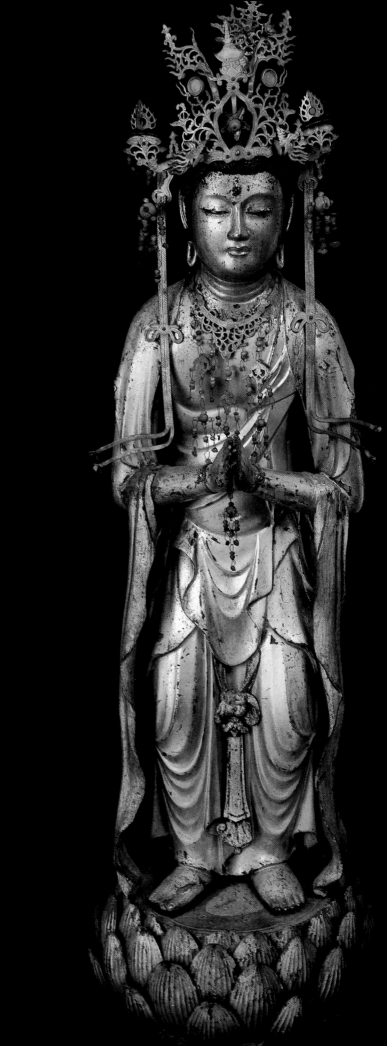

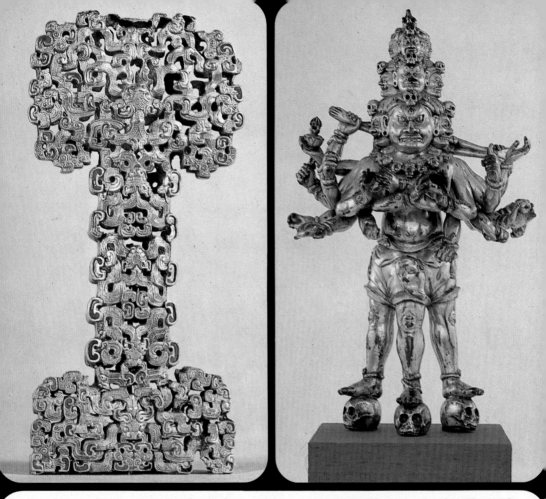

Dagger handle from China, 4th cent. B.C., 11.1 cm. long. British Museum, London, England.
The shapes of the loops and coils of the hollow handle recall winged dragons.
This unique work dates from the late Chou era.

Figure from China, Yuan dynasty (1279–1368), 45.5 cm. high. British Museum, London, England.
This "figure of Dharmapala" of gilded bronze was meant to protect believers against demons.

Buddha figure from China, c. 1400, 61 cm. high. British Museum, London, England.
The Buddhist teachings, established in the fifth century B.C., spread from India,
their land of origin, to China and Japan.
Buddha, as this gilded bronze figure shows, was usually depicted in this seated position.

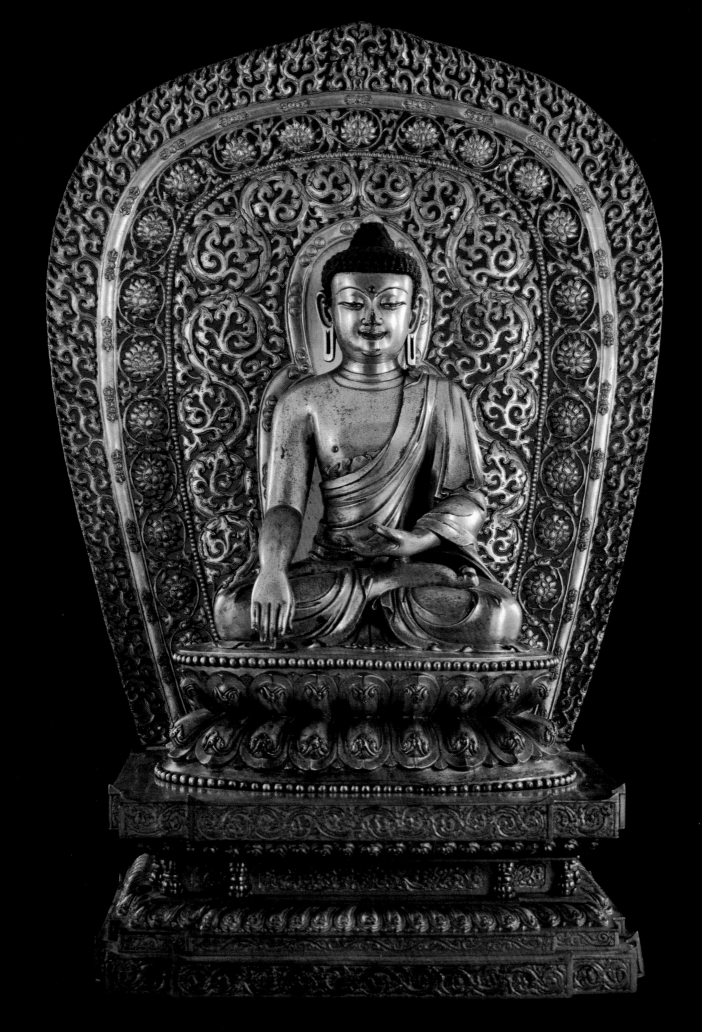

Pot and bowl from China, 16th cent., 32.5 cm. high (can), 50 cm. diameter (bowl).
British Museum, London, England.
Both pieces are worked in the cloisonné technique, which was probably introduced in eastern Asia
during the fourteenth century from Byzantium or the Near East.
This technique works as follows: Thin wire webs are soldered or attached to a metal base,
mostly gold or copper. The "cells" thereby obtained are filled with enamel paste
or enamel dust. The webs then look like outlines around the multi-colored areas.

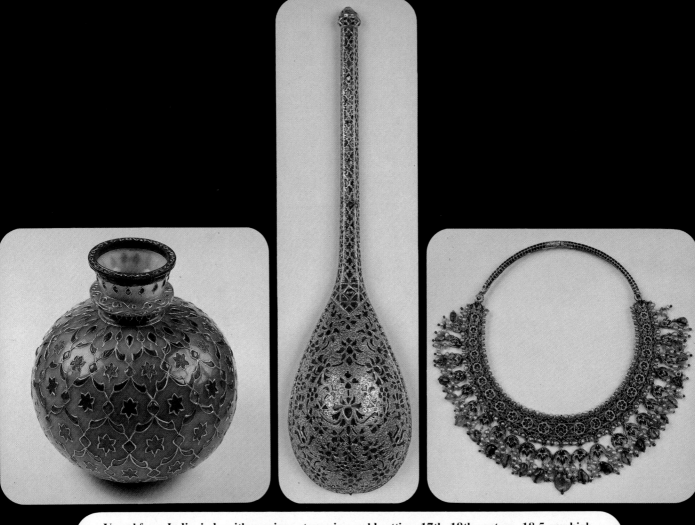

Vessel from India, jade with precious stones in a gold setting, 17th–18th century, 18.5 cm. high.
The Indians worked metals in a special way: they combined gold with steel, silver, or jade.
All the pieces shown here come from the Empire of the Great Moguls.
The Muslim dynasty of the Great Moguls ruled India from 1526 to 1851.

Ceremonial spoon from India, with rubies, emeralds, and one diamond, 16th–17th century, 18.5 cm. long.

Necklace from India, with emeralds, pearls, and enamel, 18th cent.

Vessel with lid (sacred goose) from Burma, 19th cent, 41 cm. high.
All from Victoria & Albert Museum, London, England.

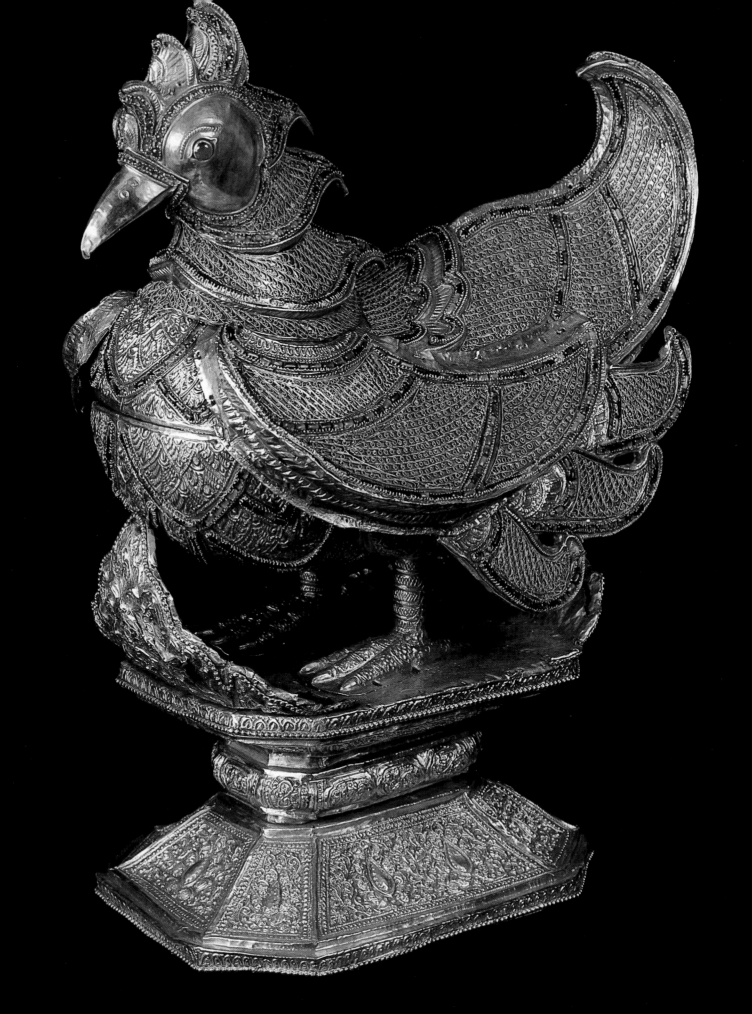

In the name of their king, the Spanish conquistadors stole the gold treasures of the Incas and Aztecs. The king never got to see a large part of the loot because he himself was robbed: the discovery of America initiated the great age of pirates. Cortez' huge shipment of gold to Emperor Charles V was captured by a French buccaneer.

The most infamous pirate of the sixteenth century was Francis Drake, an Englishman. On a secret mission for Queen Elizabeth, he plundered the

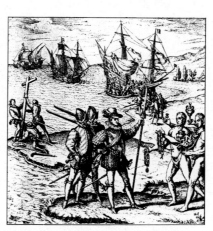

Columbus steps on American soil.

Spanish galleons of her brother-in-law Philip II. Once he even ventured into the town of Nombre de Dios on the coast of

Panama, where gold was sent to Spain. With his booty, Drake sailed across the Pacific and the Indian Ocean to Plymouth. The queen rewarded him by making him a knight.

However, the first gold transport from South America did arrive in Seville safe and sound. From the treasure that Columbus laid at his king's feet upon returning from his voyage, Spanish goldsmiths manufactured the altar baldachin of the cathedral of Toledo, then capital of Spain.

Mask from Chimu, Peru, 13th–15th century, 32 cm. wide. Rautenstrauch-Joest Museum, Cologne, Germany.
In ancient Peru, the dead, prior to their burial, were wrapped in cloths. Often masks of various materials were placed upon them or hidden in the cloths.
This mask of embossed gold foil was probably one of the grave furnishings of a well-to-do man.

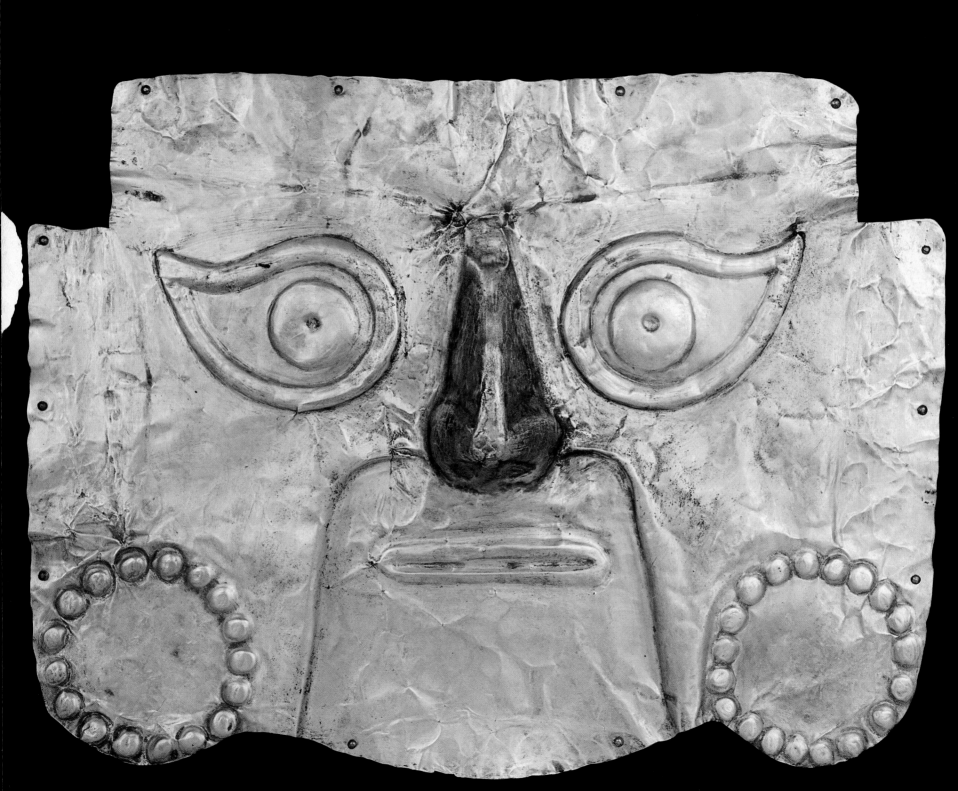

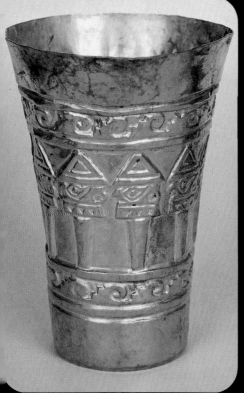
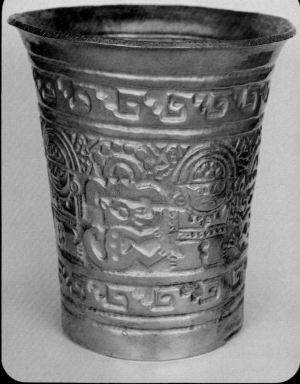
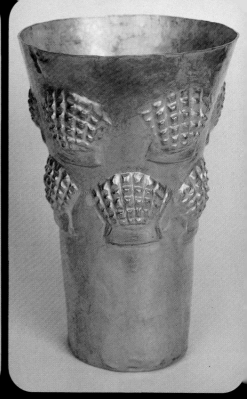

**Drinking cup from Peru, 11th–15th century, 13.6 cm. / 20.5 cm. / 15.2 cm. high.
Ludwig Collection in the Rautenstrauch-Joest Museum, Cologne, Germany.**
*Such golden cups were found frequently. We can therefore assume that the ancient Peruvians used
them not only for religious or liturgical purposes, but also in their daily lives.*

**Vessel from Chimu, Peru, 13th–15th century, 20 cm. high. Ludwig Collection in the
Rautenstrauch-Joest Museum, Cologne, Germany.**
*The gold vessel, originally painted, is assembled from individual parts. Black ceramic vases
of the same form have also been found.*

Following double page:
**Figurine double vessel from the Tiahuanaco Coast, Peru, 10th–13th century.
Dumbarton Oaks Museum, Washington, D.C.**
The standing mannikin has a monkey on one shoulder, a bird on the other.

**Figurine vessel from Chimu, Peru, 14th–15th century, 14.5 cm. high. Ludwig Collection in the
Rautenstrauch-Joest Museum, Cologne, Germany.**
*Like many Peruvian gold objects, this bird-shaped vessel was once painted.
Traces of a light red are still discernible on the bill.*

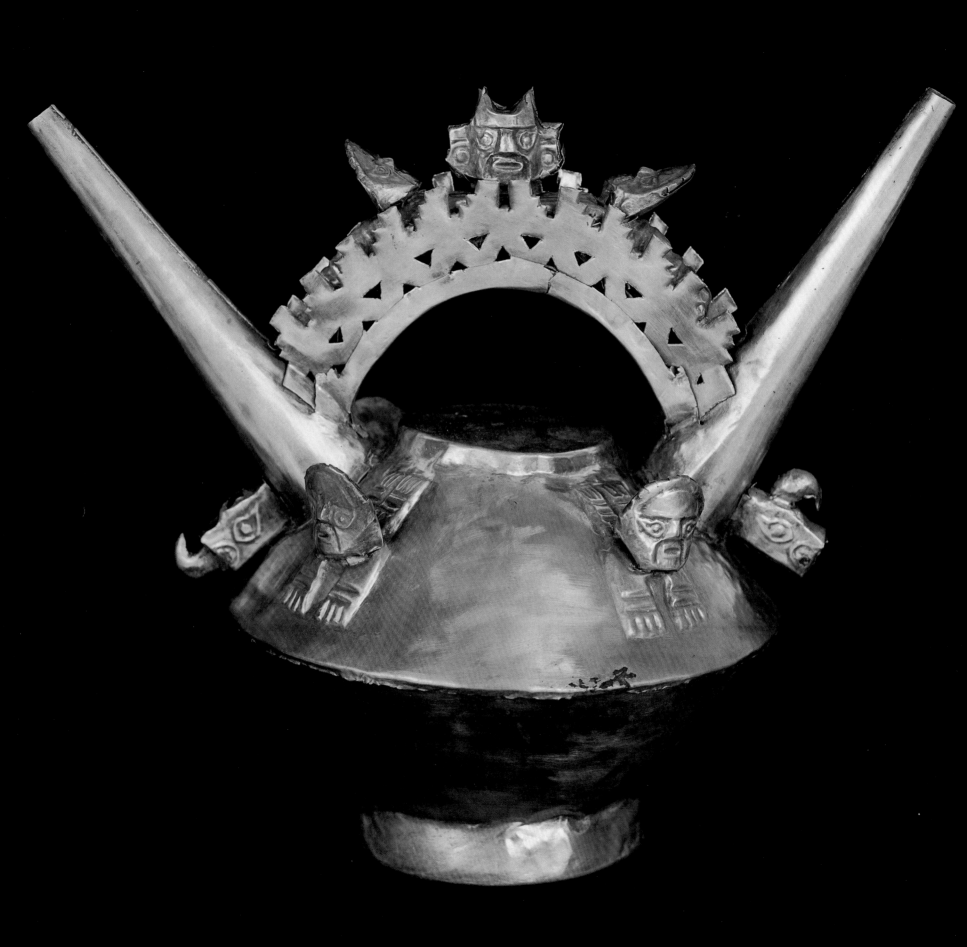

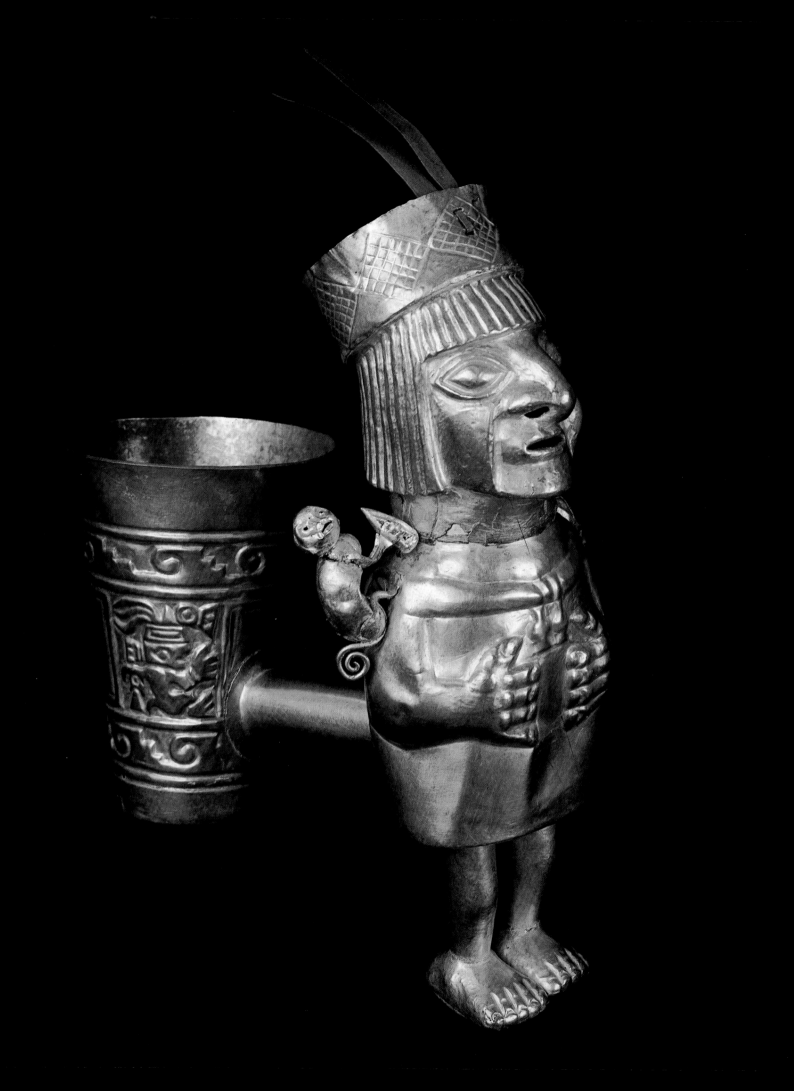

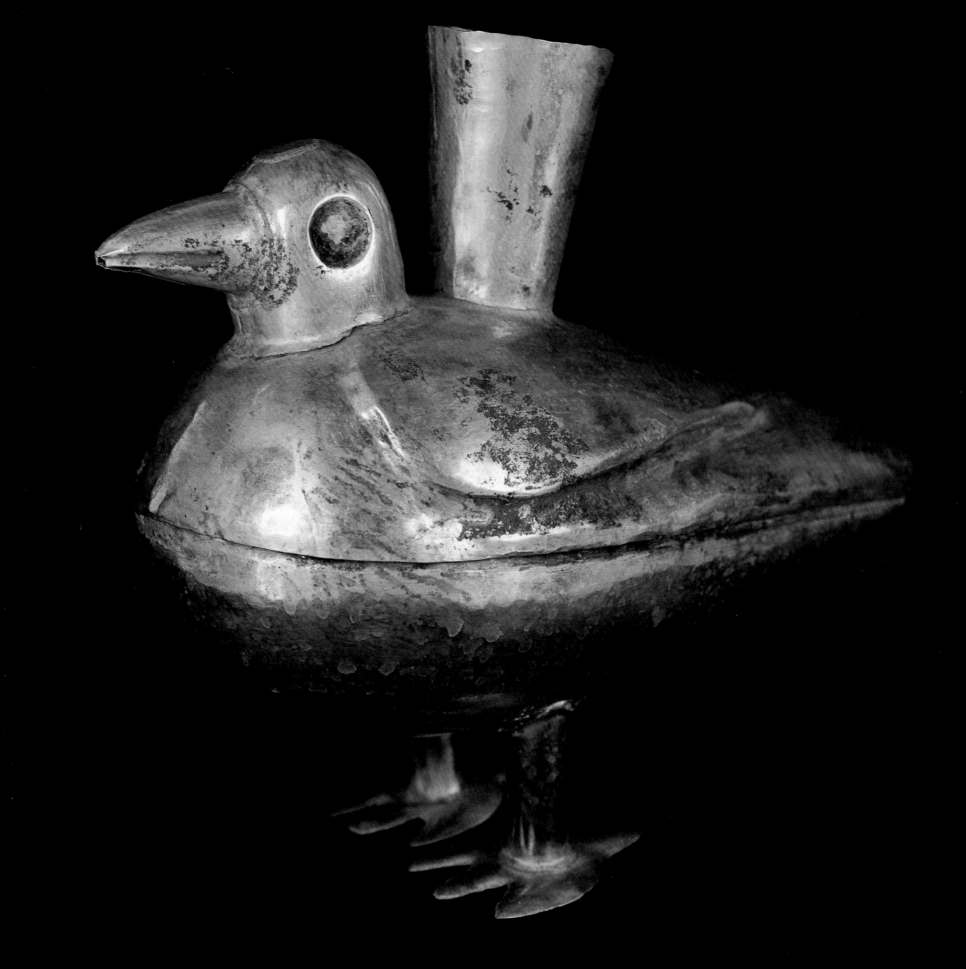

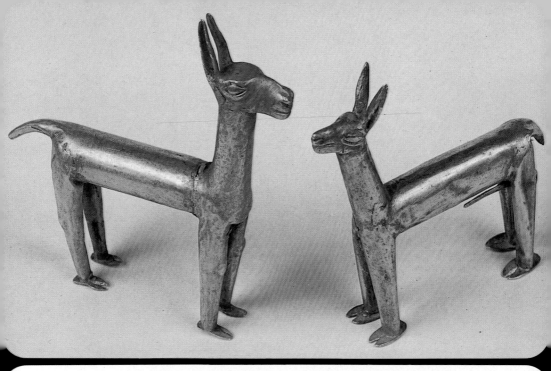

**Llamas from Peru, 15th–16th century, 4.4/5.4 cm. long, 5/5.9 cm. high.
Museum für Völkerkunde, Hamburg, Germany.**
*Such figures were used as sacrificial gifts to increase the fertility of the llama herds.
Even today, small stone llamas are used for such purposes.*

Female figure from Peru, around 1500, 24 cm. high. Museum of the American Indian, New York City.
„*This figure was probably dressed originally. It weighs over one pound. It is probably one of the
few pieces that weren't melted down by the Spanish conquerors during the
sixteenth century. The figure was obtained in Panama in 1916. Its earlier history is unknown.*

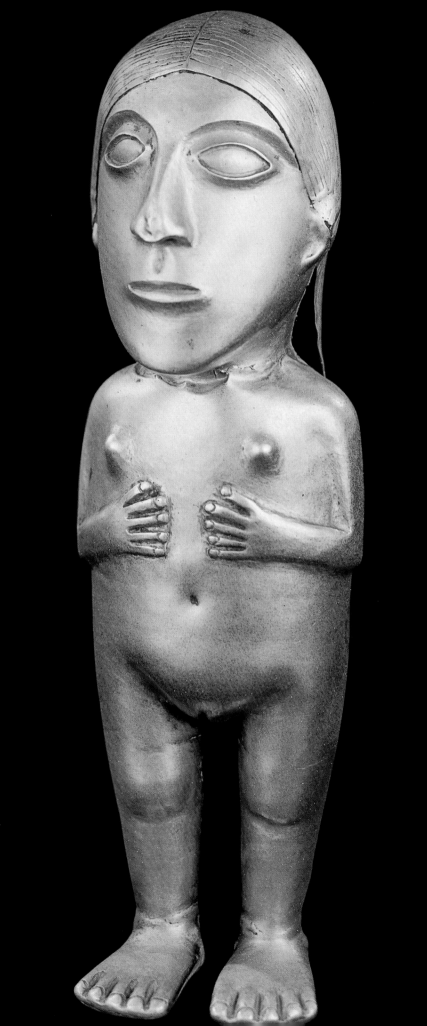

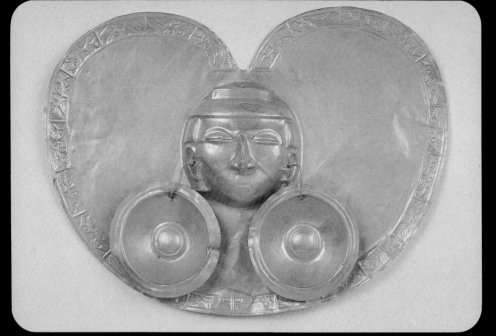

Breastpiece from Calima, Colombia, 12th–15th century, 26 cm. wide. Museo del Oro, Bogotá, Colombia.
Shell from Calima, Colombia, 12th–15th century, 28.5 cm. long. Museo del Oro, Bogotá, Colombia.
Nose ornament from Calima, Colombia, 12th–15th century, 16 cm. long.
Museum of Primitive Art, New York City.
Heart-shaped, richly ornamented breastplates, conch forms, and decorated nose ornaments
are typical of the oldest goldsmithery in Colombia–the Calima style.

Following double page:
Three pendants from Tolima, Colombia, 11th–13th century, 14.8–19 cm. high.
Museo del Oro, Bogotá, Colombia.
Human and animal features are united in these strongly stylized cast figures.
Breastplate from Tolima, 11th–13th century, 23.5 cm. high. Museo del Oro, Bogotá, Colombia.

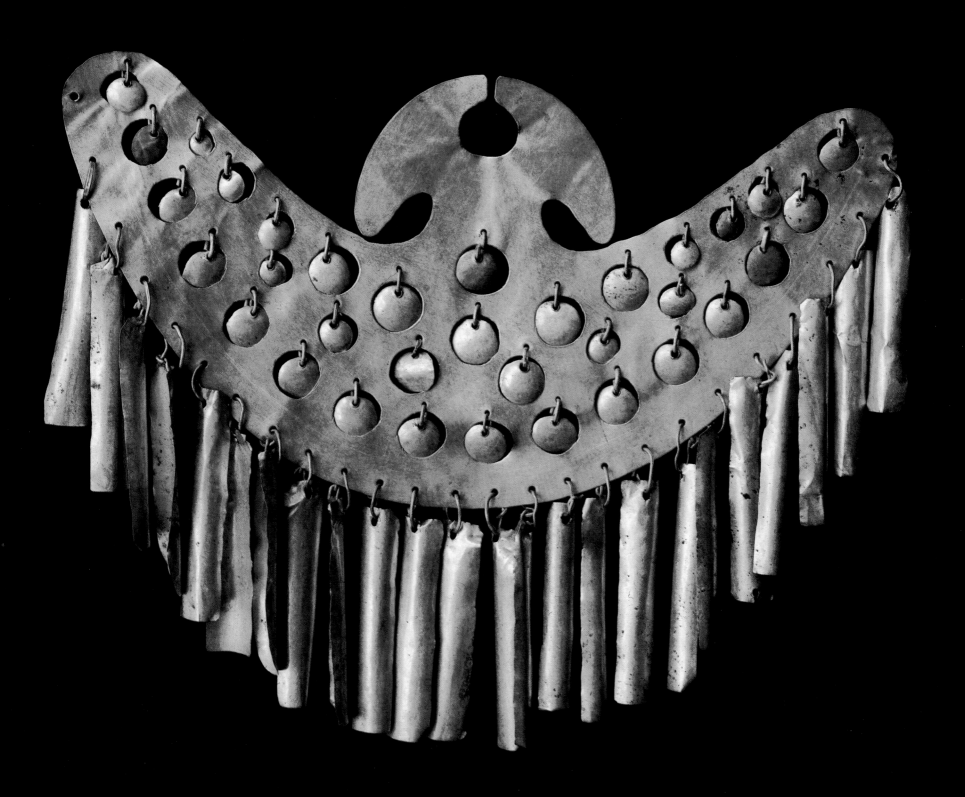

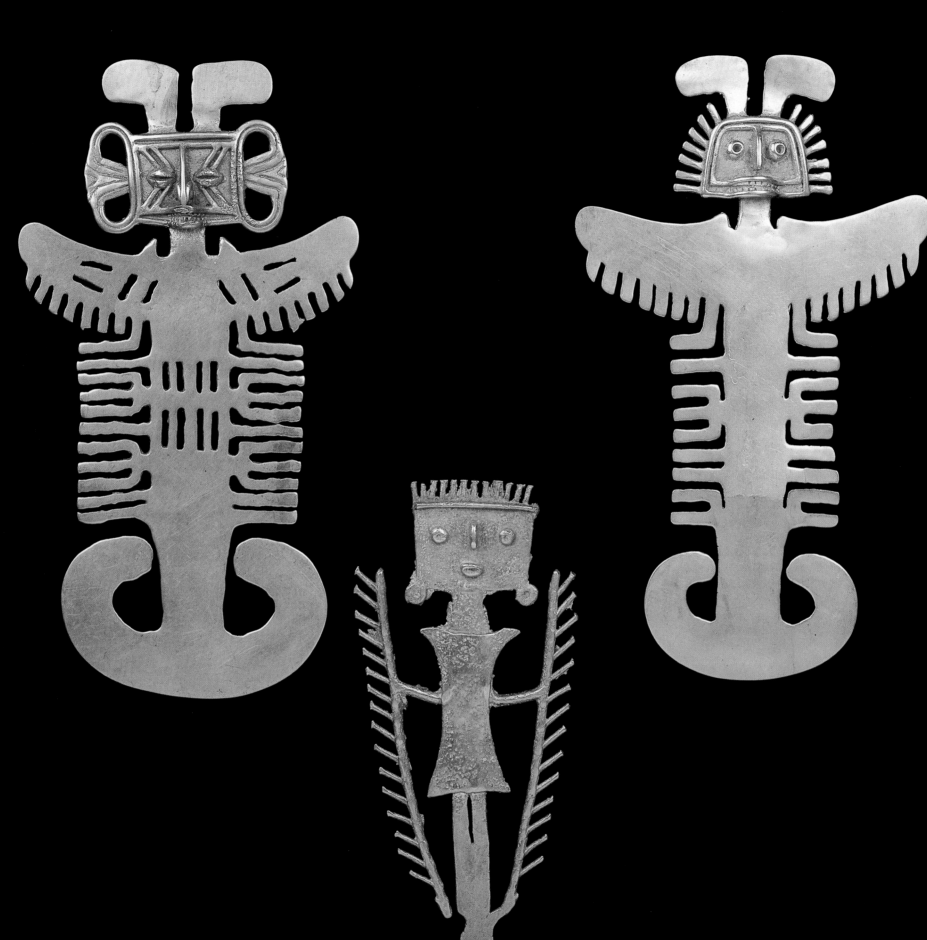

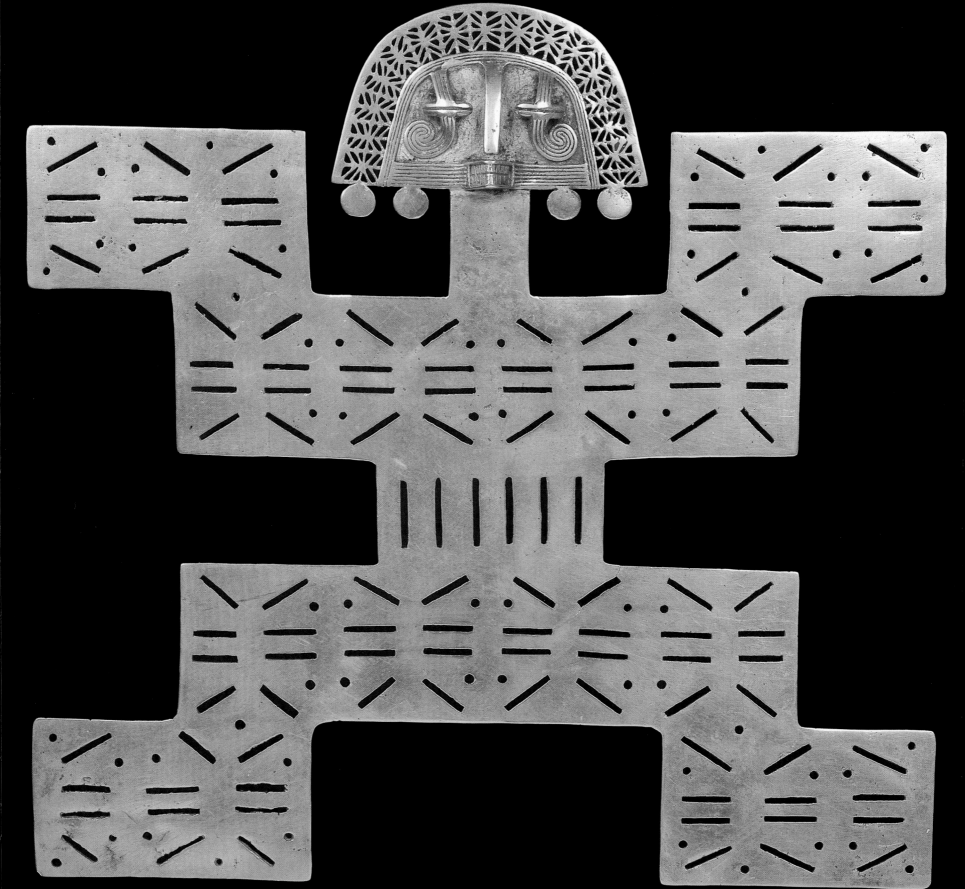

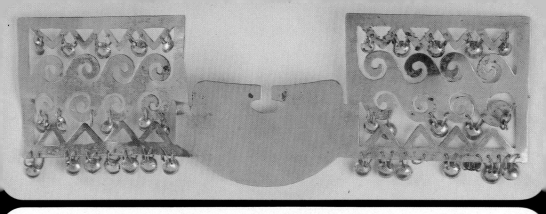

Nose ornament from Nariñor, Colombia, 13th–15th century, 18.3 cm. long.
Museo del Oro, Bogotá, Colombia.
Breastpiece from Muisca, Colombia, 12th–16th century, 21 cm. high. Museo del Oro, Bogotá, Colombia.
The breastpiece is made of tumbaga, a copper-gold alloy. This Indian invention had two advantages:
tumbaga was harder than the pure metals and it had a lower melting point. A certain plant
concoction was used to clean the copper away from the surface. This gave the piece a warm gold tone.

Following double page:
Human figures from Muisca, Colombia, 12th–16th century, 8–14 cm. high.
Museo del Oro, Bogotá, Colombia.
These "tunjos", oblations with geometric features, are typical of Muisca art (near modern-day Bogotá).
There is an amazingly meticulous wealth of details
(facial features, weapons, limbs) with the aid of wires that were cast with the piece.

Raft from Muisca, Colombia, 12th–16th century, 19.5 cm. long. Museo del Oro, Bogotá, Colombia.
The most beautiful piece ever found in Colombia: the raft mentioned in the legends of Eldorado.
Once a year, the chief of the Chibchas, powdered with gold and hung with gold jewelry,
floated into Lake Guatavita on a gold-covered raft to sacrifice gold and emeralds to the gods.

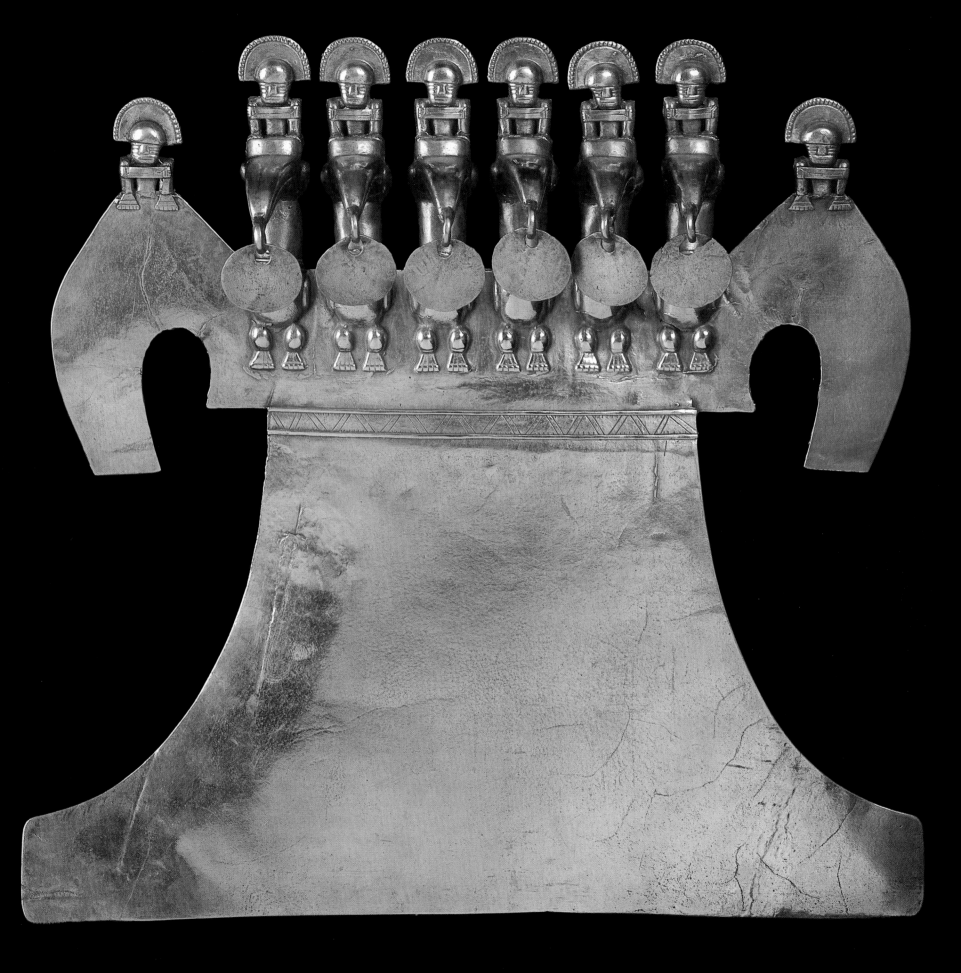

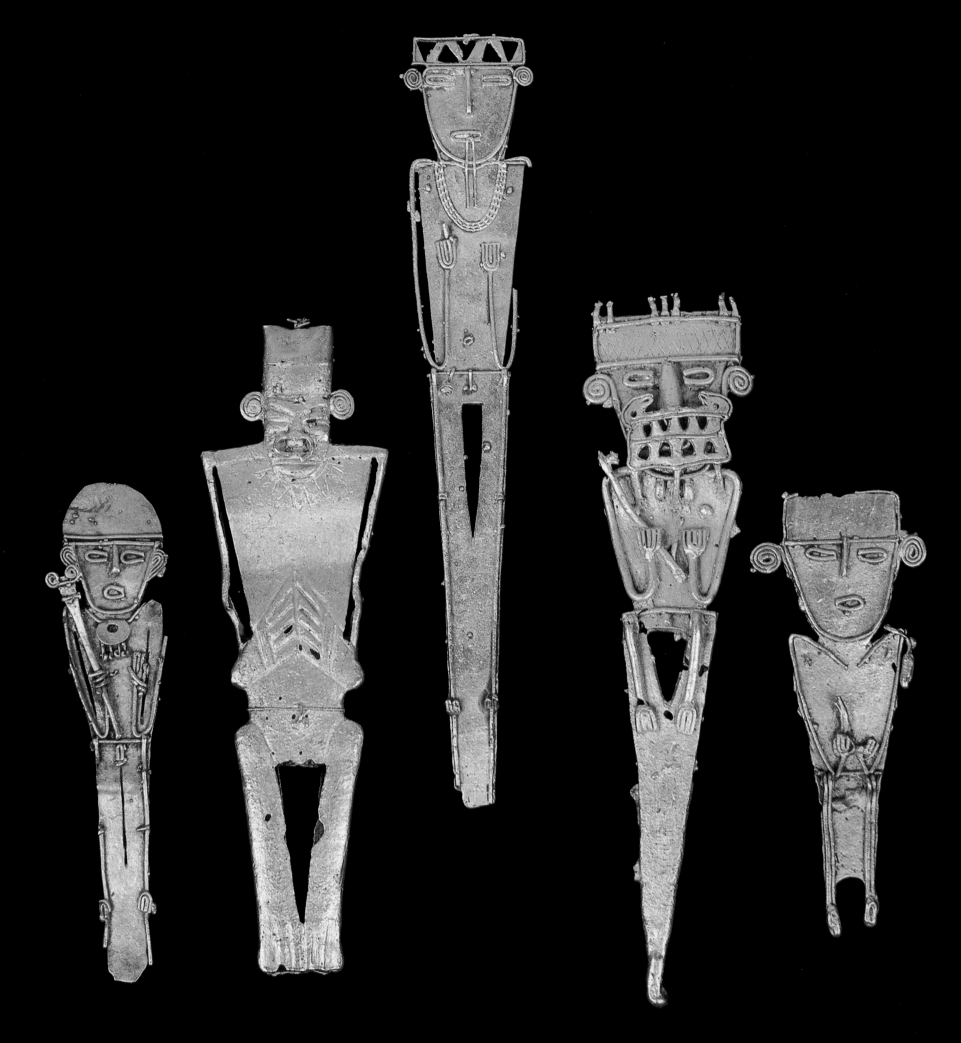

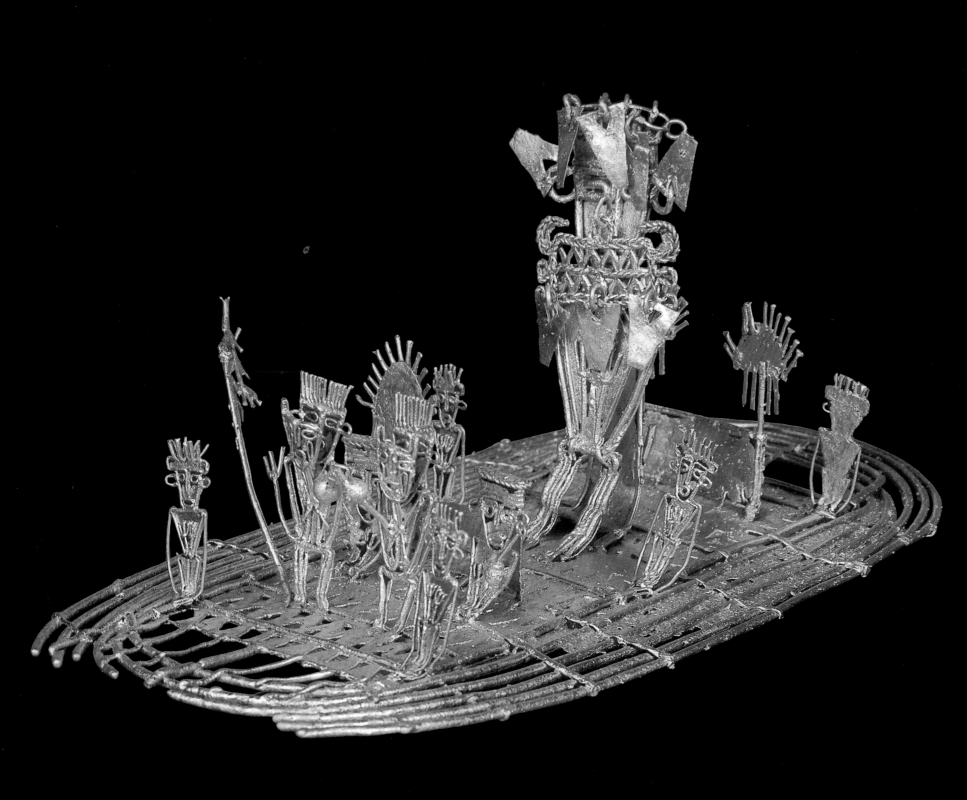

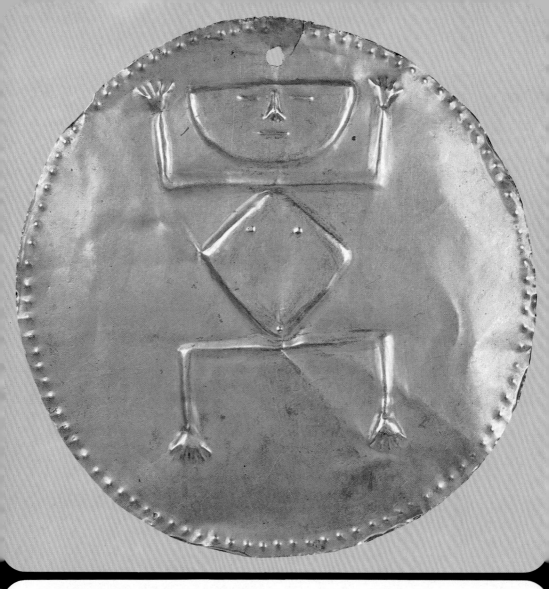

Breastplate from Quimbaya, 13th–15th century, 14.5 cm. diameter. Museo del Oro, Bogotá.
Pendant from Quimbaya, Colombia, 13th–15th century, 11 cm. high. Brooklyn Museum, New York City.
When the Spaniards conquered Colombia, the Quimbayas, who lived in the middle Cauca Valley,
were famed as the best goldsmiths. There is no technique of metal processing that was not
known in South America. The oldest extant examples of goldsmithery date from the Chavin culture
(Peru c. 400 B.C.). Even platinum was worked,
though the bellows was unknown to the people of South America.

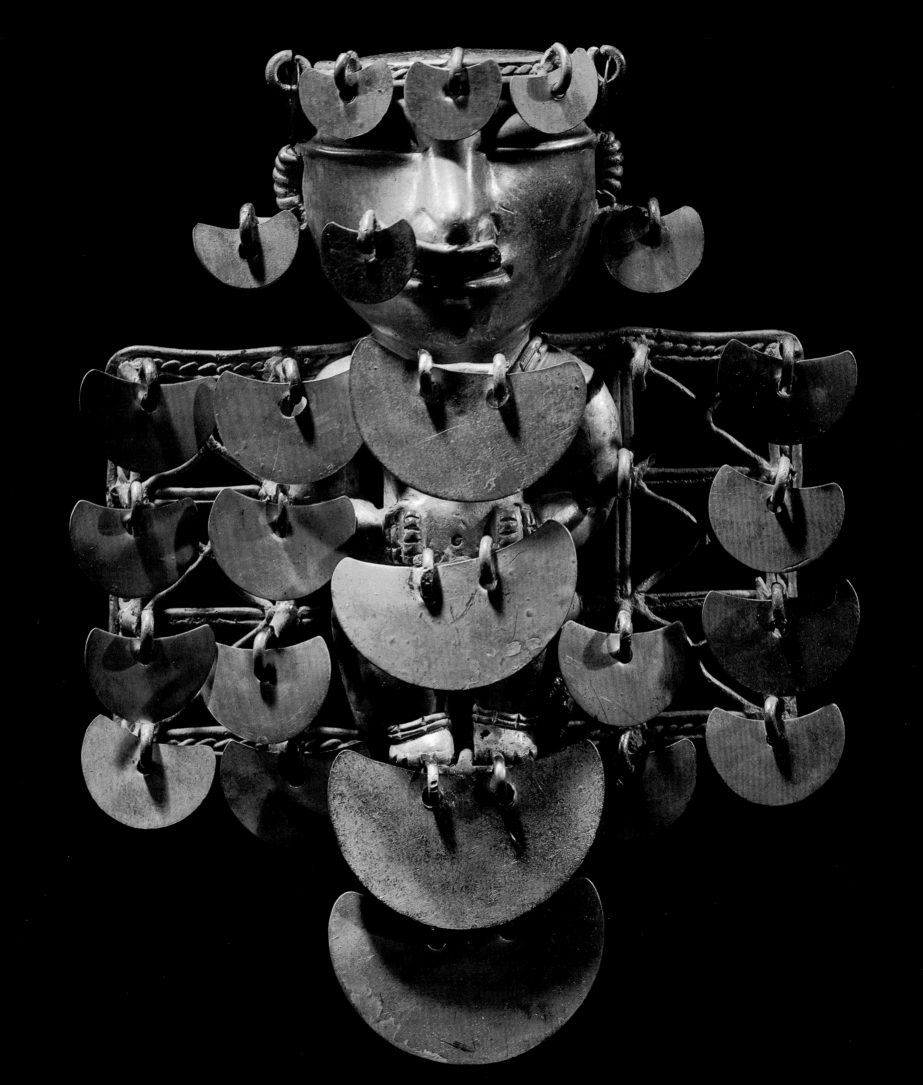

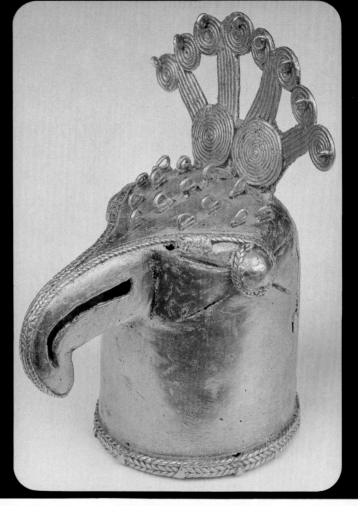

**Eagle's head from Colombia (Sinu), 12th–16th century, 11.5 cm. high.
Museo del Oro, Bogotá, Colombia.
Owl from Colombia (Sinu), 12th–16th century, 12.5 cm. high.
Museum of Primitive Art, New York City.**

Following double page:
**Birds from Colombia (Sinu), 12th–16th century, 20 cm. long, 508 gr.
Museum of the American Indian, New York City.**

These golden animals were perched on the tips of wooden ceremonial wands. Rich grave furnishings of the northern Colombia Sinus, especially lovely animals, were largely melted down by the Spaniards. Precise information on the destroyed art works was given in the records of a royal mintmaster.

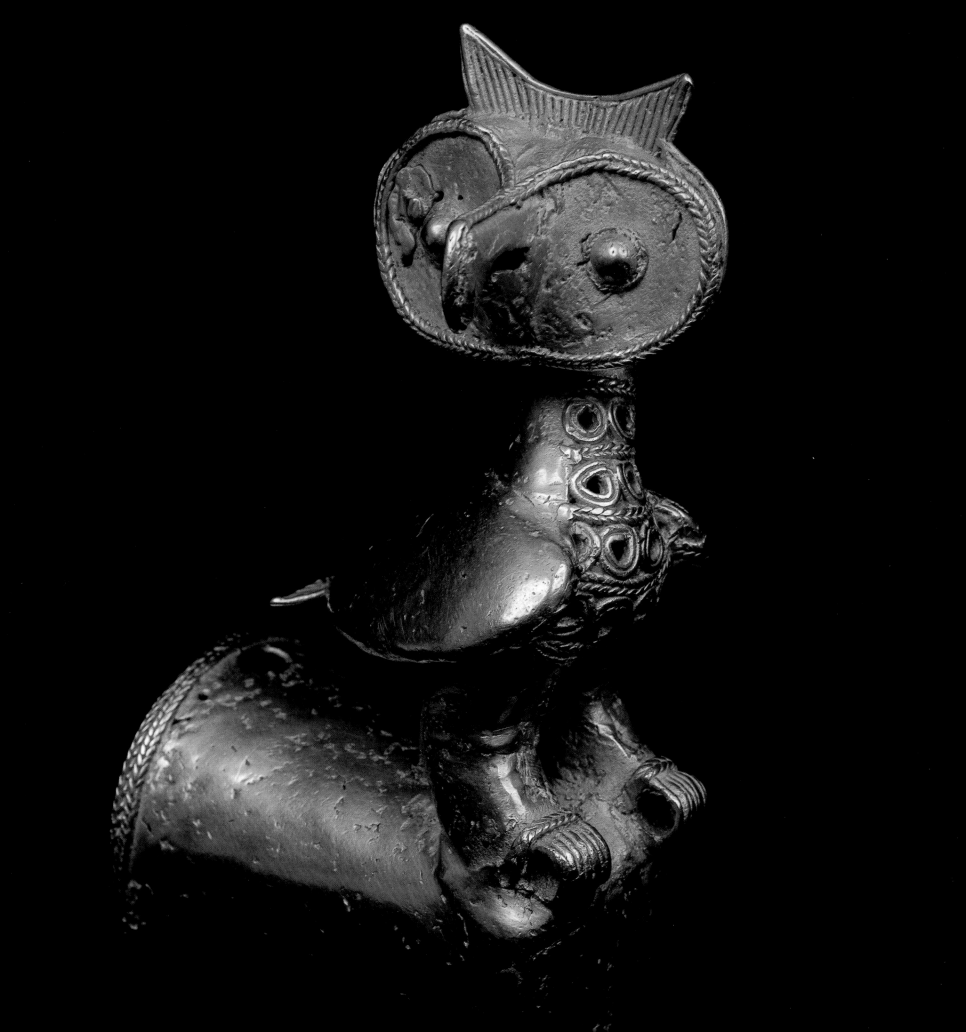

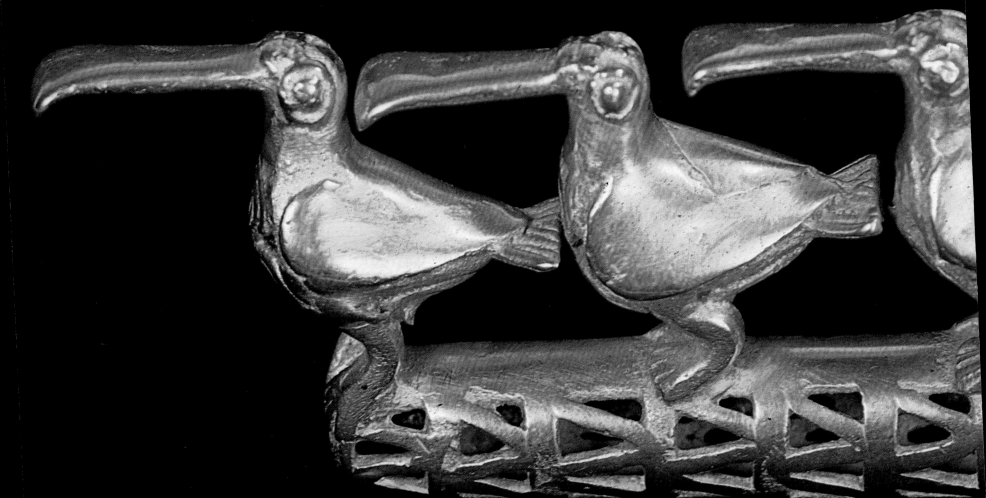

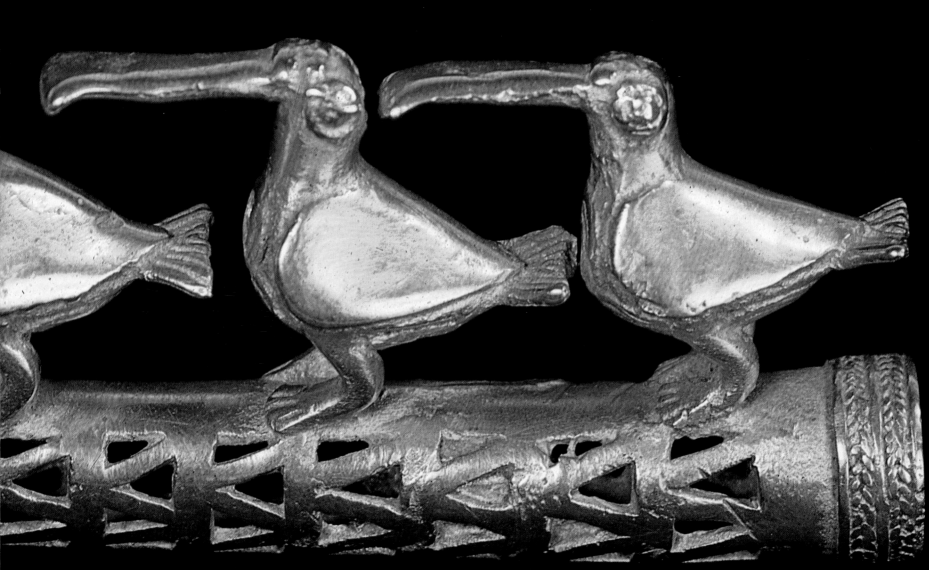

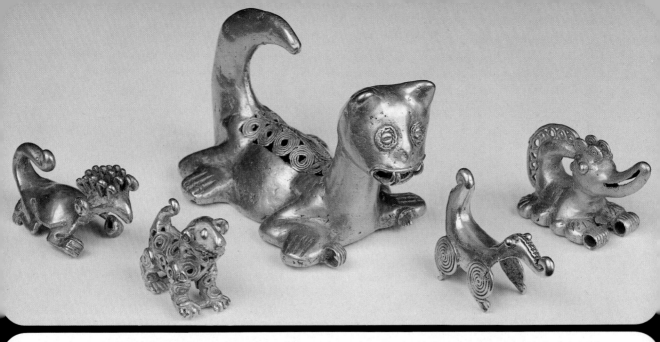

Animals from Colombia (Sinu), 12th–16th century. Jaguar: 12 cm. long. Museo del Oro, Bogotá, Colombia.
*The stylized animal depictions from Colombia, along with those from Panama and Costa Rica,
are the loveliest and most imaginative ever found.*

Pendants from Colombia (Tairona), c. 1500, 12.7 cm. high. Museo del Oro, Bogotá, Colombia.
*A characteristic feature of the goldsmithery of the Taironas is the depiction of birdlike creatures.
"Tairona" was supposedly an earlier name for the goldsmiths.*

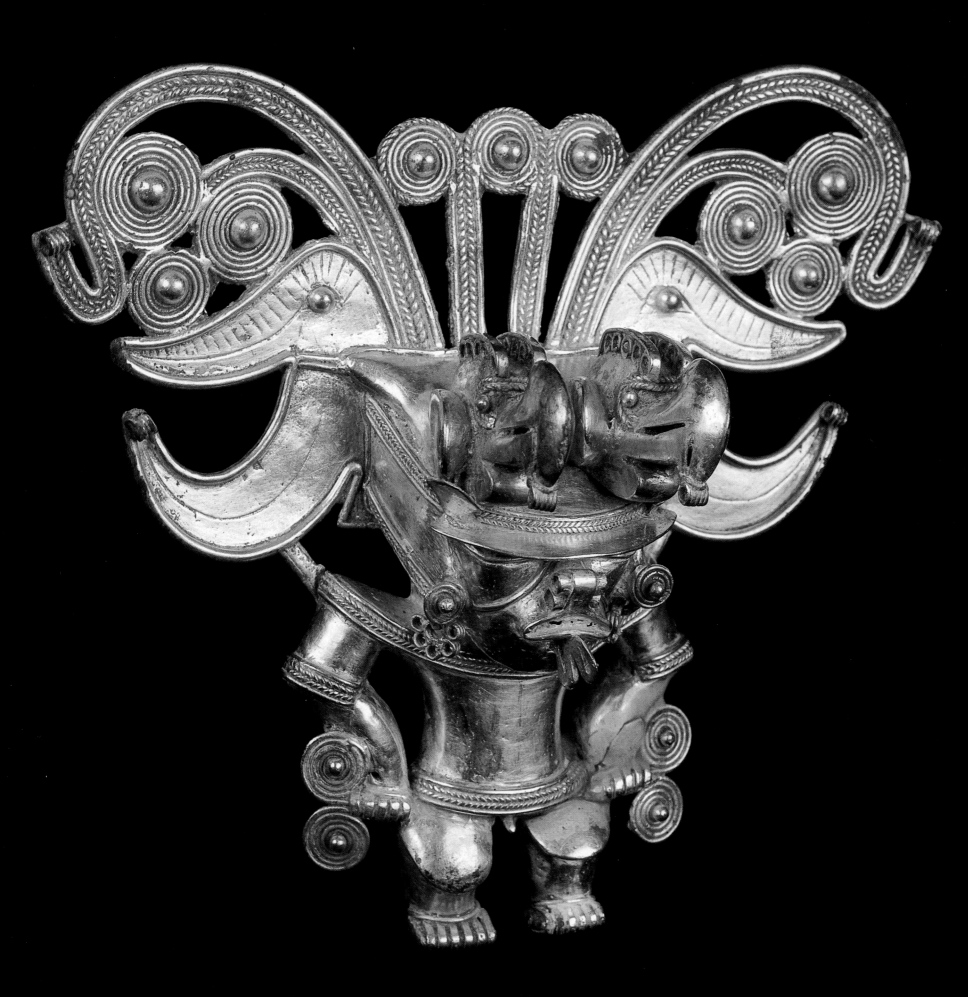

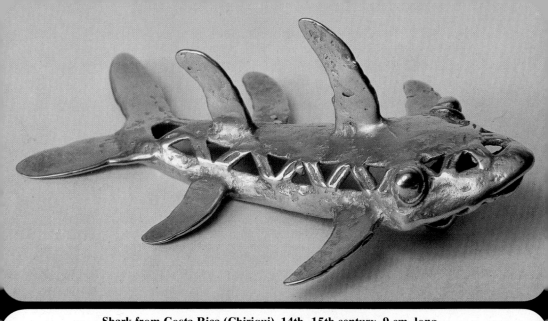

Shark from Costa Rica (Chiriqui), 14th–15th century, 9 cm. long.
Museum of Primitive Art, New York City.
Frog, crocodile, gecko, and turtle from Panama (Veraguas), 12th–14th century, original size.
Dumbarton Oaks Museum, Washington, D. C.

Following double page:
Crocodile-god pendant from Costa Rica (Chiriqui), 14th–15th century. 18 cm. high.
Museum of Primitive Art, New York City.
Frog necklace from Panama (Veraguas), 11th–16th century. Frogs: 3.1 cm. long, 2.8 cm. wide.
Museum für Völkerkunde, Hamburg, Germany.
Frogs as fertility symbols play a major role in the mythology of many peoples in the southern part of Central America. That is why images of these animals were often used as oblations.

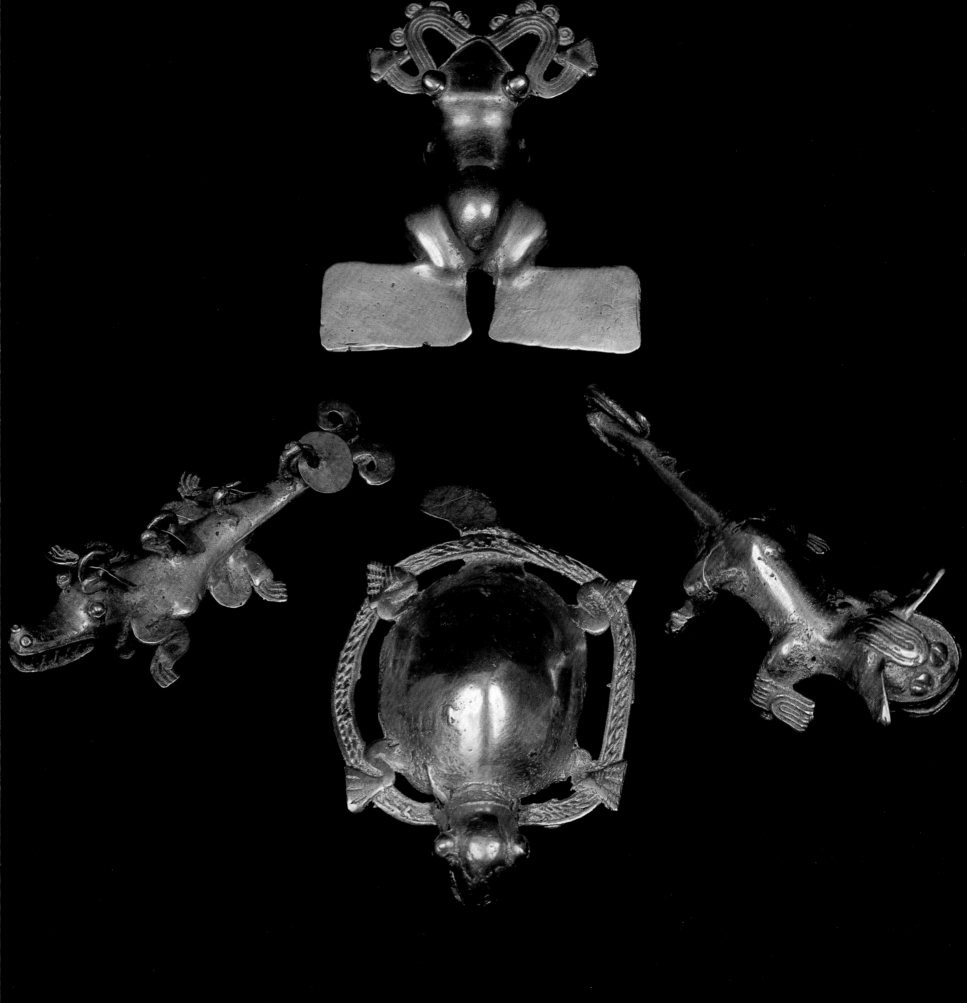

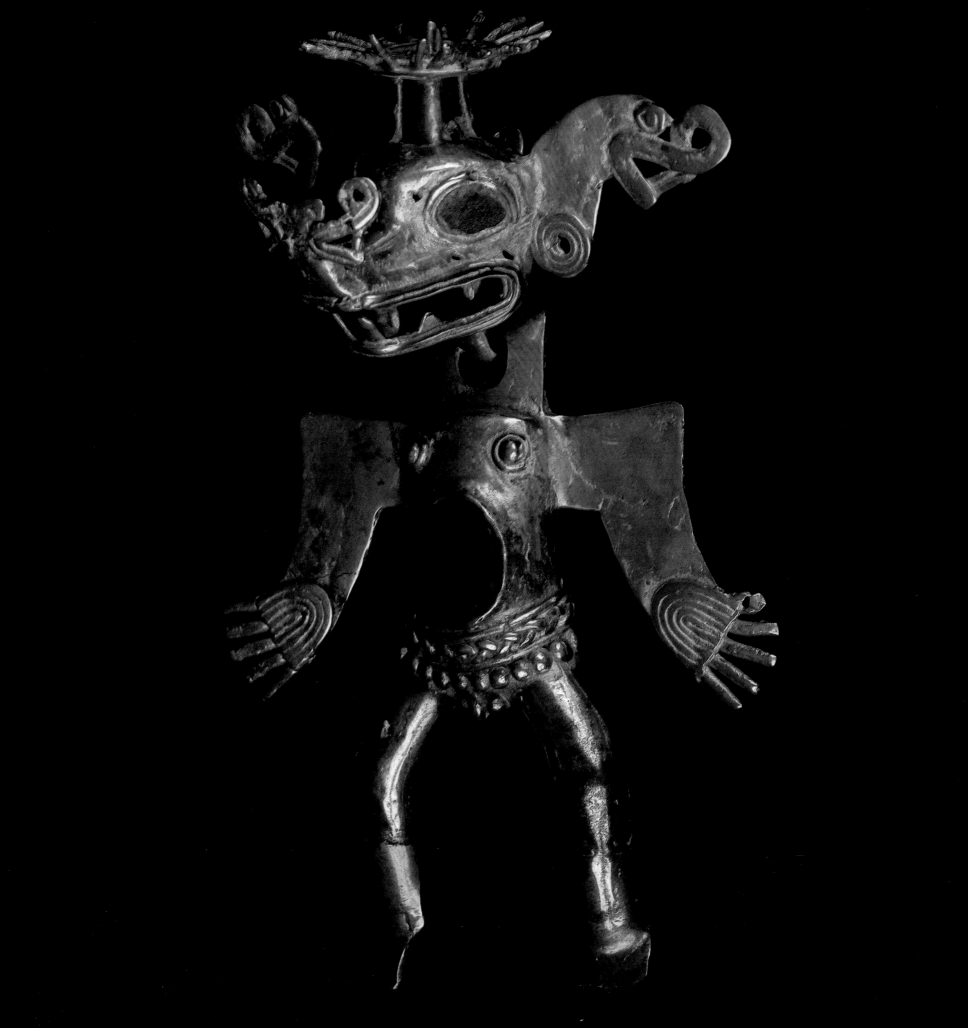

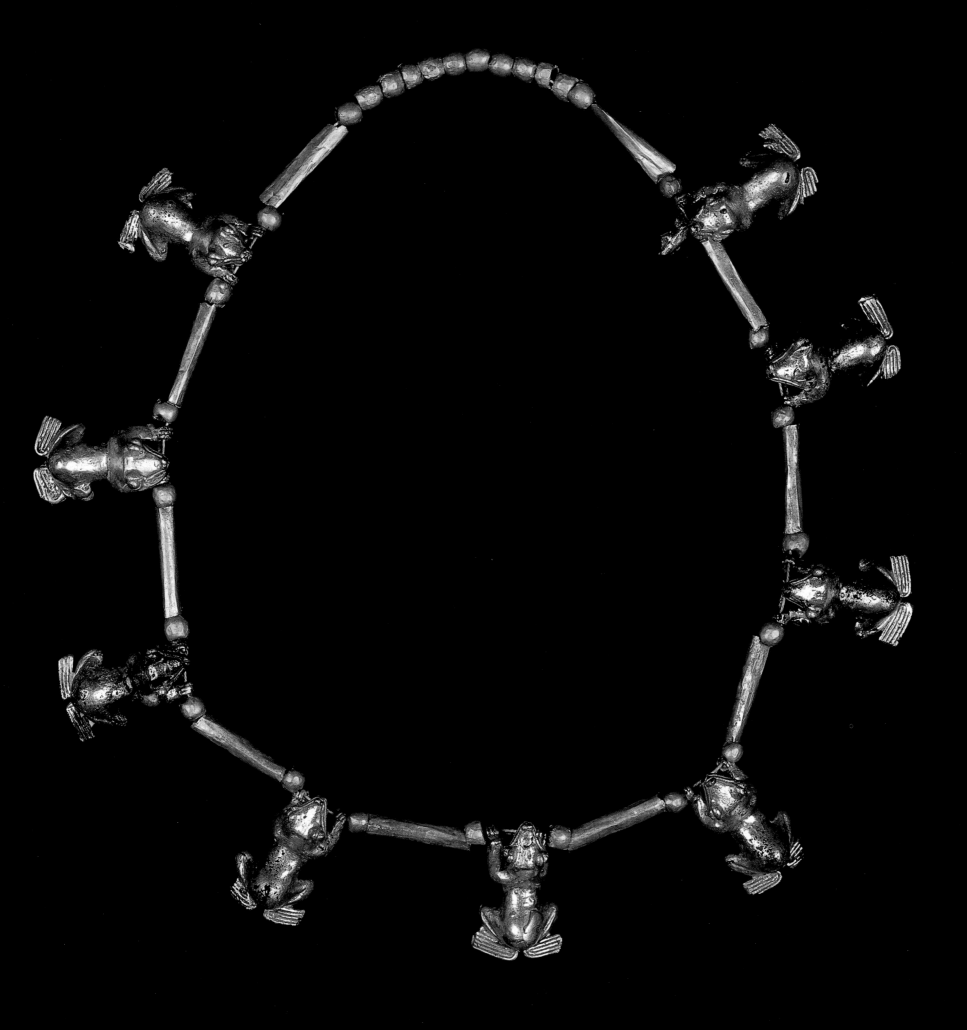

Religions

For medieval Christianity, gold was the symbol of eternity and light. It had no material value, but it visually represented the religious value of the things it was linked with: gold crowns, altars, reliquaries, and gospel books. Byzantine theologians, Irish monks, German nuns–they all spent decades copying Bibles and painting illustrations and initials on golden backgrounds. The finished work was bound in gold and set with jewels. The evangeliaries were not just meant for kings and emperors. Every monastery and every cathedral needed a relic to document the presence and the mission of God. And likewise, a costly gospel was a visible proof of how greatly the word of the Lord was venerated. This tradition of the medieval Church was a godsend for posterity. Thanks to the industry of monks, we now posses countless examples of the high art of Christian book illumination.

Bible illuminator in the Middle Ages.

Reliquary of the Magi, Cologne, Germany, 1181–1230, 220 cm. long, 153 cm. high, 110 cm. wide. Cathedral treasury, Cologne, Germany.
The reliquary was designed and generally executed by Nicholas of Verdun. It is the largest and most valuable piece of medieval goldsmithery. Next to the relics of the three Magi, the shrine contains the remains of Gregory of Spoleto as well as St. Nabor and St. Felix. Over 300 ancient gems and cameos, more than a thousand precious stones, countless pearls and colored enamel adorn the ornaments and figures, which are worked in an outstanding technique of goldsmithery.

Following double page:
Rose from Avignon, early 14th century, 60 cm. high. Musée de Cluny, Paris.
At Eastertime, the popes would give golden roses to influential personalities. This Rose d'or de Bâle is the oldest known example. It was given to a Basel bishop by Pope Clement V, who resided in Avignon as of 1309. The filigree knot is probably one hundred years older than the rose, which was executed by an Italian goldsmith in Avignon.

Diamond monstrance from Vienna, 1699, 82 cm. high, 26 lbs. 4 oz. Loreto Church, Prague.
The monstrance was executed by the goldsmith Kühnischbauer and the jeweler Stegmayr after a design by J. B. Fischer von Erlach. It is adorned with 6,222 diamonds.

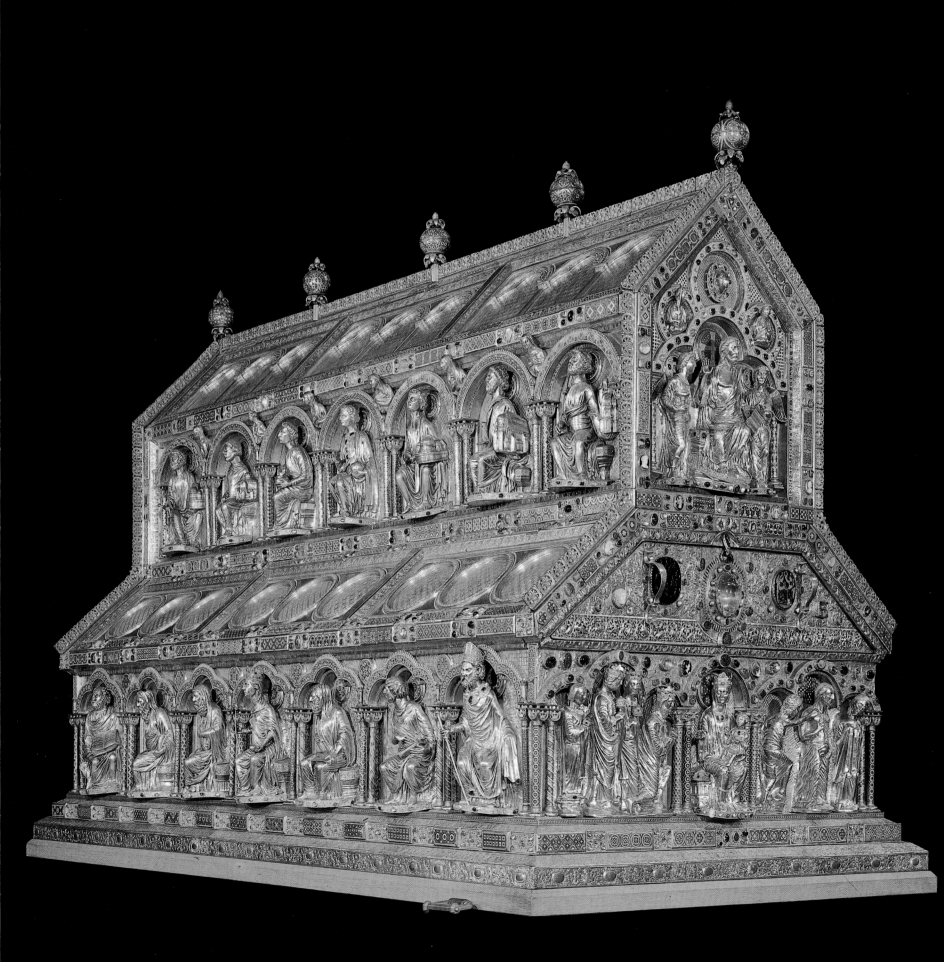

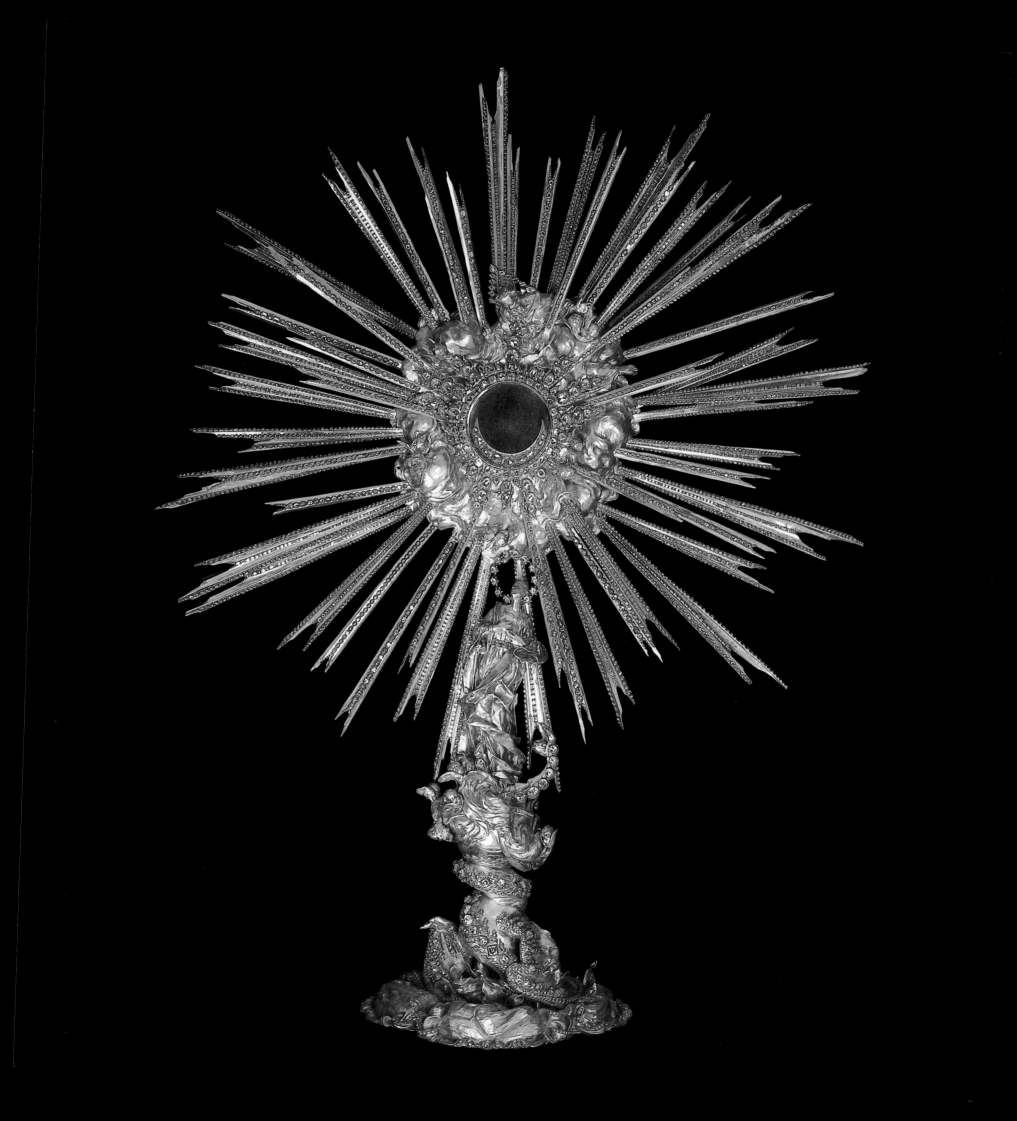

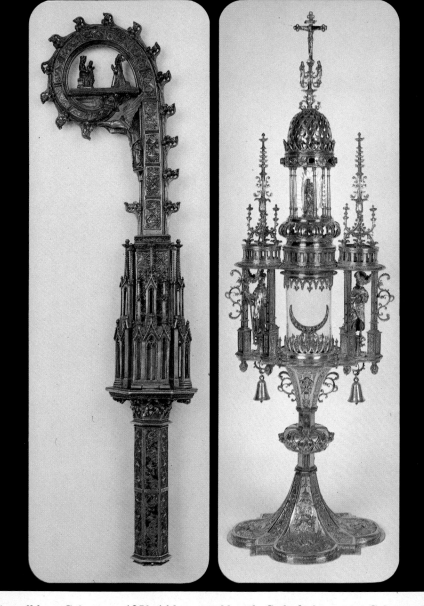

Bishop's staff from Cologne, c. 1350, 146 cm. total length. Cathedral treasury, Cologne, Germany.
*The crook of the late Gothic staff (of gilded silver) seems particularly precious because of the
transparent colored enamel.*

**Cylindrical monstrance from Aachen, Germany, 1619, 77.5 cm. high. Church parish
of St. Johannes-Baptist. Aachen-Burtscheid, Germany.**

Gospel from Bamberg, early 11th century, 24.2 × 33.4 cm. Bavarian State Library, Munich, Germany.
*The binding of this gospel, created for Otto III (983–1002), is densely set with pearls and jewels.
A close look reveals a cross formed by the emphasis of the vertical and horizontal axes.*

Following double page:
**Luxury Koran from Turkey, 16th century, 37 × 51 cm. Stiftung Preussischer Kulturbesitz,
Berlin, Germany.**
This Koran supposedly belonged to the mausoleum of Sultan Selim II in Istanbul, Turkey.

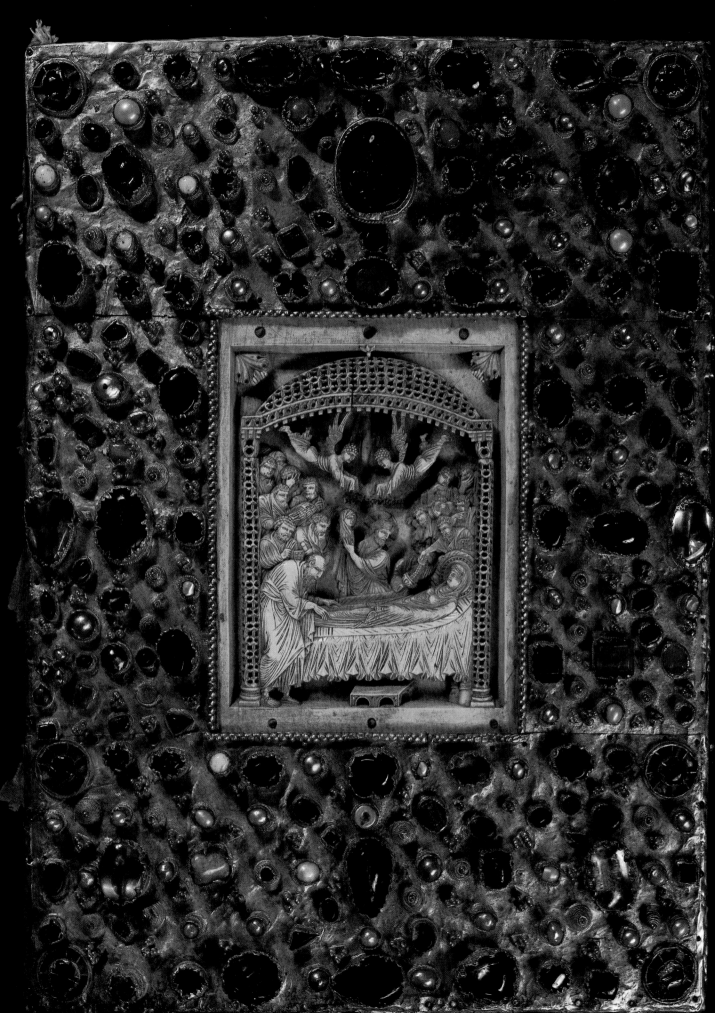

Coins

The richest and most influential private person of the sixteenth century was Jakob Fugger.

The Fuggers had earned their millions as weavers, dyers, and finally textile dealers in Augsburg, Germany. In 1504, the head of the family, Jakob Fugger, was knighted by Emperor Maximilian I. A short time later, he was made an imperial counselor, which simply meant that he was now the exclusive creditor of the imperial house. And vice versa: the sovereigns became permanent debtors of the Fuggers, who hardly got back any of their loans. The war against Italy (1509) was financed by Jakob Fugger for Emperor Maximilian I with 170,000

Jakob Fugger, financier of emperors and kings.

gold ducats. In 1519, when two kings campaigned for the throne of the emperor in Frankfurt, Charles V of the House of Hapsburg won over Francis I of France.

Most likely, Charles V had used a large portion of the 300,000 guldens of election money (guaranteed by the Fuggers): Charles had doled it out among the electoral princes in the committee to strengthen their well-known dislike of the French ruler. Toward the mid-sixteenth century, most of the ruling houses of Europe owed money to the Fuggers.

The military campaigns of Philip II of Spain cost the Fuggers a fortune—over 4,000,000 gold ducats. Together with the emigration and expulsion of other religions, these wars contributed to the total bankruptcy of Spain. This terminated the role of the Fuggers as patrons of princes.

Gold coins. Coin cabinet in the Badisches Landesmuseum, Karlsruhe, Germany.
First row: Staters from Persia (Darius II, 425–405 B.C.), electron stater from Cyzicus in Asia Minor (c. 380 B.C.), stater from Macedonia (Alexander the Great, 336–323 B.C.), "rainbow bowl" (Celtic recoinage of a Macedonian coin, 2nd century B.C.).

Second row: Aureus from Rome with the image of Caesar (44 B.C.); gold medallion from Rome (Constantine II, 337–61); solidus minted in Marseille (Childebert the Adopted, 656–61); dirhem from Turkey (Abbassides, 9th century).

Third row: Ducat from Venice (Andrea Dondolo, 1343–64); gold gulden from the Electoral Palatinate (Friedrich the Victorious, 1449–76); gold shield from France (Philip VI, 1328–50); three-emperor thaler from Austria (gold impress of the ducat; Ferdinand I, 1556–64).

Fourth row: Rhine gold ducat from the Electoral Palatinate (Electoral Prince Karl Theodore, 1777–99); quadruple from South America (King Ferdinand VI of Spain, 1748); Rhine gold ducat from Baden (Grand Duke Leopold, 1832); double crown from the German empire (20 marks, 1873).

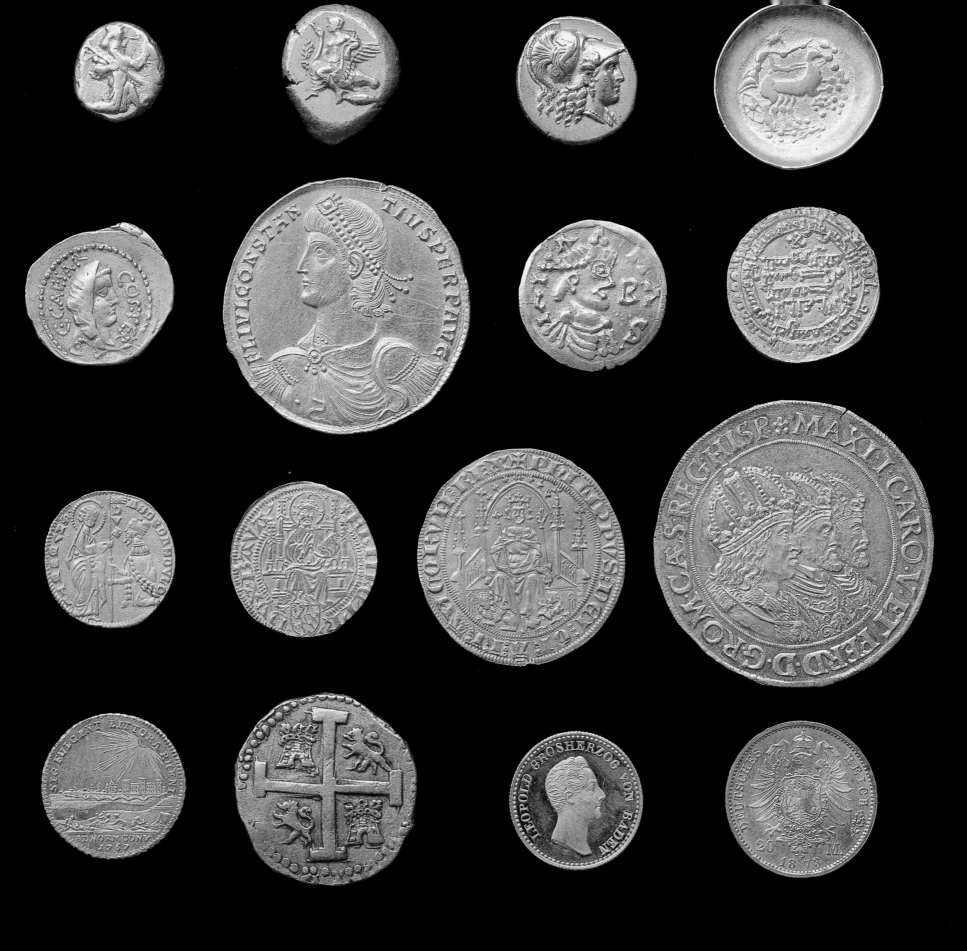

Europe

Augustus the Strong, king of Saxony and Poland, financed the apothecary's apprentice Johann Friedrich Böttger. He wanted him to spirit gold out of the test tube. The king didn't desire this gold for himself. He needed it for Johann Melchior Dinglinger, one of the most famous goldsmiths and jewelers of Europe. Dinglinger worked exclusively for the royal court, making Dresden the center of the guild of goldsmiths, just as Nürnberg and Augsburg had been a hundred years earlier due to the work of Wenzel Jamnitzer and other artists.

In his works, Dinglinger used two new stylistic ele-

Johann Melchior Dinglinger, royal jeweler of Augustus the Strong.

ments: strapwork (trimming, as on the rims of cups) and chinoiseries (Chinese vessel forms, enamel coatings as imitations of porcelain, and

Chinese motifs). His ideas were so successful that he also supplied designs to the porcelain factory run by Johann Böttger, the unsuccessful goldmaker. King Augustus used every free minute to discuss new projects with his jeweler. He was inconsolable when he had to pawn Dinglinger's "Diane Bathing" because of his high debts. (He soon redeemed it.) Other rulers also honored the artist. When Tsar Peter the Great visited the Saxon king, he lived with the court jeweler instead of with his host. He avoided political talks as long as possible so that he could learn goldsmithing in the master's workshop.

Crown from Spain, 7th century. Musée de Cluny, Paris.
This crown of gold, silver, and precious stones was found in 1858 along with thirteen others, in a tomb near Toledo. It belonged to a Visigothic king and was hung over his head during the coronation ceremonies. The crowns were probably buried by the West Goths during the invasion of the Arabs in 711.

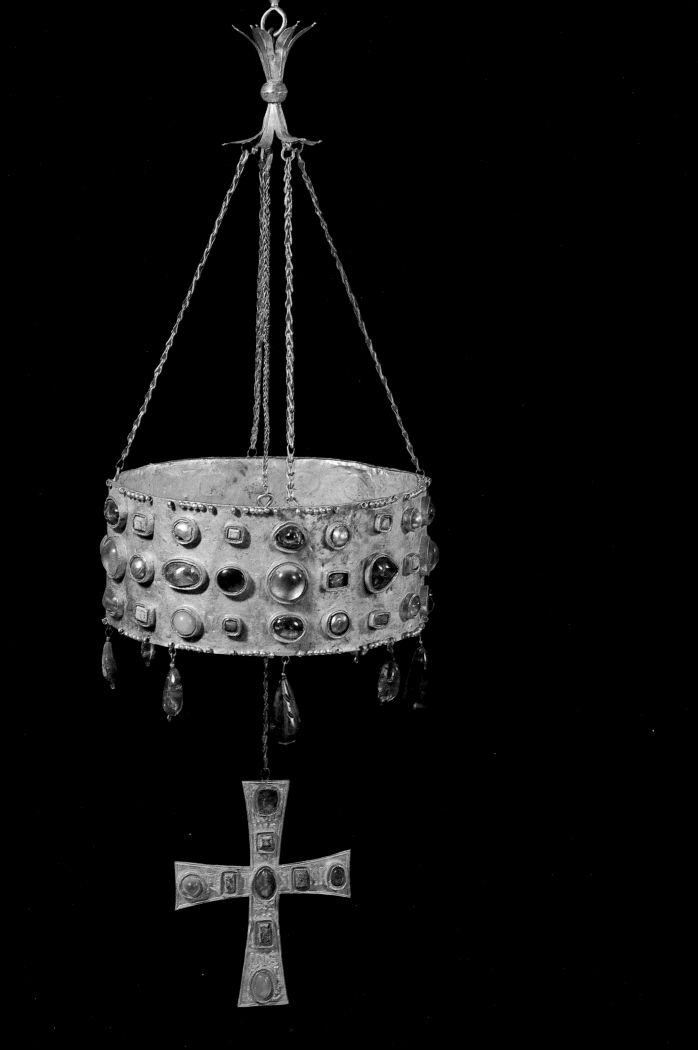

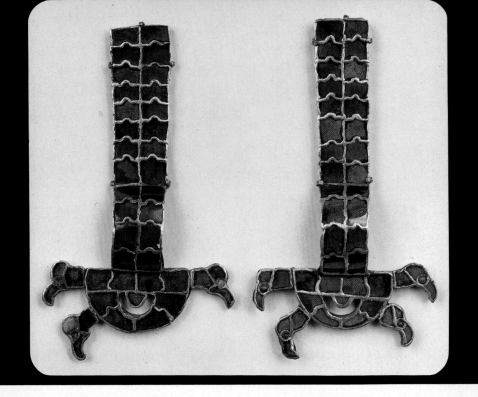

Frankish stirrup fibulas, 6th century, 6.8 cm. high. Roman-Germanic Museum, Cologne, Germany.

Scepter from France, 14th century, Louvre, Paris.
The statuette is an effigy of Charlemagne; the reliefs underneath show three scenes from his life.
The scepter belonged to Charles VI of France, who ruled
from 1380 to 1422 and fought successfully against England in the Hundred Years' War.

Following double page:
Helmet and shield from France, 16th century. 35 cm. (helmet) and 68 cm. (shield). Louvre, Paris.
These magnificent pieces belonged to King Charles IX of France (1550–74). Charles became king
at the age of ten, with his mother Catherine de' Medici ruling for him. In 1572, Charles agreed
to the massacre of St. Bartholomew's Day, in which 20,000 Huguenots were killed throughout France.

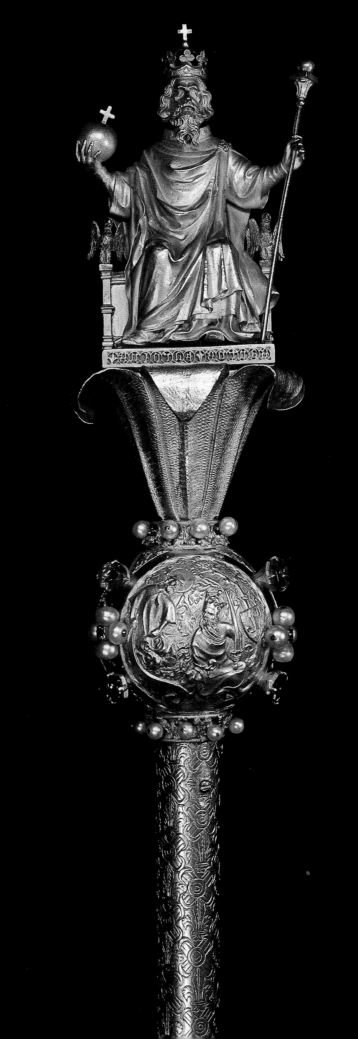

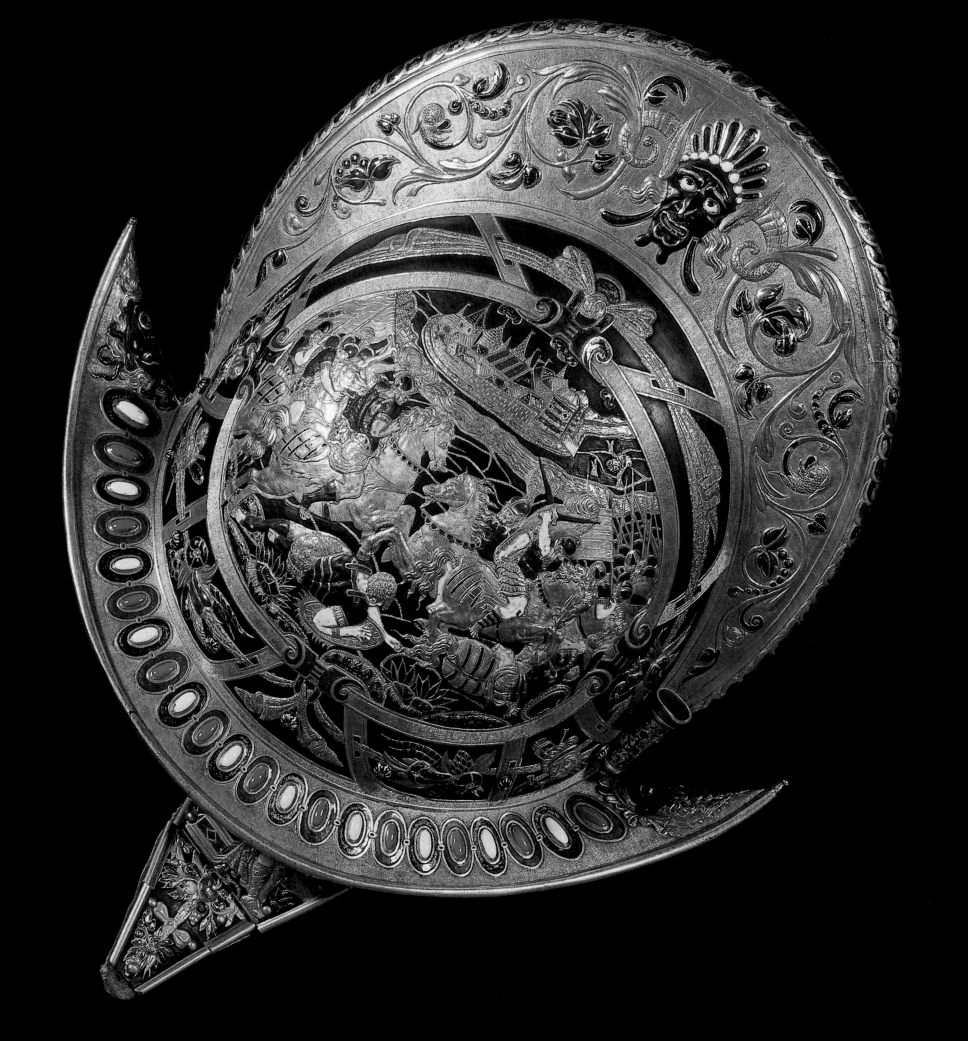

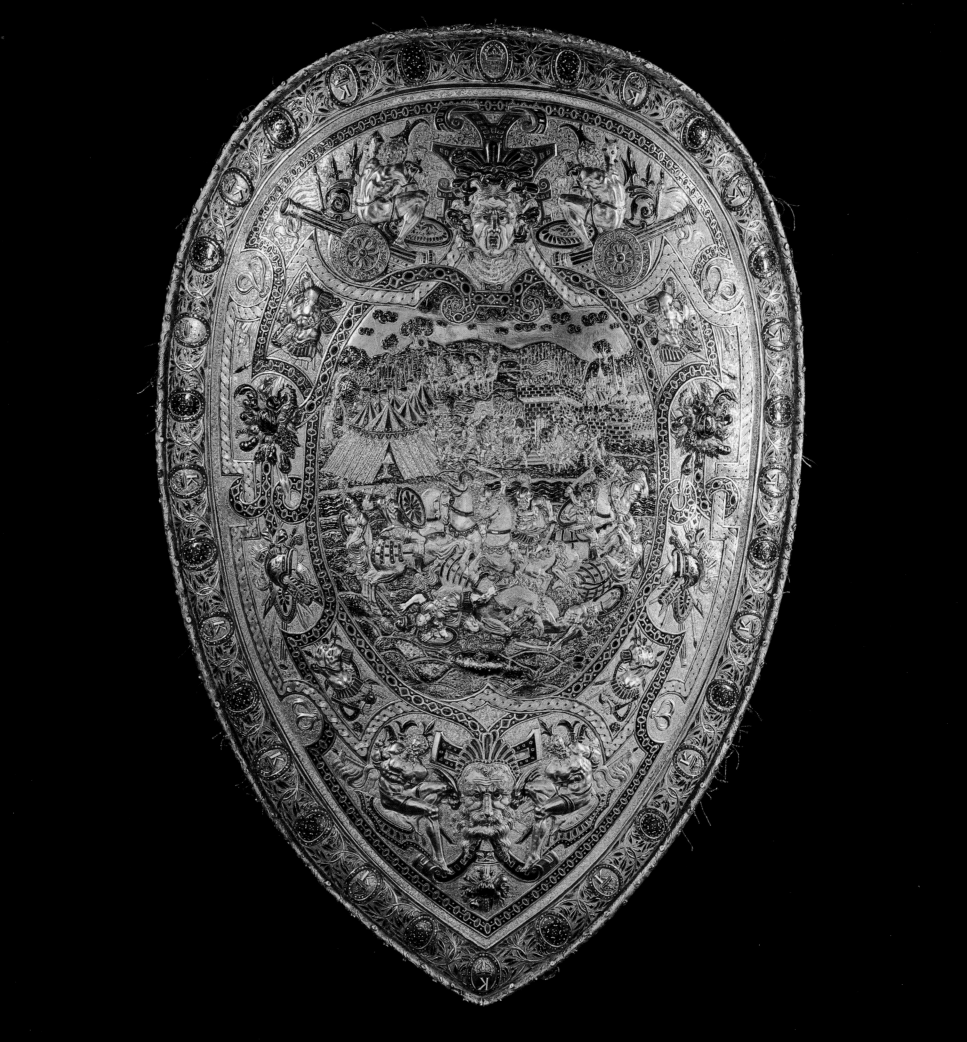

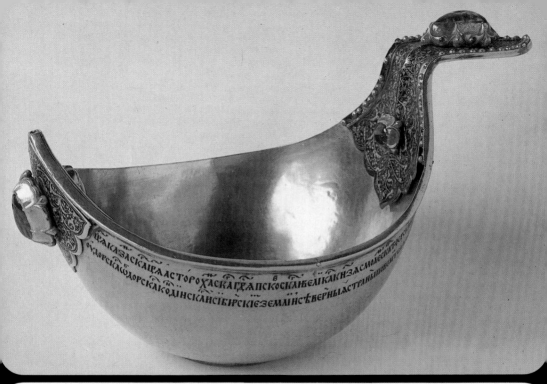

**Drinking bowl (Koffsh) from Russia, after 1563, 23 cm. long, 1,050 gr.
Grünes Gewölbe, Dresden, Germany.**
*According to the inscription, this drinking bowl of Ivan the Terrible was made of gold from Polotsk,
a city that the Tsar had conquered in 1563. The vessel of gold, niello, sapphires,
rubies, and pearls was a gift presented by Peter the Great to Augustus the Strong.*

Lidded goblet from Nürnberg, c. 1535, 28.5 cm. high. Württemb. Landesmuseum, Stuttgart, Germany.
*An equestrian effigy of Emperor Charles V is engraved inside the lid. On its outside, the goblet,
of gilded silver, shows the emperor's Tunisian campaign of 1535.*

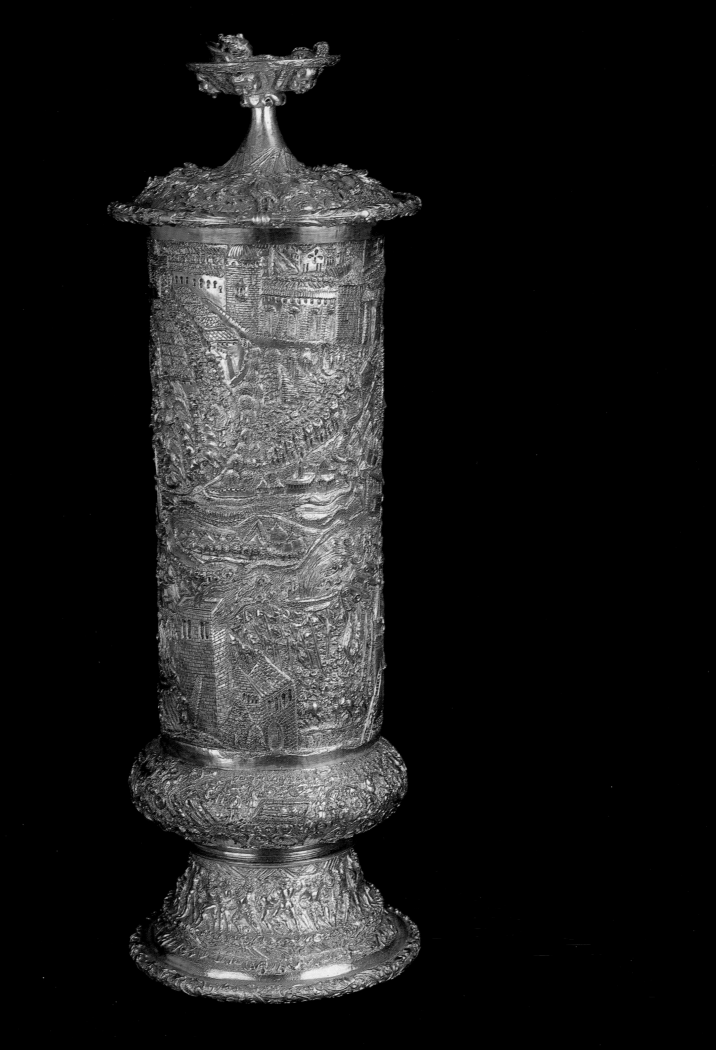

Snuffboxes from Dresden, late 18th century. Grünes Gewölbe, Dresden.
The Dresden royal jeweler Johann Christian Neuber had huge successes throughout Europe with his "stone cabinets", a kind of scientific mineral collection. The round box shown above has a number engraved next to every stone. Inside, the box contains a tiny catalogue indicating the places where the stones were found.

Order of the Golden Fleece, from Geneva, Switzerland, c. 1750. Grünes Gewölbe, Dresden.
The jeweler who made this was André Jacques Pallard of Geneva. The client was Augustus II. The medal, made of gold, diamonds, and Brazilian topazes, belongs to the diamond-lozenge set of the Saxon crown treasury. The Order of the Golden Fleece was founded in Burgundy during 1430: "For the protection and promotion of the Christian Faith and the Holy Church, for the increase of Virtue and Morality."

Following double page:
Luxury pot from Nürnberg, early 17th century, 46 cm. high. Grünes Gewölbe, Dresden.
The pot, created by Christoph Jamnitzer (a brother of the famous goldsmith Wenzel Jamnitzer), is one of the masterpieces of early baroque goldsmithery in Nürnberg.

Tower elephant from Nürnberg, late 16th century, 52 cm. high. Grünes Gewölbe, Dresden.
The creator was Urban Wolff. The tower and the elephant of this drinking vessel are hollow. The platform of the tower and the mount can be removed. The materials used are gilded silver, mother-of-pearl, emeralds, rubies, sapphires, hyacinths, and mountain crystals.

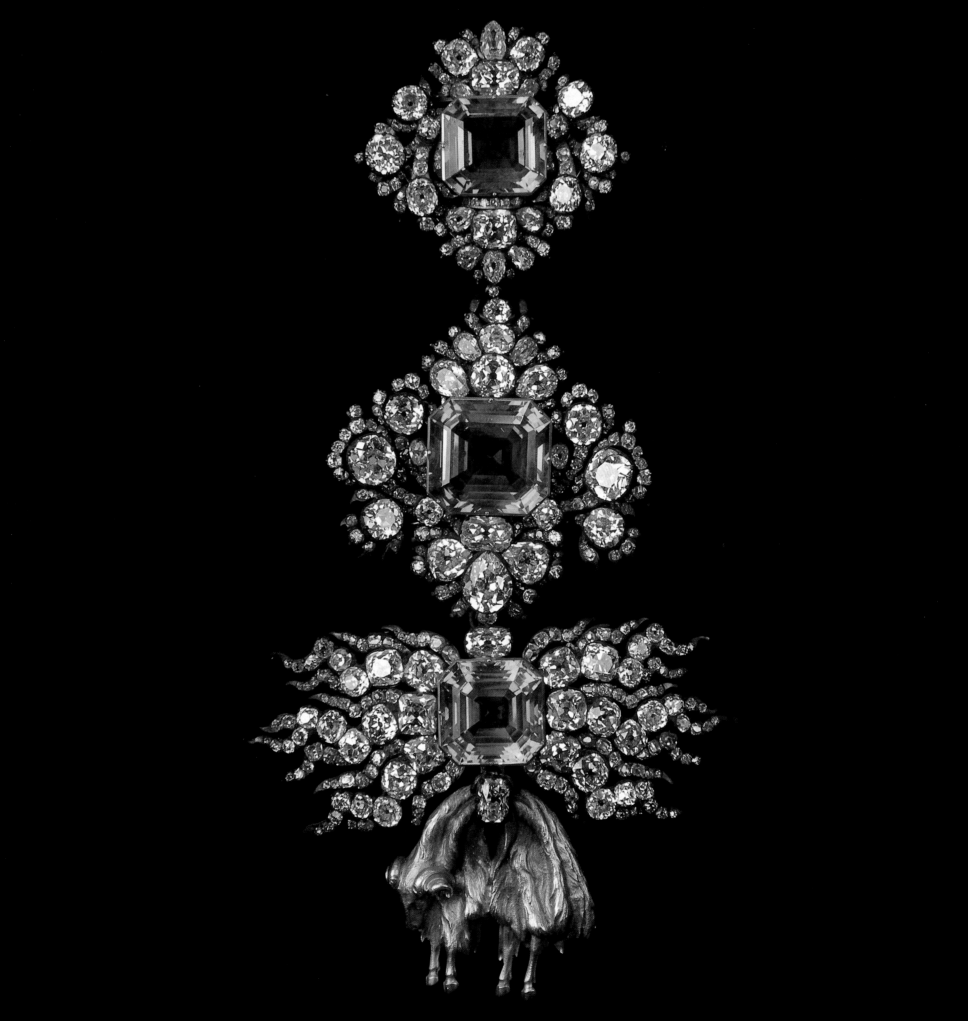

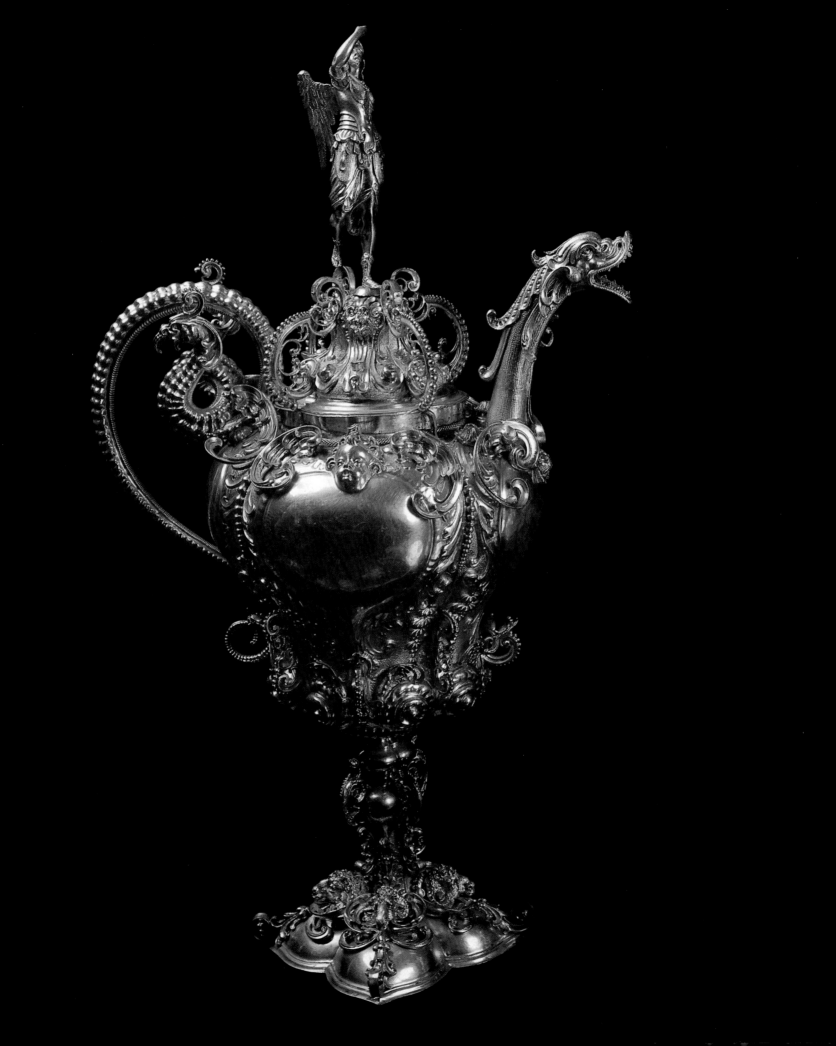

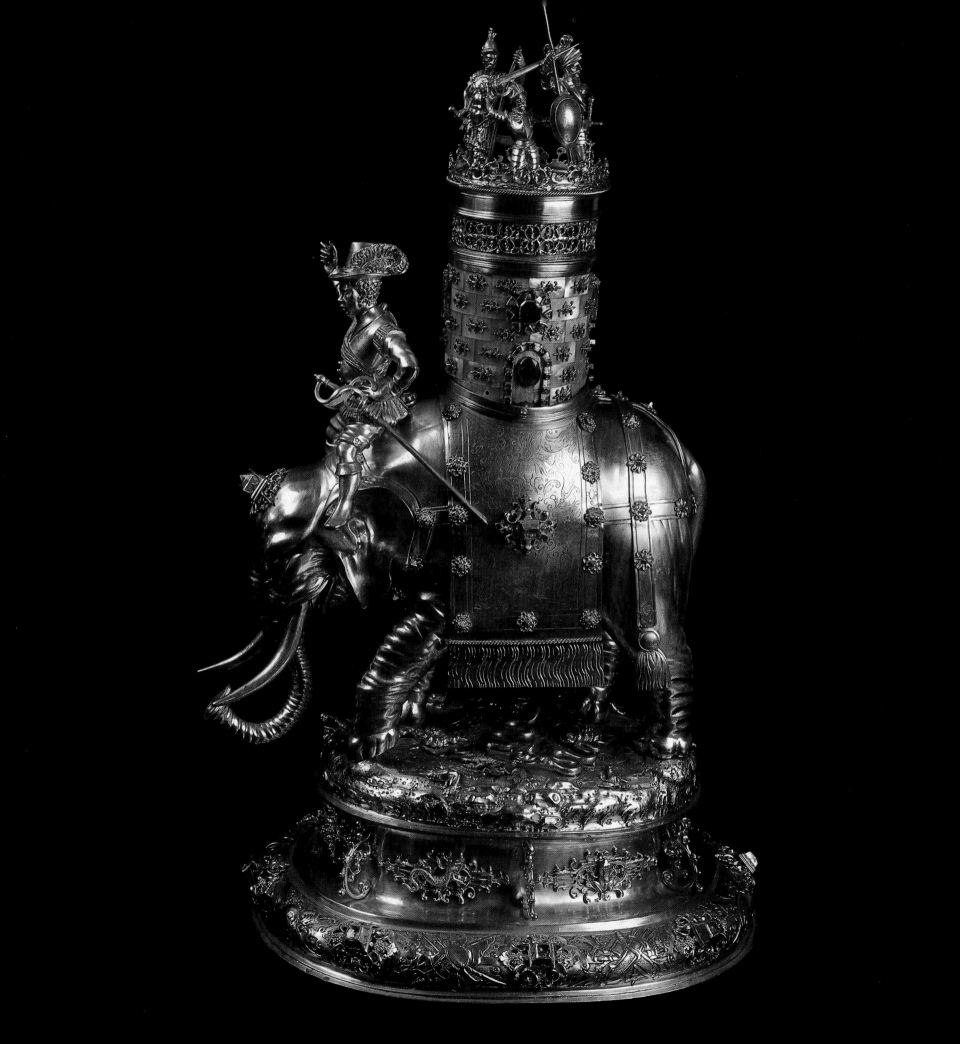

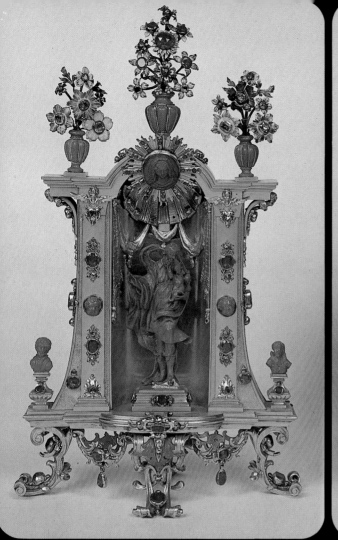

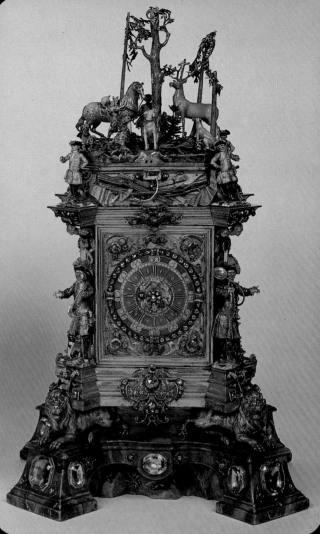

Altar from Dresden, c. 1720, 30 cm. high. Grünes Gewölbe, Dresden.
Johann Heinrich Köhler, the creator of this altar of gilded silver, coral, diamonds, rubies, emeralds,
topazes, and enamel, was one of the royal jewelers
of King Augustus the Strong of Saxon. He was a specialist in small creations.

Table clock from Dresden, c. 1720, 36 cm. high.
Grünes Gewölbe, Dresden.
This clock was known as the St. Hubert's Clock because of its rich depiction referring to hunting.
The case was made by Johann Heinrich Köhler, the clockwork by Johann Gottlieb Graupner.

Clock on chatelaine, from France, late 18th century. Louvre, Paris.

Following double page:
Cabinet piece "The Royal Household of Delhi on the Birthday of the Great Mogul Aureng-Zeb".
From Dresden, 1701–8, 58 × 142 × 114 cm. Grünes Gewölbe, Dresden.
The "Household" is a superlative work by the royal jeweler Johann Melchior Dinglinger and his
brothers Georg Friedrich (enameler) and Georg Christoph (jeweler). The materials were gold, enamel,
and silver, 4,909 diamond roses, 164 emeralds, 160 rubies, 16 pearls, 2 cameos, and 1 sapphire.
This was the first major chinoiserie in German art, the masterpiece of baroque jewelry. It was full of
encylopedic learnedness, for Dinglinger had prepared himself by studying all the available
literature on India. Aureng-Zeb ruled in India from 1656–1707.

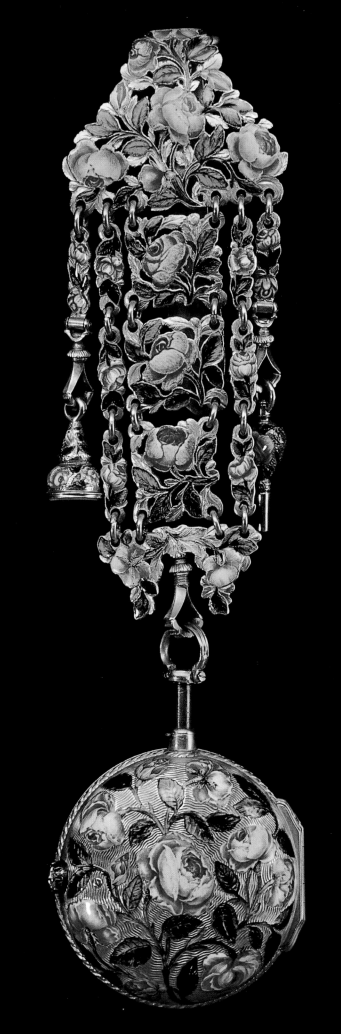

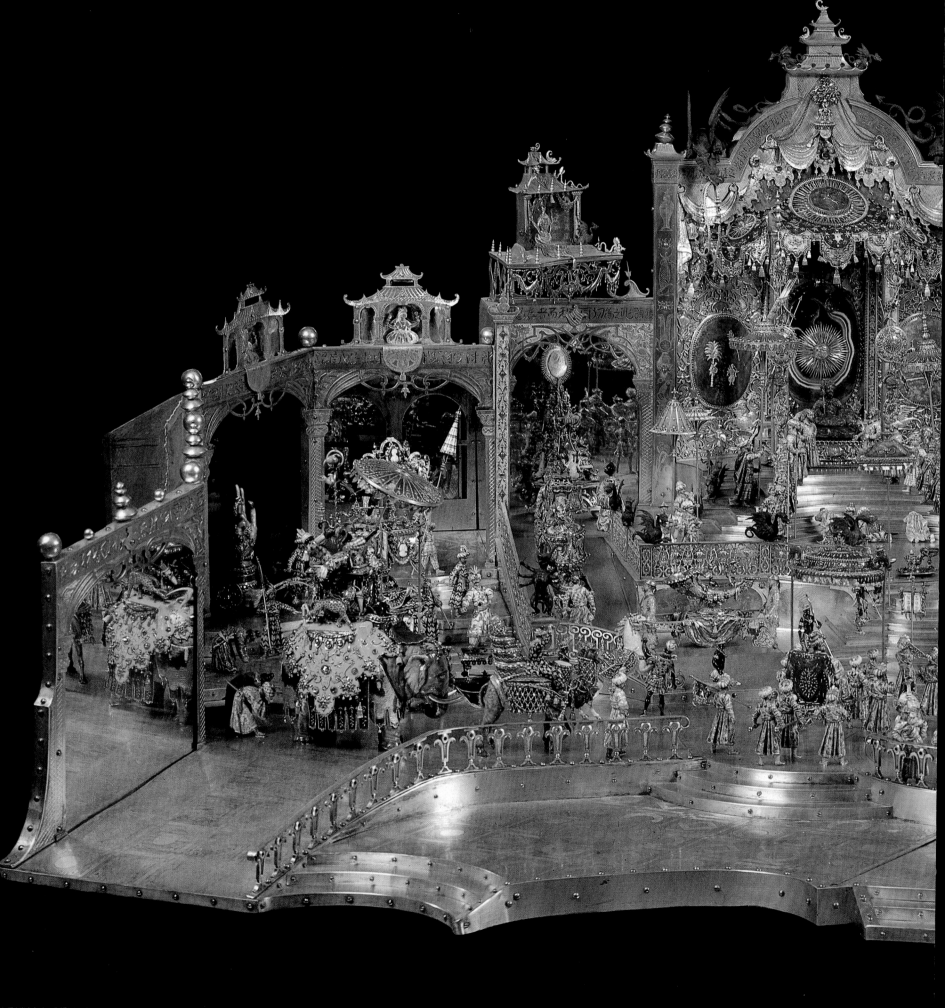

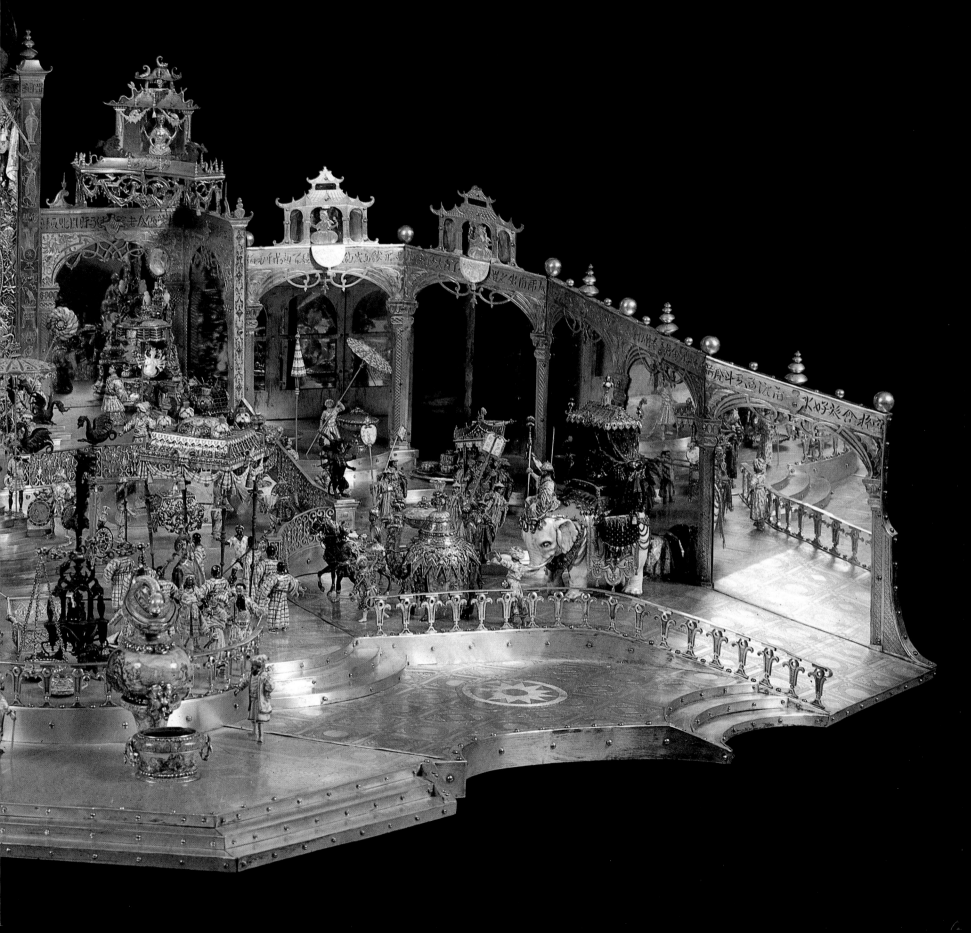

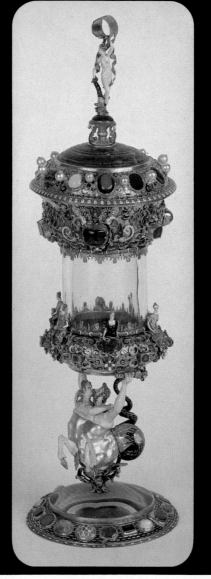

Goblet from Augsburg, 1580–90, 22 cm. high. Württembergisches Landesmuseum, Stuttgart, Germany.
This splendid work of mountain crystal, gold, pearls, precious and semi-precious jewels depicts, among other figures, the sea-demon Triton, the goddess Fortune, sea nymphs, and virtues.

Goblet, 1st half of 17th century, 25.8 cm. high. Württembergisches Landesmuseum, Stuttgart, Germany.
The combination of two different snails determines the unusual quality of this goblet.

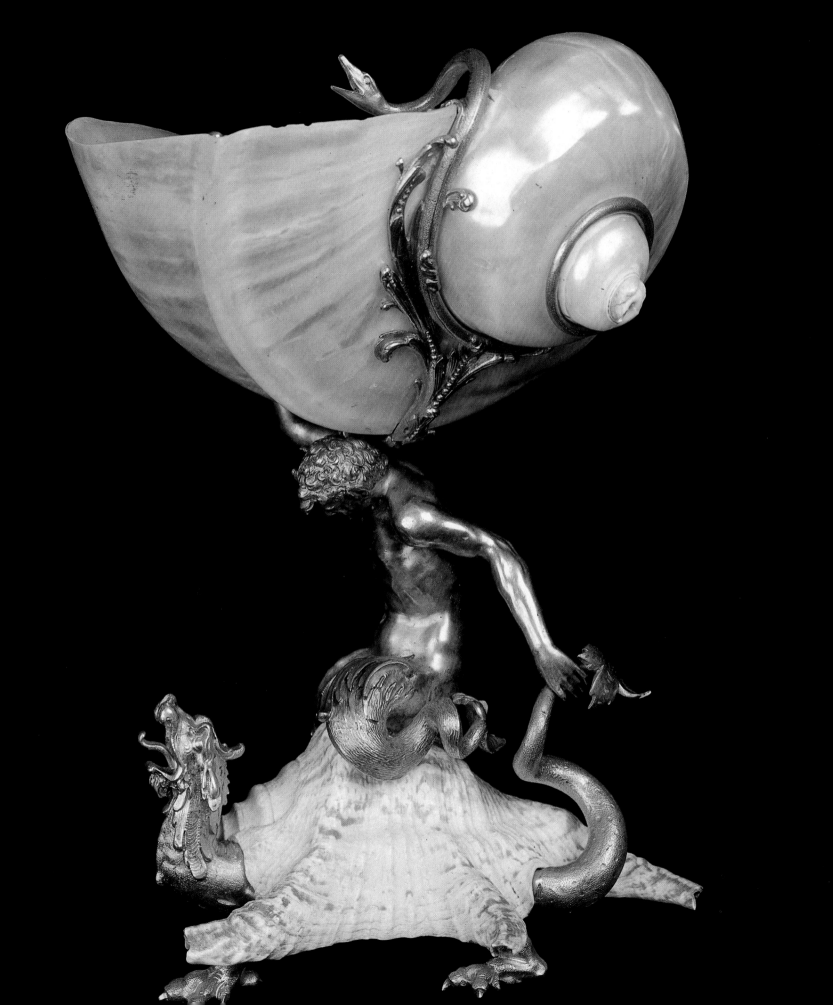

Persia

The crown treasure of the Persian royal house is the most valuable collection of jewelry in the entire world. Most of the treasure was hoarded up by the dynasty of the safavids, who founded the national Iranian state around 1500. Their kings procured gold from mines in Turkestan and pearls from the Persian Gulf. They bought jewelry and art works in India, Constantinople, and Venice. They took gifts of gold and diamonds from official guests. And they brought precious stones as war booty back to Persia.

Shah Reza Pahlevi.

In the early eighteenth century, the crown treasure was plundered by the Afghans. Many precious pieces circuitously reached the court of the Indian Great Moguls. Shah Nadir got them back in 1739. A short time later, Ahmad Khan Abdali made himself shah. He stole a portion of the treasure, including the Koh-i-Noor diamond, and fled abroad. The subsequent dynasty of the Kadjars added extremely valuable pieces to the royal collections: the nadir throne, the Kiani crown, the jeweled globe, and forty-eight South African diamonds, five of which weigh more than 100 carats.

Nadir throne from Persia, early 19th century, 217 cm. high. Melli Bank, Teheran, Iran.
The throne was made during the reign of Shah Fath-Ali (1798–1834) and stood in the Golestan Palace. Consisting of twelve individual components, the throne could be transported to the summer residences around Teheran and shown to foreign guests. Along with gold and enamel, 26,733 precious stones were used, especially emeralds and rubies.

Following double page:
Candleholder from Persia, 18th century, 32 cm. high. Melli Bank, Teheran.
This candlestick, together with a twin, stood at the side of the throne in the Golestan Palace during royal ceremonies. It is made of gold, emeralds, rubies, spinels, and diamonds.

Globe from Persia, mid-19th century, 61 cm. diameter. Melli Bank, Teheran.
Shah Nasser-ed-din had this magnificent globe made in order to be able to present part of the individual stones in the Persian crown treasury. The seas are indicated by emeralds, the lands and continents by rubies, red spinels, diamonds, and sapphires, the equator and the longitudes and latitudes by rubies. The globe weighs about 80 lbs.
The 51,366 jewels employed in it weigh a total of 18,200 carats.

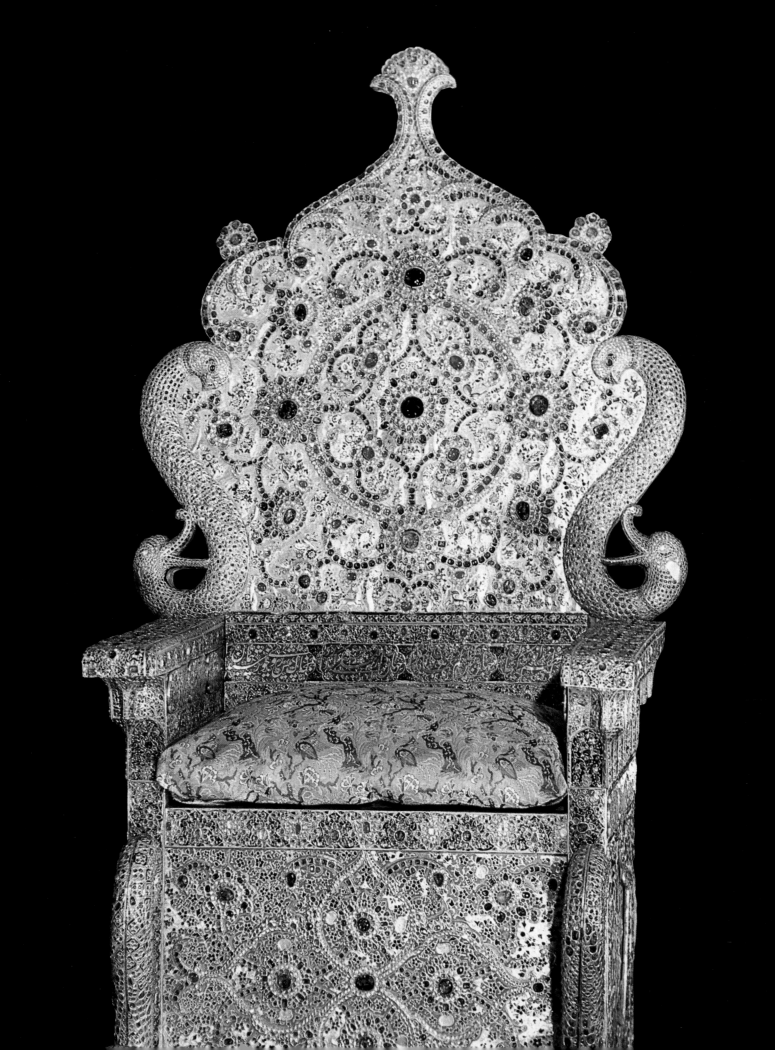

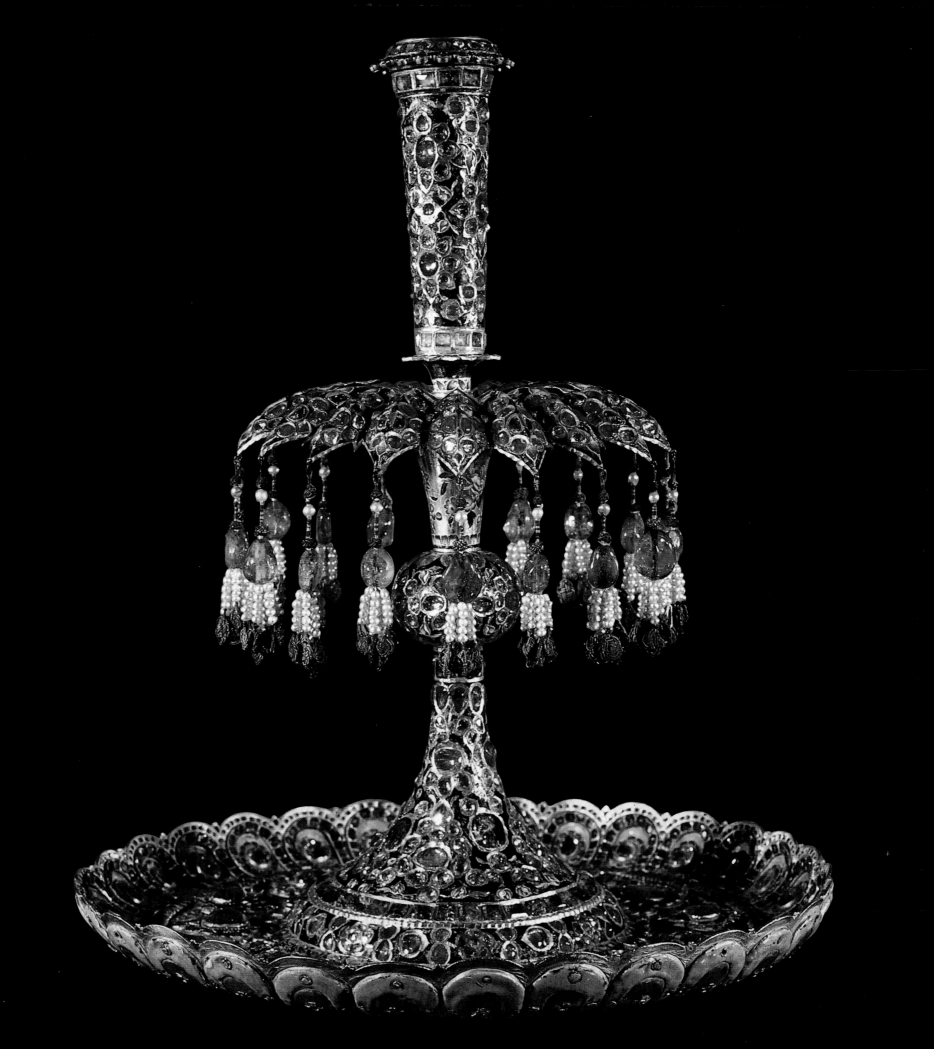

Gold today

In the past, gold was almost always worked into jewelry. Today, only 45 per cent of the gold yield comes into the hands of artists, and mainly into the machine production of jewelry. The most popular of such uses is the wedding band. Over half of all the gold in the world is piled up in the vaults of banks or is used profanely by industry, just like iron or lead.

When astronaut Edward H. White stepped out into

Edward H. White in the cosmos.

cosmic space, the navel cord binding him to his

capsule was made of gold. His space helmet was galvanized with gold.

Atomic reactors are lined with gold foil. Gold is used in the finest electronic circuits. And radioactive gold particles help physicians in examining organs. And yet: the art of the goldsmiths lives on. Aldous Huxley explains why: "The products of the goldsmith's art are numinous by nature. They are at the very essence of every mystery. . . ."

Necklace by Jacques and Pierre Chaumet, Paris, 1971.
Modern necklace in the form of a stylized chrysanthemum of gold, white gold, and diamonds.

Necklace by Andrew Grima, London, 1974.
Modern necklace of gold with opals and diamonds.

Gold and economy

The Coin Story

The most recent gold fever in the Western world raged in November 1974. At its peak, a German banking house, the Hamburger Sparkasse, reported the following: Every day, it was selling, at 60,000 to 90,000 marks, gold coins of the Krüger-Rand type, South Africa. These coins with the head of the Boer hero Ohm Krüger were so greatly in demand that customers were paying up to 20 per cent over the price of pure gold.

For more than two and a half thousand years, gold coins have kept their fascination. The citizen of Miletus in the seventh century B. C. and the West German of the twentieth century A. D. are worlds and cultures apart. But both feel the same pleasure at holding a piece of gold in their hands. The inventions of modern money economy—checking accounts, checkbooks, bills of exchange, paper money—may be rational. But gold is sensual. The heavy noble metal in the hand is, for many people, better than the blue-chip bond. The golden glow seems to present a better hedge against crises and inflation than printed paper. It's no coincidence that the most popular capitalist of our time, Walt Disney's Scrooge McDuck, has only one passion in life besides earning money: every day he dives into the gold heaps of his money warehouse for a nice warm bath.

No one knows the source of Scrooge McDuck's happiness, i.e., who minted the first coins. All that's certain is that the earliest coins ever found come from Asia Minor and go back to the seventh century B.C. It was around that time (according to certain scholars) that an early form of capitalism developed in the Hellenic area: an economic system in which some settlements produced not only for their own use but for a wider market. The specialized export/import commerce required a means of payment that was uniform, easy to transport, and internationally recognized. They minted coins of gold and silver, and the quality was vouchsafed by the stamped effigies of kings or princes.

The philosopher Aristotle described the genesis of coins: "People were importing what they lacked and exporting what they had in excess, and as this spread more and more into foreign countries they had to create the device known as money. For not everything that was naturally necessary was easy to transport. People therefore agreed that for the purpose of trading they would give and accept something that could be useful but was also easy to handle in living commerce, for instance iron, silver, and simi-

lar things. At first, it was only determined by size and weight; at last, however, it received an impress in order to make weighing superfluous. . . ."

The invention of coins was not the inspiration of a moment, but the result of a long development. Thousands of years earlier there had already been such a thing as metal money, predominantly in the form of axes and rings of copper, bronze, silver, and gold. This money at first had a twofold function. Above all, it was a magical symbol of power and worth. The ax was an attribute of gods and kings, the ring warded off demons, inspired superhuman strength, and guaranteed eternal faith. The beauty of the precious metals used for making axes and rings (especially gold) strengthened their divine energy. The more treasures a man owned, the greater his magical might. The symbolic metallic money was, hence, not to be spent, but to be gathered and hoarded.

The use of metal as a means of payment was only secondary, within a proscribed area (a city or country), and for a tiny, wealthy upper class (Pharaohs, kings, priests).

The two most highly developed cultures of the third millennium B.C., Babylon and Egypt, took the first step toward rationalizing money. The reasons were economic. Both empires were centrally ruled. The capital cities became command posts, control centers, with gigantic armies of officials, who did not produce directly but planned, led, and administered. These accomplishments had to be computed in terms of products. The peasant's labor (visible in the harvest) and the tax collector's labor (producing nothing solid) required a common denominator, a standard of measurement. The solution was metal money: silver in Babylon; silver and gold in Egypt. Weight units were created: 1 mina = c. 1 pound, 60 minas = 1 talent = c. 65 pounds. All commodities and services were calculated in terms of this monetary value system. A taxpayer was no longer required to hand over a cow or a carpet to the royal collector. Instead, he was billed for a debt of a certain number of silver or gold minas—which didn't exclude the possibility of paying in kind. The noble metals became standards of value, but in exceptional cases they were used as currency.

It was the Greeks who first made metallic cash a means of exchange. They made gold and silver into coins, which anyone could carry anytime, and which were recognized anywhere. Coins arose through the expansion of international trade —and established the first functioning money economy. Its principles influenced the West until the Middle Ages.

Coin currency was economic progress. Nevertheless, as Hans Gebhard, a numismatologist, points out, there was "something naive" about Greek money. The coin value was always identical with the intrinsic value, i.e., the silver or gold content of the coin. These coins may have been more practical and efficient than the axes and rings of the Babylonians and Egyptians. But they were still regarded as precious material, as valuable in themselves, and not as abstract currency.

Greek banks were equally

162

awkward. Thus a banker from Miletus, wanting to transfer a certain amount to Athens, had to send a transport of money on the dangerous journey: the other businessmen only took cash on the line.

This bent for sensuality, for "money as an end in itself" (Gebhard), greatly disturbed Plato, the authoritarian philosopher, and he demanded the use of "token money" in domestic commerce—coins of worthless metal, good only as currency. This idea was a step toward the abstraction of money. But its motives were pedagogical. Plato wanted to drive out his compatriots' lust for gold and money. So his idea went unheeded.

During the fourth century B.C., through colonies in northern and southern Italy, the Greeks passed their coinage system on to the Romans. Previously, the Romans had been using a currency in keeping with their rustic mentality: pieces of metal weighing several pounds. It was only by taking over the Greek money economy that the Romans, during the next few centuries, could control the enormous economic areas they had conquered in the Punic and Macedonian wars. Around 200 B.C., Rome minted the first truly Roman coin: the silver denarius. One hundred and fifty years later, under the rule of the Caesars, the government also issued gold coins, a sign of the boom in the Roman Empire.

But, like their Greek teachers, the Romans were not prepared to deviate from the intrinsic value of the coins. A coin had the exact silver or gold value stamped upon it. It wasn't until the second century A.D., when official bankruptcy was looming, that the Romans flouted this principle—with intentions to deceive. They reduced the titer (lawful standard) of their coins, while falsely stamping on the old values. This inflationary policy sent the prices soaring to dreadful heights and ended only with economic collapse.

Emperor Constantine then reintroduced a solid coinage. It was based on the solidus, a gold coin that was soon emulated by the neighboring Germanic tribes.

Until the seventh century, this type of coin determined the currency of the Franks. But then King Pippin was out of gold, and so he minted only silver money. Charlemagne finally defined the weight of silver coins, and his system has persisted in Great Britain until this very day, despite the switch to the decimal system: 1 pound sterling = 20 shillings = 12 pence.

The German Middle Ages cannot be called a brilliant era in the history of money. The coinage right, previously restricted to the king, was now transferred to princes and cities. The rulers, constantly afflicted with cash-flow crises because of their luxurious households and expensive wars, used the new privilege for indirect tax raises. The most popular method was depreciation: the princes threw new gold or silver coins on the market, coins containing less of the precious metals than the ones previously in circulation. The subjects were forced to trade in their old ("demonetized") coins for the new ones at a one-to-one rate. The prerequisite for such maneu-

163

vers was of course the coinage monopoly. Within the princely dominion, all goods could be paid for only with domestic money.

This restriction blocked commerce, affecting the trade cities, which instantly leaped to the defense. They formed an unofficial lobby, creating their own currency. This currency consisted of coins of precious metals, any kind of coins, any age. Like gold ingots, they were valued solely by their weight and purity. At last, the trading centers got foreign aid. The leading commercial cities of Florence and Venice could not get along with the relatively simple currency of gold bars, and so, in the second half of the thirteenth century they created the gold gulden, a coin that became international currency basis for all merchants.

The silver taler, coined during the late fifteenth century in Joachimsthal, Germany, was based on the gold gulden standard. The value ratio of gold to silver was circa 11:1. But even in those days, the gold standard could not forestall crises. Since Germany had no institution responsible for currency, every prince took in as many silver thalers as he could, and then melted them down, minting inferior token coins, change for everyday use, the nominal value being higher than the intrinsic worth. This minting fury triggered a small-coin inflation, which in turn devoured the silver thaler. The silver thaler now contained more silver than the sum of small coins with which it could be bought. The thaler vanished from the market. It wasn't until the end of the nineteenth century that this coin chaos in Germany was abolished by law.

Despite their negative consequences, the introduction of the small coins marked the start of a new phase in the Western history of money. For the first time, money was reduced from its material value to its function alone. You couldn't buy anything for the metal in the small coins, but you could buy something for their nominal value, which was indicated by the number stamped on them. The cheap coins had once and for all demythologized both money and gold. Money had played out its symbolic role and was now merely a means to an economic end. The Italian trading cities drew the necessary conclusions. They flanked gold money with a completely new form of payment: paper money and deposit money. They used letters of credit, with which a merchant could obtain cash in other cities. They transferred sums from debit to credit columns without transporting the concrete money itself, as their colleagues had done in ancient Greece. They operated with IOUs and government bonds.

The whole of Europe adopted the new system, which was already in use here and there. As a result, financial procedures were greatly facilitated in international trade, which was flowering. Eventually, in the sixteenth century, in Sweden, Italy, and then in England, payments were made with what was then the most modern form of money: the bank note. Originally, like letters of credit, the bank note was nothing but a bank receipt for deposited metal money. Then the state began printing bank notes and guaranteed their value, at least

164

theoretically, with the vitality and efficiency of its economy. Until well into the twentieth century, emperors, kings, and politicians were not always serious about this guarantee. They printed money whenever they needed it and paid little heed to national economy. The result: excess money and inflation. The first master of this mass fraud was the Scotsman John Law. As a financial consultant to the French government, he swamped France with such a flood of notes in 1720 that state bankruptcy was unavoidable.

Even after the introduction of paper money, most European countries kept minting coins, and using them as currency. But since World War I, fewer and fewer states have been issuing coins worth their weight in gold. Economic systems had grown so complicated, the need for money had soared so rapidly, that good old gold was past its prime as a coinage metal.

Today, gold coins are manufactured only for collectors and investors, although one can still officially pay with Krüger-Rands in South Africa, sovereigns in England, and double eagles in the United States. But there's little chance of anyone handing their precious gold coin to the cashier at the supermarket.

Collecting gold coins is a science in its own right. Rare coins are negotiated at fantastic prices like rare art works, and these prices have nothing to do with the pure gold content of the coin. Less expertise and less money are needed for buying coins as investments. There are some nine current gold coins sold at bank windows:

Krüger-Rand (South Africa), 50 pesos (Mexico), 100 kronen (Austria), sovereign (Great Britain), 10 guldens (Holland), 20 marks (Germany), double eagle (U.S.A.), 20 francs vreneli (Switzerland), and Napoléon d'or (France).

These coins vary in their content of pure gold. (The Krüger-Rand, for instance, has exactly one ounce; the 50 pesos piece 37.5 grams.) And these coins are sold with varying surcharges over their pure-gold value. The price is based on the rarity (Rands are constantly minted and can thus be easily obtained and with a low surcharge) and the gold rate (in fall 1974, for example, the Deutsche Bank raised the surcharge on the Rand by over 100 per cent—and then lowered it furiously).

Gold at the Golden Gate

Once, in 1848, on the American Pacific coast, there was a completely ignored piece of land, unknown to most of the inhabitants of the young republic. All they did know was that after the war of conquest against Mexico, this territory had fallen to the United States. One of the biggest towns in the new province was called Yerba Buena and had a population of about 500, including Indians. Pious settlers had just finished redubbing the place in Christian fashion: San Francisco. But the new saintly name hadn't caught on yet.

The few scouts who knew the inland were enthusiastic about an idyllic hamlet on the American River, a fortified farm with a sawmill and a rose garden, 200 square miles of land,

12,000 heads of cattle, 2,000 horses, 10,000 sheep. It was all the property of an able Swiss named Johann August Sutter, who had also performed the miracle of getting along with the Indians, whom he even hired as workers on his land.

Sutter was a rich man in a poor province. But then came January 24, 1848, and a few years later California was rich—and Sutter a pauper. His cattle were stolen, his wheat fields ravaged, his roses trampled, and he himself driven from his own land.

The reason: on that January 24, 1848, Sutter's partner James Marshall found gold in the American River. At first, the gold epidemic struck Sutter's 600 workers, who wallowed like madmen in and around the river—and found gold. Soon the news had made it to San Francisco—at the latest by the time the first diggers with sackloads of nuggets and gold dust had appeared in the taverns. The two newly founded newspapers of San Francisco had to close shop. Their advertisers, readers, and reporters had vanished from one day to the next, taking off for the gold fields. By the end of 1848, 10,000 men were digging claims, which were so generous that some men were content to put up with lots of a hundred square feet.

The gold news had already reached the Atlantic seaboard—to the joy of President James Polk in Washington. For months, people had been violently criticizing him for the war against Mexico, which the United States had started, and which had brought nothing but empty coffers and a piece of bleak, worthless wasteland.

Now Polk could declare to Congress on December 5, 1848, that the war had been worthwhile after all. He did lie a bit (for self-enhancement). He claimed he had known even before the war that California was chock-full of gold.

The President's speech and the arrival of the first gold from California infected the whole nation and then the whole world with gold fever. In 1849, at the East Coast, the procession of the "Argonauts" began. Middleclass gazettes knew their Greek mythology and gave the gold diggers a classical moniker. Soon these prospectors called themselves the "forty-niners", and it was with this name that they became an American pioneer legend. As one reporter wrote, it was the "most civilized adventure expedition of all time." For the land between the Pacific and the Sierra Nevada lured not only shady sorts, who are always present in every gold rush, but also tens of thousands of respectable citizens: lawyers, craftsmen, merchants, bankers, farmers, sailors. Even painters, journalists, actors, physicians, and writers joined the rush, and thus nothing in pioneer history has been better documented than the settling of California.

There were three routes to the promised land. The longest was a maritime passage of 12,000 miles around South America to the harbor of San Francisco. The voyage cost between 300 and a thousand dollars, lasted at least four months if the winds were favorable, and was inconceivably arduous. Clever shipowners dolled up dismantled whalers and overloaded

them with gold prospectors. Shaken by seasickness, fed on salt pork, they could only pray that the rotten planks would hold as they tossed through the storms off Cape Horn.

Since the ships were bad, the owners didn't mind the certain loss. Most of the vessels did arrive in San Francisco. But here, along with the passengers, the entire crews charged ashore in the direction of gold. Until the 1850s the harbor of San Francisco was filled with abandoned ships, cheek by jowl.

The second route led cross-country, some 3,000 miles. It was cheap—and dangerous. City folks, accustomed to comfort, had to fight against bad weather, raging torrents, enormous deserts, mountains, wild beasts, and hostile Indians until they could finally dig their spades into the Californian soil.

The third route was the fastest: by ship to Panama, then overland to the Pacific coast, from there by ship again to San Francisco. That was also the most expensive way and it was hardly used by gold seekers. It was mainly for people who were already rich: high officials, gamblers, and prostitutes.

Before the Argonauts could start prospecting for their fortunes, they had to pay through the nose. They needed clothing, food, tools—all of which were sold at horrendous prices by the merchants of San Francisco. There is a fully documented story about a businessman who bought 1,500 dozen eggs at a few cents per dozen and then sold them at 37½ cents a dozen. A few minutes later he saw that the buyer was hawking the eggs for four bucks a dozen. The merchant bought them back—and offered them at six dollars a dozen. Naturally, he got rid of the eggs at this high price too.

Some of the biggest fortunes in America started in the San Francisco gold rush—for example the riches of the Bavarian blue-jean manufacturer Levi Strauss or the wealth of meat manufacturer Philip D. Armour.

But most of the newcomers weren't smart enough to earn their money off the rushers themselves. Instead they joined the mob. They worked hard, sixteen hours a day. Their tools: The finely porous tin pan, in which they kept shaking sand and debris until only the grains of gold, if they were present, were left. The "cradle"—a wooden crate, the top part of which was filled with soil and had holes punched in it; this top part was shaken back and forth and flooded with water. And the "sluice", a stair-like contraption through which water and sand were poured so that gold would stick to the steps.

Only a few diggers earned more than their upkeep—even though some did strike it rich and discover a wealthy mine. However, the total of the gold mined by hundreds of thousands soon exceeded ten tons.

As of 1850, the thin successes of private gold hunters became more and more infrequent. The easily attainable gold had been creamed off. Now the mining companies and their engineers took over. Geologists surveyed and analyzed the gold fields, which were then exploited by

the most modern machines arduously transported all the way from the east. California's gold output rose to seventy tons and then one hundred tons a year—more than half the total world yield.

Many of the forty-niners gave up. They settled down as farmers, returned to the east, or followed the next gold rumors to Montana or Colorado. Their personal disappointment interested no one. They went under in the gigantic boom that the gold of Sacramento and the American River brought to California and all of North America. The state mint at San Francisco, purchasing gold for fifteen dollars an ounce, issued four million dollars' worth of coins in 1854. Two years later, the total issue was twenty-four million dollars. Within a few short years, America became rich.

Stalwart prospectors blew their hard-earned nuggets in a few days, perhaps by seeing Lola Montez dance in San Francisco or paying 600 dollars to spend the night with a Mexican girl. But in New York, entrepreneurs, bankers, and politicians were already stoking the boom with California gold. They invested in factories, exported it to gold-parched countries like Great Britain or Germany, or stored it in banks as a crisis-proof guarantee for government bonds.

California and its big city San Francisco flourished fastest and most conspicuously. By 1852, the former village of Yerba Buena had a population of 35,000 and was growing at a frightening clip. Land became scarce, property prices doubled within weeks, so that real estate firms blossomed. Businessmen and banks from the east set up branches—storekeepers pocketed profit margins of about 500%, the banks demanded over 100% interest rates on loans. This was still little in comparison to the loan sharks of the gambling halls, who extorted 87,600% a year. Gangster syndicates were established, the citizens of San Francisco formed vigilante groups who lynched first and asked questions later. The vitality of this town was so great that the fires destroying entire districts every year left no visible signs: the houses were rebuilt in just a few weeks.

San Francisco's harbor became bigger and bigger, stretching farther and farther into the sea. For the building sand was dumped into the water to gain new land. Ten years after the gold rush, San Francisco was the metropolis of the American West.

When Californians had to give their state a nickname, there was only one possibility. They named it the "Golden State".

Gold Awakens a Continent

When a city like Melbourne has almost no inhabitants left and only one policeman, what does that mean? That means: gold rush. The Australian gold fever, breaking out exactly three years after the Californian epidemic, was a direct import from America. Edward Hargreaves, the first Australian to discover gold (in 1851), had worked as a forty-niner in Sacramento.

Like the Californians, the Australians were lucky in that the original inhabitants of the

168

country had never been interested in gold. There were masses of alluvial gold lying about, the accumulations of thousands of years.

And as in California, the gold boom was the foundation and the motor for the opening and the economic flowering of Australia. The fifth continent needed it. Having been discovered but barely settled, Australia, for the sixty years since 1788, had been nothing but an immeasurably enormous convict island, a land of exile for 80,000 criminals who had been transported there from England. Even today, Britons still mockingly refer to the Australians as the Prisoners of the Motherland.

As of 1830, a few immigrants came into the colony. They raised sheep, but didn't forge very far inland. No one cared to earn the two-thousand pound reward that the government offered for a north-south crossing of the continent.

But the discovery of gold changed everything. The news spread that Australians had found lumps of gold weighing 100, 150, even 200 pounds, and the chase was on. The convict island became the most popular destination for immigrants in the world. Within seven years, the population shot up by ten million people. The government was faced with the almost insuperable problem of controlling and ruling the masses—with officials who ran off to hunt for gold. The governor of Victoria finally demanded soldiers from England, and desertion was threatened with court-martial. He also helped out the bureaucracy with retired prison wardens, who were too weak to endure the grind of a gold rush.

The gold-prospecting expeditions wiped the white spot of Australia from the map. They put up their tents in deserts and steppes, and wherever they detected promising gold mines, they founded cities. Melbourne and Sydney emulated San Francisco, developing from villages to big cities in just a few short years. Australian gold brought industry to the continent, it financed water systems and telegraph lines, electric works and railroads.

And, unlike what happened in California, the gold rush never ended. More and more deposits appeared. It was only in the twentieth century that the Australian gold production reached its peak with over a hundred tons a year. It seems not unfair to say that gold had made a new continent.

Eldorado Today

According to an estimate of the Deutsche Bank, all the gold in the world (coins, ingots, jewelry, industrial gold) weighs a total of 77,000 tons. If it were all melted down into a cube it would just about fill out a room 50 feet long, wide, and high.

This treasure increases annually by some 1,300 tons. Over half of it comes from South Africa, for decades the biggest gold producer in the world. A comparison with other outputs of 1973 proves that top position:

South Africa	852.3 tons
Soviet Union	370.6 tons
Canada	60.0 tons
U.S.A.	36.2 tons
Ghana	25.0 tons

South Africa lives on gold. The higher the price of gold, the better. The 852 tons obtained in 1973 make, according to the gold rate of November 1974, a fortune of six billion dollars.

Strangely enough, the South Africans at first had no interest in gold. When prospectors discovered the first traces in 1850, the settlers, Boers from Holland, drove them away. They were farmers, cultivating land and building up their cattle. They knew their peaceful life would be done with if the gold hunters came. Prospecting was prohibited. But it didn't even take the economic interests twenty years to win out. President Pretorius permitted prospecting. However, in contrast to California and Australia, South African gold hunting was systematic from the very outset. English engineers constructed mines and mills, in which the gold was melted and chemical means were used to make it as fine as possible.

In 1886, a second gold fever of sorts broke out in the Witwatersrand, where lavish, easily accessible deposits had been found. Diggers hurried to Transvaal and founded Johannesburg, which grew in ten years from 3,000 to 100,000 people.

Most of the prospectors gave up private hunting and hired themselves out to the mines. Access to capital resources and scientific methods became of vital importance.

By 1900, 14 per cent of the world's gold was coming from South Africa. That same year, the gold cost the South Africans their independence. After the lost Boer War, South Africa became British. But England would certainly have relinquished the struggle if it hadn't been for that glowing lure of the metal in the soul of the inhospitable, unexplored country.

Today, the Republic of South Africa is once again independent, and it is producing more gold than ever. From fifty mines, it streams to Johannesburg, where it is processed into 25-pound ingots.

The land around Johannesburg is sown with scars: masses of earth and rock that were burrowed out by prospectors trying to get to the gold. For one ounce, an average of three or four tons of rock have to be ground down. And miners have to keep going deeper and deeper. The shafts have reached a level of 10,000 feet below the soil and will soon reach 13,000 —once the technologists have solved the climate problem. The miners have to drudge in temperatures of 110 to 120 degrees in tunnels they can only crawl through. Explosions are limited to the smallest possible area since there is always the danger of an entire tunnel collapsing. At such depths, the pressure in the rock masses is so powerful, the statics so balanced, that a slight cough can cause a slide. Such accidents keep recurring despite the computers that supposedly warn in time. The heat, moisture, and danger are accompanied by an inconceivable racket: in a space of just a few square yards, thirty pneumatic drills are hammering away. Often, they have to be worked by foot because the tunnels are too low.

Despite the unbearable working conditions, the mining

companies find more than enough laborers. They employ 400,000 black miners, mostly from Bantu tribes. Although badly paid by European standards, they can earn a lot more here during the six to eighteen months of their contracts than in their native villages. Their goal is to save up enough so that, as the Bantu idiom puts it, "they can get home by sundown", i.e., proudly present their hard-earned prosperity to their tribe. But, says one Bantu, "Many of us sneak back only after dark—or we pack stones in our valises to make it look like something." The miners live rent-free in the barrack towns constructed in the neighborhood of every new shaft entrance. But clothing, food, and alcohol are expensive and gobble up salaries unless a miner can lead an ascetic life in his leisure—and who can do that after the grueling shift in the mountain? The miners are carefully prepared for their torture. The company physician examines them thoroughly. Only completely healthy men can withstand the temperatures in the galleries without suffering heat stroke. After that they undergo training. For days on end, they have to shovel piles of stones over a low wall and back again. This under the guidance of a black overseer who teaches the men how to achieve maximum performance with the lowest expenditure of energy.

Next they are prepared for the heat in the depths like top athletes training for the Olympics. In four-hour shifts, they step up and down a stone step in a humid room at a temperature of 110 Fahrenheit. For the first day, they have to do this twelve times a minute. The man who can survive this will be doing 24 climbs a minute after a week, his body having grown accustomed to the heat strain.

Black miners who extend their contracts can work their way up to foreman after a few years. Until recently these foremen were known as "boss boys". Today, with South African apartheid being slightly toned down, they are called "team leaders".

When the rock is brought to the surface from a depth of thousands of feet, it is broken down into pieces as large as a fist. Practiced workers at the assembly line sort out the pieces with no traces of gold. The pieces that do contain gold are smashed down further and mixed with water. They are then filled into a rotating vessel that contains steel balls. These balls crush the ore into powder.

Next, cyanide is added to this powder-and-water mixture to separate the gold and the stone. Finally, the gold and the cyanide are separated by zinc admixtures. The still impure gold is melted and electrolytic processes bring it to a titer of over 999.8. In the form of ingots, the gold finally lands in the vaults of the gold concerns.

Forty per cent of the South African gold output is controlled by the Anglo-American Corporation, with its seat in Johannesburg. Its general director has one of the most famous names in the gold business, Harry F. Oppenheimer. Oppenheimer, sixty-six years old, is one of the richest men in the world—not just as a major stockholder in his corporation, but also through oil and coal concerns and his participation

in the De Beer diamond monopoly. Yet his power over gold seems almost sinister to many currency experts. Oppenheimer can operate with two thirds of the annual world output of gold and thus greatly influence the price of the precious metal. If, for example, he holds back large amounts, gold will grow short and the price will rise. On the other hand, by means of an oversupply on the market (which would lower the price), he can have his banks buy up so much gold that the rate will be stable and fairly high—even soaring in case of new demands. The criticism leveled against gold as a currency basis has been strengthened by such manipulations. Capitalist economy, experts maintain, should not be contingent on a single man.

Yet South Africa has been earning money for gold only since 1968, when, along with the low official price of gold, thirty-five dollars per ounce, a higher rate was agreed upon on the open market. The mining costs for an ounce of gold in South Africa were between 40 and one hundred dollars. Oppenheimer explained: "At such a price, the South African gold industry would have quickly been ruined."

"Mr. Gold" flatly rejects the accusation that South Africa, by limiting the gold export, influences the market according to his wishes. He blames lowered production on the ever poorer quality of the ores, whose exploitation requires constant technological improvements. The output will go up again. Oppenheimer's Anglo-American Corporation is opening up new mines, at a cost of 250 million dollars apiece. They will have to spend at least seven years analyzing, excavating, drilling until the first gold shines in the molds at the refinery.

Oppenheimer is convinced that the efforts and expense are worth the trouble, even though all the industrial nations are gradually debunking the myth of gold in economy. "Many people", says Oppenheimer, "are evidently convinced that gold is still useful, even if only to provide a feeling of security."

If things go his way, gold will not lose its magical meaning even in the age of technology.

A South African banker was less enthusiastic. He does earn money on gold, he says. But in the steel vault of his bank, which is stuffed to the seams with 25-pound gold ingots, he pointed at a customer's supply: "Just imagine: for this little heap of gold, forty people had to work for forty generations. If you don't believe that the world is crazy then you're crazy. And what do we do with the stuff? We haul it out of the ground, stick it underground again, and transport it from one room to another. Couldn't we find something better to do with our time?"

Gold Smuggling

Not everyone who wants to have gold and has the necessary money can buy it. Many countries prohibit their citizens from importing or even purchasing gold because they wish to prevent valuable currency from flowing abroad in exchange for hoarded treasures that are withdrawn from economic circulation. But gold is stronger

172

than economic sense. Despite all laws, gold-hungry collectors manage to procure the desired metal. They are helped by big smuggling syndicates in Europe and the Near East.

They work with the oldest tricks in the book, and the most ultramodern. They learn from an agent in Iraq, which prohibits gold imports, that he has found buyers for 40 or 50 pounds. They instantly notify their representative in Damascus, who immediately takes care of it. A few weeks later, a couple of flocks of sheep cross the Syrian-Iraqi border, carrying gold under their wool.

It's more complicated to supply well-to-do Soviet citizens. A typical smuggling route: Syrian goldsmiths buy jewelry, an innocent act, melt it down, and sell the impure product to a dealer. He has it smuggled to Beirut by taxi. From there, it is legally flown to London or Zurich to be refined (the titer is increased) and turned into two-pound bars. These ingots are shipped to Iran, where goldsmiths mint them into 15-ruble pieces, which are then smuggled into the Soviet Union by way of Armenia. The smugler's reward (if he doesn't get caught) is dollars with a fat mark-up.

The largest gold-smuggling market in the world is a tiny desert state on the Persian Gulf: the sheikdom of Dubai. In 1971, Dubai imported 216 tons of gold, which even then represented a value of half a billion dollars. But hardly an ounce of the metal, which is flown in from abroad, gets into the hands of the populace. It is smuggled to India, which experts have dubbed "the eternal gold drain."

There is hardly another place in the world where the solar metal of the old gods is more appreciated and more superstitiously venerated than in the most highly populated development land. Gold formed, and still forms, the basic stock of the legendary maharajah treasures and the billions of the Maravies of Rayasthan—all of which played the main role in Indian economic life for a long time. But gold is the name of the game for the less wealthy too, and even for the poor. A newborn child gets presents of gold. A bride needs gold jewelry to marry in keeping with her station (after the wedding, rings and bangles end up in a hiding place as security for a rainy day). Gold is used for potency and for cures. Worn on the skin, it brings everlasting youthful strength; thin leaves of it strewn on food keep you healthy.

Experts estimate that nearly every Indian family has a tiny gold supply of five or ten grams. Together with the gold millions of the upper class, the total Indian gold treasure is a surmised 10,000 tons. By way of comparison: the German Federal Bank had approximately 3,600 tons in its vaults in 1974, the Bank of India 216.

Even though the Indian government outlawed gold imports in 1947, even though it passed a law in 1963 to control private ownership of gold, it still hasn't gotten its fingers on the holy metal of its citizens. Helplessly, the government has to sit back and watch 200 million dollars' worth of gold flowing into the country every year—three quarters of it by way of Dubai. The smuggling

pros of Dubai, mostly Arabs and Persians, have a simple and rarely dangerous procedure. They legally import gold from England or Switzerland, cast in bars as big as a matchbox (about 115 grams). One hundred bars are sewn into a canvas jacket and loaded on 300 fishing boats, which then run out of the harbor toward India. The distance of 1,500 nautical miles is covered in five days. Shortly before arrival in India's territorial waters, the boats radio encoded telegrams to an agent on the coast. A while later, an Indian fishing boat sails to the meeting place near the coast. It takes the gold-filled jackets in exchange for silver, dollars, or traveler's checks, and brings them ashore. There, porters don the jackets and bring them to their destination by train or car.

The Indian customs officials are powerless. The smugglers' vessels are faster than their own. And even if they do catch up with a boat, the crew usually has enough time to sink the gold (on a buoy) into the sea, from which they later haul it up. The success rate of the Indian coast guard is about 6 percent.

Since 1971, the gold business has gone down in Dubai. The price has quintupled. At the old buying price of thirty-five dollars per ounce, the Dubai dealers earned a profit of 20 per cent. Today they have to be satisfied with 1 per cent. Furthermore, despite their insatiable craving for gold, few Indians are still in a position to buy even a tiny amount of the expensive metal. However, Dubai, which grew rich with the help of gold, no longer needs it so badly now that oil wells pump in the sheikdom.

Likewise, the smuggling syndicates, most of which are located in Beirut, can get along without their Indian connection for the time being. They still have enough clients, from Turkey to Brazil, from Sudan to the Soviet Union, to whom they can send out their carriers with eighty pounds of gold under their suits. The only thing they have to fear is that someday the customs booths in international airports will have scales for weighing passengers.

Gold and Money

In 1798, Great Britain was the first state since the fall of the Roman Empire to introduce the gold standard, prompted by the Brazilian gold that the English had gotten hold of through a clever trade agreement with Portugal.

The gold standard meant all the money in circulation was covered by gold, either directly through the intrinsic gold value, as in gold coins, or, as in the case of bank notes, indirectly by the stock of gold in the government bank.

During the nineteenth century, other European industrial nations followed the English example. In practical terms, this was possible only after the finds in California and Australia.

At the very beginning of that century of the Industrial Revolution, the English minister Huskisson stated a theory that soon became a principle of faith for economic scientists and politicians—and it is still one for some today. According to Huskisson's thesis, the rising output of noble metals animates industry, inventiveness, and activity, whereas a sinking production of gold will slow

down prosperity. Gold is the cure for all economic crises. In point of fact, the modern age has never known a calmer, better-balanced era of international payment than the period of the gold standard. The kind of crises now shaking the pound and the dollar were cured back then by the mechanism of the gold standard.

If a country, say Germany, had an inflation, then the currency, here the mark, was worth less in relation to foreign currencies, for instance when paying for imported goods. The importer would have to pay more marks than earlier. But he had the right to trade his paper cash in for gold at the central bank and then pay his foreign debt with the bullion.

Since in this way the deflated bank notes remained within the country, fewer marks were offered for sale abroad. The demand went up—and the rate was back to normal.

World War I destroyed the gold standard. The warfaring countries, producing almost only weapons, spent their reserves on imports. The German Reich, for instance, between 1914 and 1918, paid foreign debts with five billion dollars' worth of gold coins—thereby sacrificing its entire stock. In 1925, Great Britain tried to resume the old tradition and reintroduced the gold standard for the pound sterling. As a result, nearly all the industrial nations, uncertain because of inflation and depression (as of 1929), traded their pounds for gold. The vaults of the Bank of England were emptied. In 1931, Great Britain revoked the right to trade cash for gold, deflated the pound, inflated gold, and did away once and for all with the gold standard. Only the Americans stuck to their gold guns. They were the richest nation in the world and after World War I, as gold expert Heinrich Quiring writes, "a gold-hoarding land". On January 31, 1934, President Roosevelt set the price of gold at thirty-five dollars an ounce. The United States pledged that they would take any paper dollar from abroad in exchange for pure gold. This made the U.S. dollar an international leading and reserve currency. One big advantage was that world economy had regained a stable unit of account on which it could orient itself.

But there was also a big disadvantage. The dollar being a national currency, its stability depended on the strength of American economy. For all its riches, the United States never had large enough gold stocks actually to cover all the dollars in circulation. The supplies at Fort Knox could not sink below a minimum of 25 per cent of the circulating dollars.

The British national economist John Maynard Keynes was against the gold exchange standard from the very start. Gold, he felt, was a "barbaric metal", an "alien body" in a paper currency system based on credit. He claimed it was absurd to make international solvency contingent on the potential yield of a few mines. This was an allusion to the fact that the world's gold had long since failed to keep pace with the monetary needs of an expanding economic system.

Despite Keynes's words of warning at the Bretton Woods currency conference in 1944, the U.S.A. stuck to its gold

standard. It had no cause to doubt the health of its economy. World War II had left Europe impoverished. America, however, scarcely affected by the consequences of the war, had some forty billion dollars' worth of gold.

In 1947, leaning on the reserve currency of the dollar, the International Currency Fund began its work. It had been established by forty-four countries as a kind of loan institute. Every member paid a certain amount calculated according to the gross national product: one fourth in gold, the rest in its own currency. It thereby had the right to obtain a short-term loan when necessary. This system functioned quite well into the sixties. The price of gold remained constant at thirty-five dollars per ounce. If it threatened to rise, the United States sold bullion on the London gold market. If the rate fell, the United States brought it back to normal with careful purchases.

But then the gold currency standard revealed its negative side. The American balance of payment got more and more into the red. The United States was importing more than it was exporting. U.S. concerns were investing abroad, and the development aid payments were going up. Other factors were involved too. The result was that the amount of dollars outside the United States increased. Foreign issuing banks kept gathering more and more currency that they could exchange for American gold –theoretically. For even though the United States maintained the gold standard, it had reached an agreement with the European issuing banks in 1960 that these banks would accept IOUs from the American Treasury Department for their dollars instead of American gold, which was shrinking constantly. Except for France, the national bankers have been sparing the gold deposits of Fort Knox.

But the American gold kept shrinking–not only because General de Gaulle exchanged every dispensable dollar for gold, but also because it was being bought up by speculators and jewelers.

Finally the Europeans tried to prevent the dollar crisis and the resulting depression which seemed in the offing. In 1961, seven lands (U.S.A., Belgium, West Germany, France, Great Britain, Holland, Switzerland) formed the gold pool to help the United States retain its ingots and keep down the price of gold. But this didn't faze the speculators. Now, instead of going to the United States, they got their gold from the pool nations–with the certainty that because of the ever deteriorating economic situation of the United States and because of the shortage of gold, the price of gold would someday have to clamber over the thirty-five dollar border.

In 1967, France, the European country with the largest reserves of gold, withdrew from the pool. It was an open secret that President de Gaulle wanted to force up the price of gold and thereby the value of his hoard overnight.

In 1968, the gold pool ran out. Something that currency experts in the United States and in Europe had always predicted now revealed itself to be true: as long as the American

176

balance of payment was out of order, as long as too many dollars circulated abroad, any action for saving gold was futile. The American government introduced restrictions for politicians, industry, and citizens to stop the outflow of dollars: less help for developing countries, fewer investments abroad, lower spending on vacation trips.

To halt the consumption of gold, the Western industrial nations split the gold market in two. One market was only accessible to issuing banks and could only be used for payment transactions between states, at the old gold price of thirty-five dollars per ounce. The other market was free: gold could be negotiated like a commodity, its price determined by supply and demand.

At the end of the sixties, the gold currency standard was merely a fiction.

In 1969, it became even more relative. The International Currency Fund conceived and realized a new reserve currency, which was to be as reliable as gold had been (and was therefore christened "paper gold"): special drawing rights.

The members of the ICF could lay claim to certain amounts of gold, say, to put their balance of payments in order. But these sums were not loans, they were an additional "money made out of thin air" *(The Economist)*. The scope of the special drawing rights had been worked out for each country according to a complicated system.

In August 1971, America terminated her obligation to redeem dollars with gold. The last bastion of the gold standard had fallen. A few months later, the dollar was devaluated. An ounce of gold cost thirty-eight dollars now.

The U.S.A. was steering a straight "demonetization course". It zoomed full speed ahead to dismantle the outstanding significance of gold, "the superfluous metal" (Keynes) in Western currency. This was exactly what Keynes, or, in the early sixties, Professor Fritz Machlup, a Keynes student, had recommended: "Sell the stuff, but don't buy any more of it. Someday you won't be able to get lunch for gold, but you will for dollars."

Yet, although most of the Common Market countries supported the anti-gold policies (or at least didn't openly fight them) and had as good as frozen their reserves of the noble metal since the end of the gold pool, there was still no getting rid of gold. As of 1972, the price clambered irresistibly high. The reason was formulated by Janos Fekete, vice-president of the Hungarian National Bank: "There are 300 leading economists in the world who are against gold. The problem is that these three hundred scholars are opposed by three billion people on earth who still believe in gold as much as ever."

In the time of two-digit inflation rates, gold, for most people, once again became the metal that guarantees everlasting value and survives all crises. And so all efforts to drive gold out of world currency ran side by side with the soaring of gold prices on the free market. The highest rate of gold since

1934: $ 190.50 per ounce on November 18, 1974.

Finally the International Currency Fund hit upon a temporary compromise between the strict, experience-ridden American hostility toward gold and the gold love of "three billion people". Thus, since 1974, the central banks of countries have been allowed to operate once again with their gold supplies. That is to say: they cannot only sell gold (in limited amounts), but they can also buy it. Furthermore, the transactions of the currency agencies with one another are connected to the current market price of gold, and not an artificially fixed "official" price, which considerably revalued upward the gold hoards.

In principle, however (according to Great Britain's Minister of Economy Denis Healey in early 1975), the nations are agreed to drive gold out of the currency system little by little. The Common Market countries have demonstrated their good intentions by promising not to increase the amount of gold within the Common Market during the next two years.

Still, gold believers throughout the world have not let these developments interfere with their appreciation of the yellow metal. During the first half of 1975, the price of gold did not hit the record level of November 1974. Yet it did hover between 160 and 178 dollars per ounce—five times as high as at the time of the intact American gold standard. Many experts feel that gold has no chance of regaining its dominant role in the currency system. They believe that in the foreseeable future it will have a purely intrinsic value like copper or tin. Others, such as Harry F. Oppenheimer, the gold king of South Africa, are convinced that gold will once again take over its old place in the currency structure. Then again, others, who will not venture to forecast anything about currency, declare it doesn't matter whether gold plays a part in the currency system or not. Its price will keep going up.

Thus one chapter of gold history will probably never come again: the time about which British Foreign Secretary Ernest Bevin grew enthusiastic in 1946: "I would like to see the day when I can pocket a few gold pieces, walk over to Victoria Station, buy a ticket, and go to any country I damn well please."

Instead, another chapter will be continued: the half-hour ritual, celebrated twice a day, of establishing the price of gold at London's Rothschild Bank. At 10:30 A.M. and 3 P.M., the representatives of the gold-dealing houses of Johnson, Matthey, Ltd., Samuel Montagu & Co., Mocatta & Goldsmid, N. M. Rothschild & Sons, and Sharps, Pixley & Co. meet in the gold room.

The Rothschild representative presides. He jots down the buying and selling wishes of his colleagues, who telephone their clients throughout the conference, informing him of offers by raising and lowering small Union Jacks. If someone raises the flag, that means a new order. At 11 o'clock, the Rothschild representative lifts his table flag. The fixing is over, supply and demand have been reckoned against one another.

The gold price is established for the next four hours.